CYCLE
CHIC

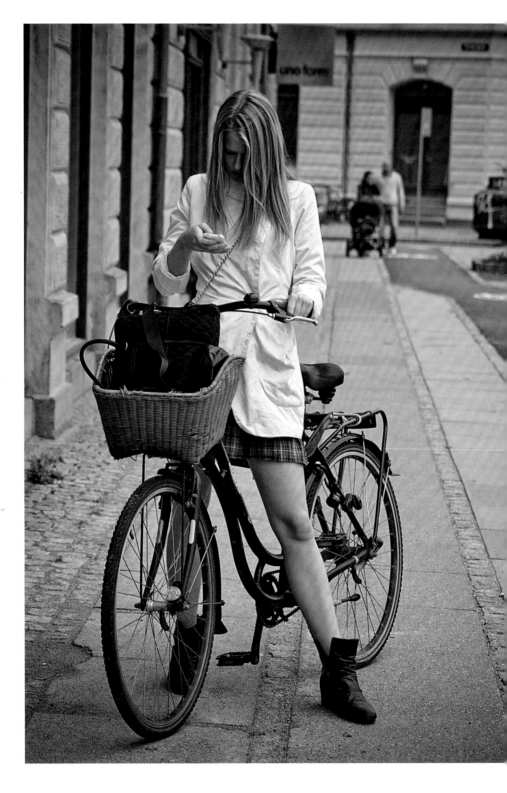

MIKAEL COLVILLE-ANDERSEN

CYCLE CHIC

368 ILLUSTRATIONS, 358 IN COLOR

🌀 Thames & Hudson

To my children, Felix and Lulu-Sophia.
The next generation of bicycle users and
my constant source of joy and inspiration.

RIDE SAFE

Mikael Colville-Andersen was the first to bring urban style and cycling together
when he launched Copenhagen Cycle Chic in 2006, which has been voted a
top-ten fashion blog by the *Guardian* newspaper and one of the top 100 blogs
by *The Times* (London). He is also the founder of Copenhagenize, a website
and consultancy that advises governments and policy-makers on the importance
of city cycling.

Cover photography (front and back) by Mikael Colville-Andersen

Copyright © 2012 Mikael Colville-Andersen

Designed by Myfanwy Vernon-Hunt

All Rights Reserved. No part of this publication may be reproduced
or transmitted in any form or by any means, electronic or mechanical,
including photocopy, recording or any other information storage and
retrieval system, without prior permission in writing from the publisher.

First published in 2012 in hardcover in the
United States of America by Thames & Hudson Inc.,
500 Fifth Avenue, New York, New York 10110

thamesandhudsonusa.com

Library of Congress Catalog Card Number 2011937754

ISBN 978-0-500-51610-2

Printed and bound in China by Toppan Leefung

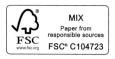

MIX
Paper from
responsible sources
FSC
www.fsc.org FSC® C104723

CONTENTS

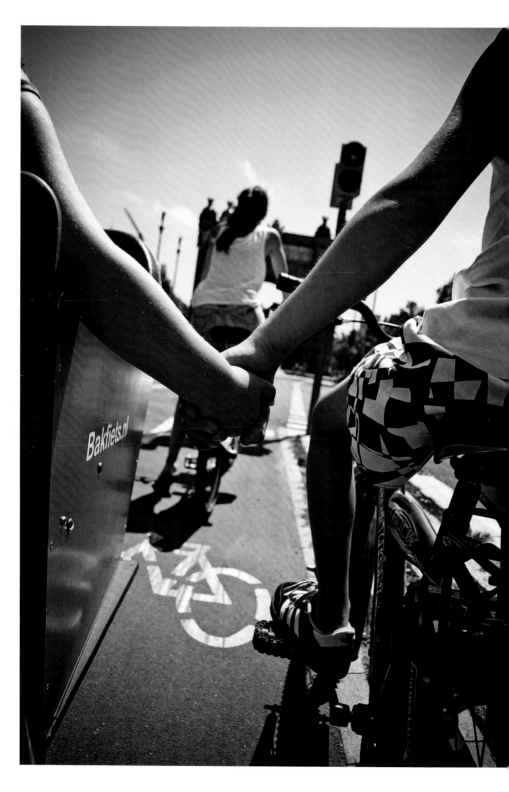

INTRODUCTION

What a splendid ride. Ever since I took that first photo – 'the photo that launched a million bicycles' – on Åboulevarden, Copenhagen, on 14 November 2006, Cycle Chic has enjoyed a warm, steady tailwind, rolling calmly and stylishly around the world. What happened afterwards is testament both to the power of the Internet and social media, and to the timeless appeal of the humble bicycle, which has returned to public consciousness, and now, nearly six years later, shows no sign of fading away.

I've always left it up to others to define what 'cycle chic' is. Some call it fashion, others see street style. Early on I called it 'bicycle advocacy in high heels'. Generally, I prefer to regard it as street photography, documenting the return of the bicycle to the urban landscape. This book is a selection of photographs of beautiful people who are adding to the social fabric of our cities by choosing to ride a bicycle. In many ways, it is also a time machine. Cycle Chic is just a way of describing how Citizen Cyclists have used the bicycle since it was invented in the 1880s. Fashions and fabrics have evolved, as they always do, but the simple imagery of people using bicycles in our cities is timeless. It is my sincere hope that these photographs, taken in the now, not only reflect the past, but also allow us a glimpse into our future – a future in which bicycles are accepted and respected, and are a feasible form of transportation.

After the launch of Cycle Chic in 2007, it was clear that there was a growing interest in how the bicycle was an integral part of life in the city, and specifically in how the stylish natives use the bicycle without any form of cycling 'gear'. The blog kick-started the growth of a Cycle Chic Republic, with sites around the world devoted to cycling in the city, from Barcelona to Bordeaux, Ottawa to Odessa, Vienna to Valencia.

History is repeating itself. Bicycle Culture 2.0 is upon us. The rapid rise of the global movement that Cycle Chic has spawned points to the fact that society has longed for the return of the bicycle. Now, more than ever, the bicycle is back. We've missed it. Let's keep it around this time, shall we?

The Cycle Chic Manifesto

- I choose to Cycle Chic, and, at every opportunity, I will choose Style over Speed.
- I embrace my responsibility to contribute visually to a more aesthetically pleasing urban landscape.
- I am aware that my mere presence in said urban landscape will inspire others without my being labelled as a 'bicycle activist'.
- I will ride with grace, elegance and dignity.
- I will choose a bicycle that reflects my personality and style.
- I will, however, regard my bicycle as transport and as a mere supplement to my own personal style. Allowing my bike to upstage me is unacceptable.
- I will endeavour to ensure that the total value of my clothes always exceeds that of my bicycle.
- I will accessorize in accordance with the standards of mainstream bicycle culture, and acquire, where possible, a chain guard, kickstand, skirt guard, fenders, bell and basket.
- I will respect the traffic laws.
- I will refrain from wearing and owning any form of 'cycle wear'.

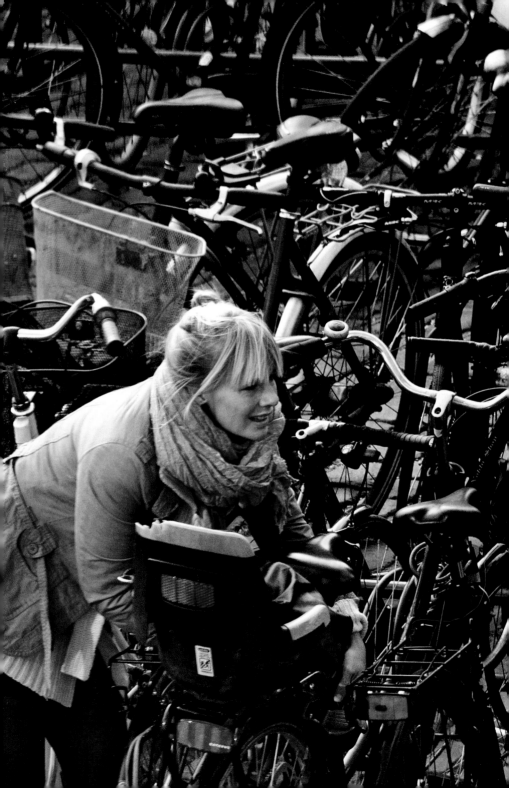

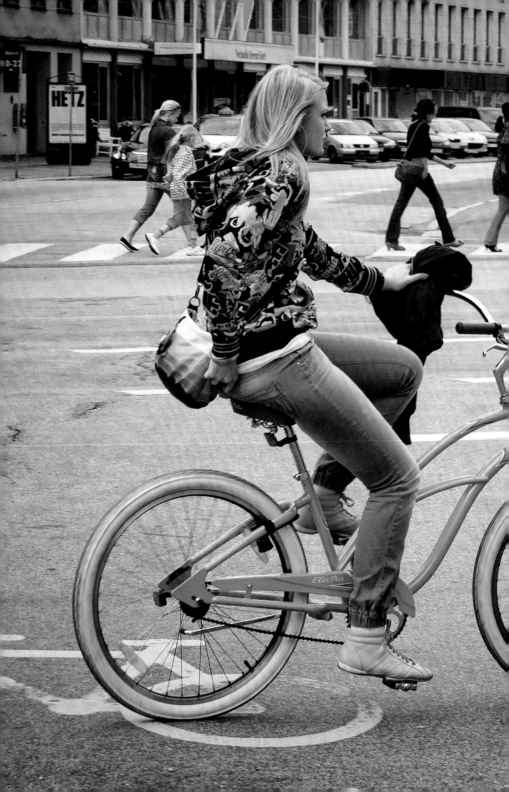

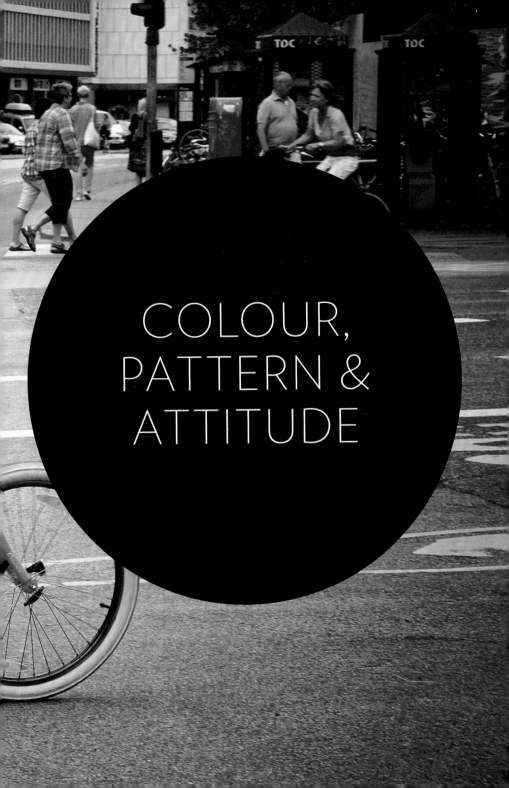

COLOUR, PATTERN & ATTITUDE

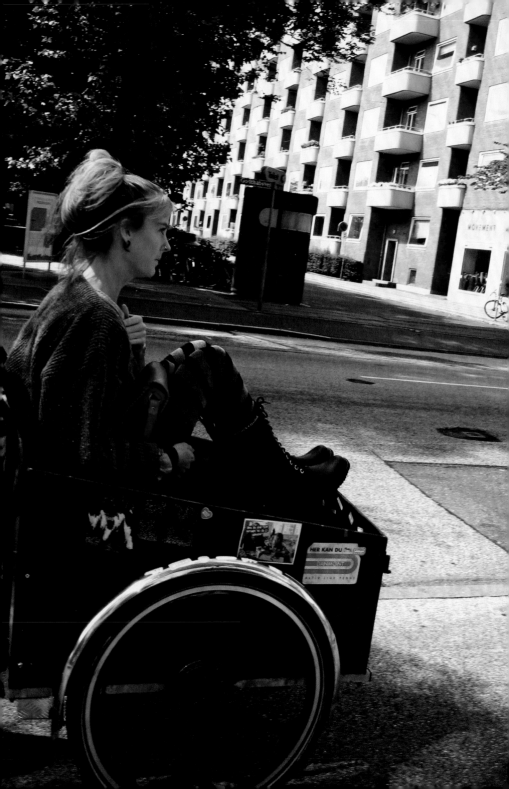

The greatest gift that street-style photography has given to the world is variety – the opportunity to see countless combinations of textures, patterns, colours and personal style. The Internet has liberated style from the narrow focus of the fashion magazines, handing the power to influence firmly back to the people. The web has become the fashion version of Speaker's Corner in London's Hyde Park. Stand up and show off who you are.

With the resurgence of the bicycle in our cities, we have once again been provided with a graceful and mobile catwalk on which Citizen Cyclists can display their fashionable inclinations and inspire others. Indeed, the bicycle itself can contribute to the overall look. Choosing the colour of your bicycle is as important as choosing a pair of shoes, not to mention the colour of the skirt guard, chain guard and fenders. Basket or back rack, or both? Do these pedals go with these heels?

Despite regional differences in style and taste, this chapter highlights the inevitable similarities, and patterns and colours that aren't worlds away from each other pop up in cities that are separated by oceans and continents. Your style will forever be yours, but if you peer into the global mirrors, you may discover a reflection that is pleasantly recognizable. Rest assured, you'll never ride alone in the Cycle Chic Republic.

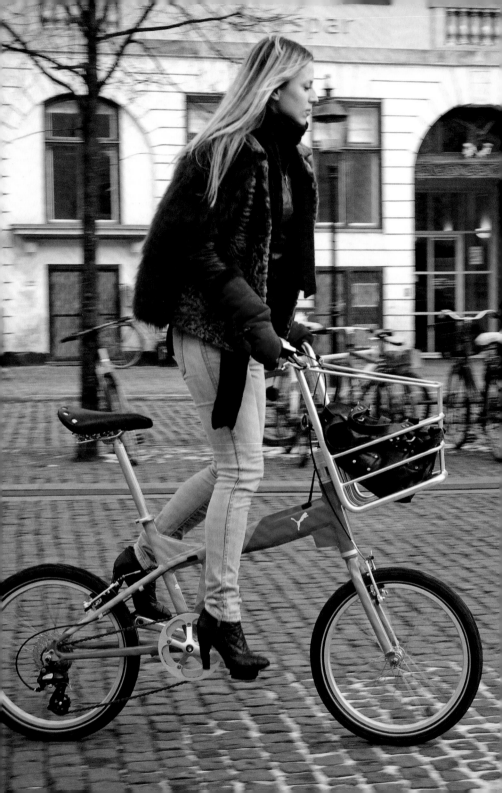

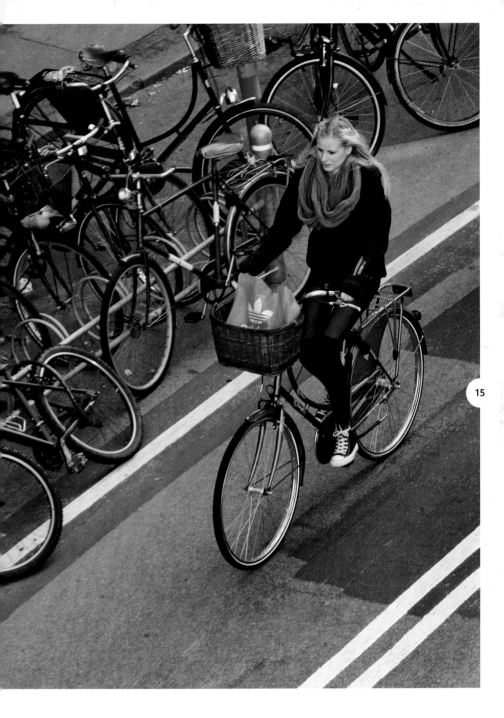

VIOLET FEMMES According to the rules of dream interpretation, purple represents devotion, kindness and compassion – a comfy sentiment that is given some edge by the addition of a pair of trainers or some furry red gauntlets.

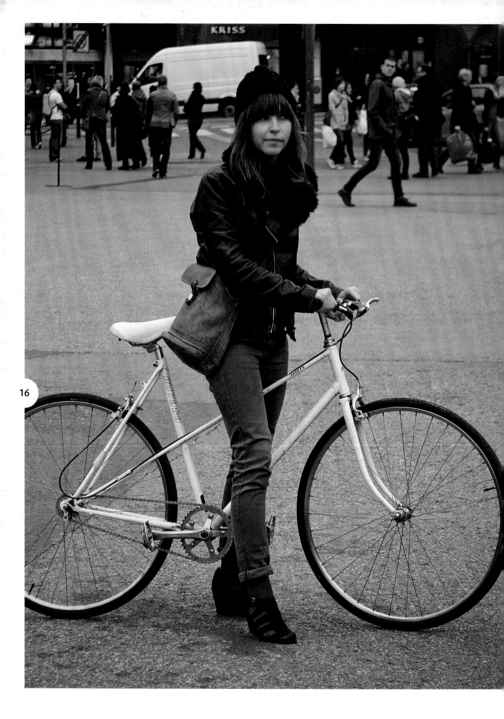

PURPLE REIGN Shades of violet are given an outing in Helsinki (above) by matching socks to bike chain. In Japan (opposite, top right and bottom left), the use of purple is more restrained, pepped up by a pair of orange bikes.

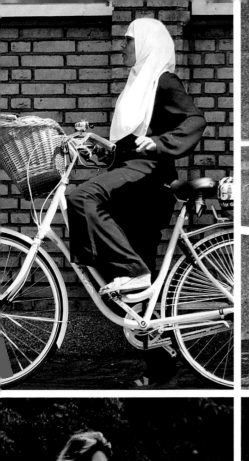
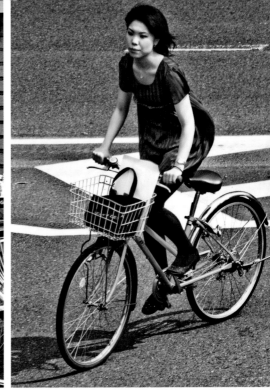
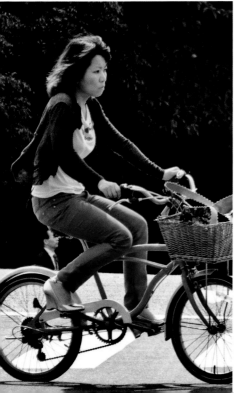
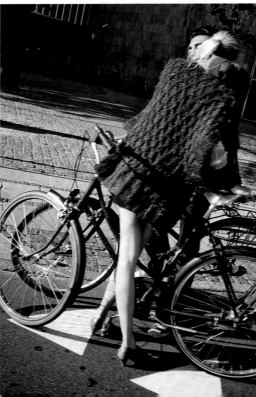

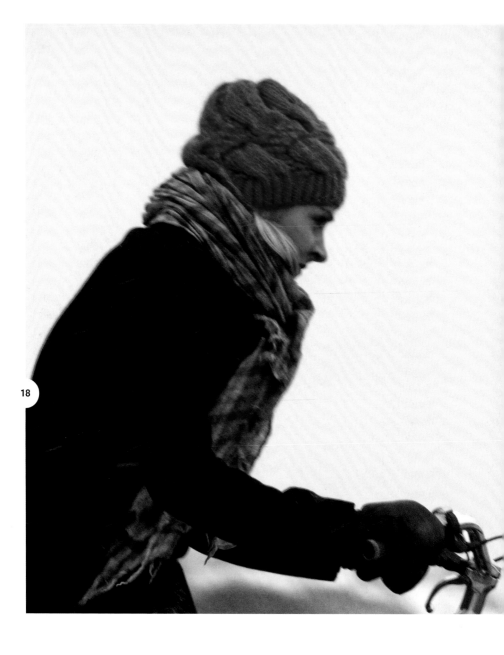

KNITTY GRITTY Keeping it cosy, keeping it warm. A knitted hat provides a colourfully elegant exclamation mark atop the head of this cyclist (above), pushing forward through the traffic on Queen Louise's Bridge in Copenhagen.

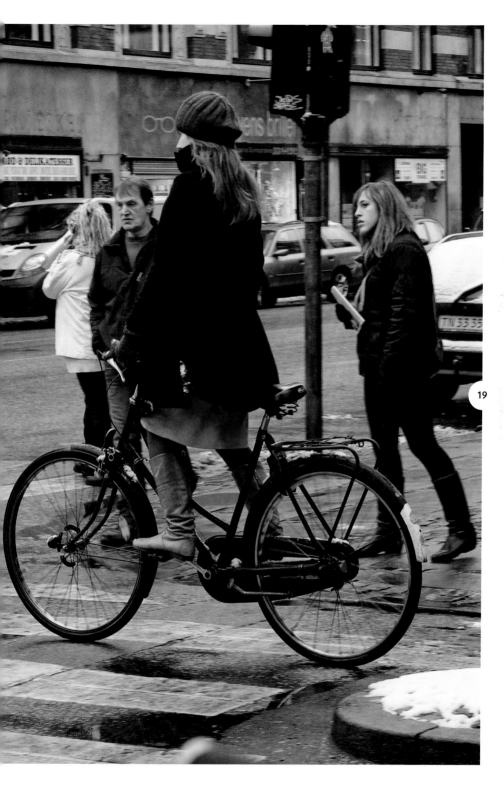

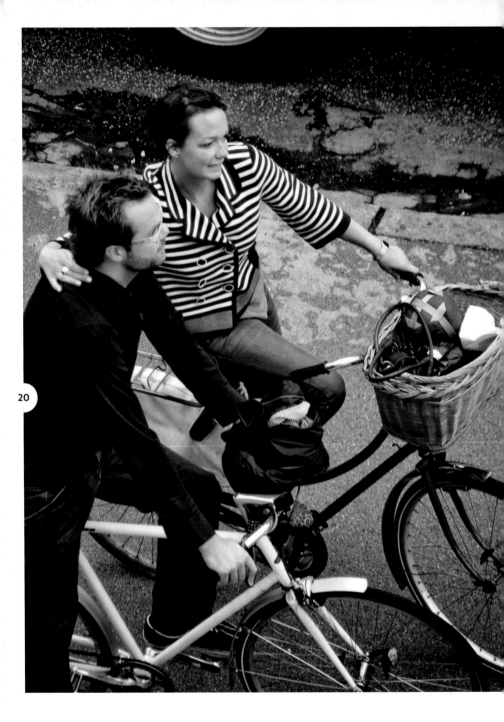

EARN YOUR STRIPES Like Albert Einstein once said, 'When you can accept the universe as being something expanding into an infinite nothing, which is something, wearing stripes with plaid is easy.'

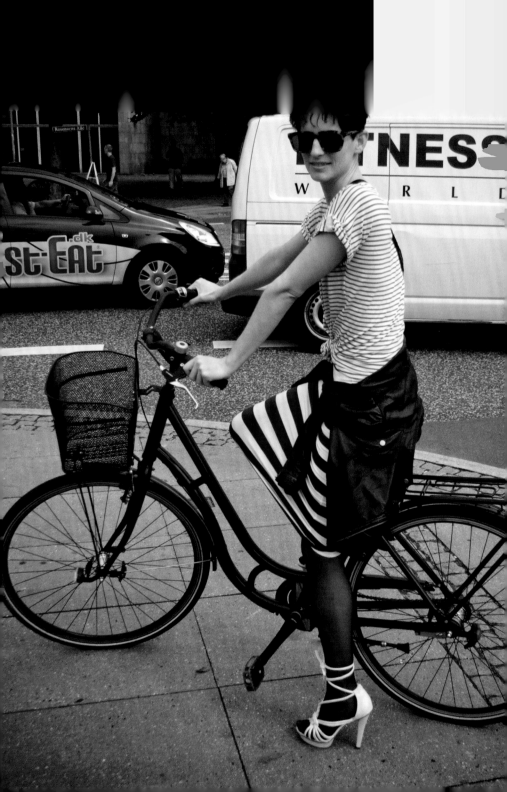

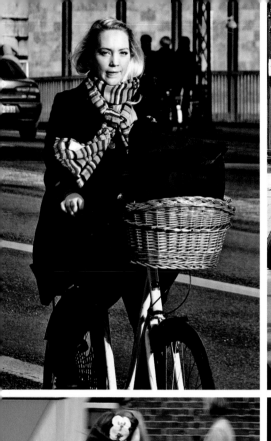
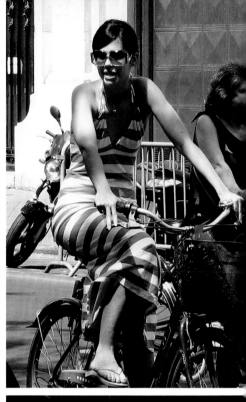
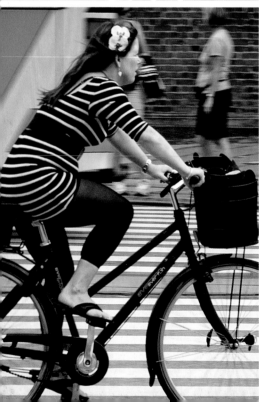
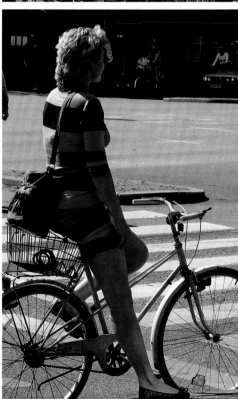

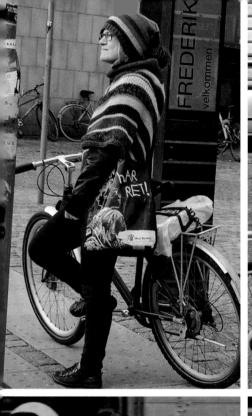
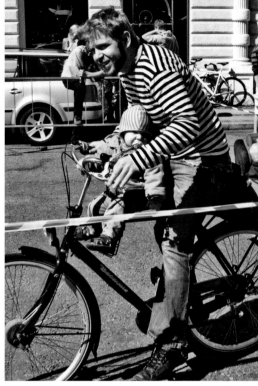
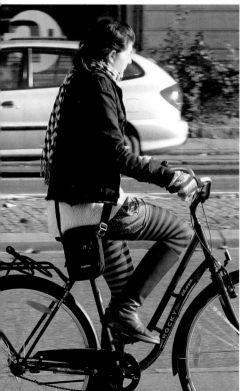
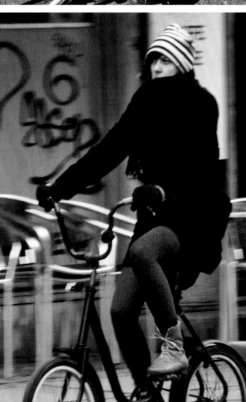

RED MEANS GO Roll out your own red carpet and let your bicycle do the talking for you. A matching red dress and bicycle, together with a beaming smile, add a cheery note to the somewhat less inspiring suburbs of Vancouver (opposite).

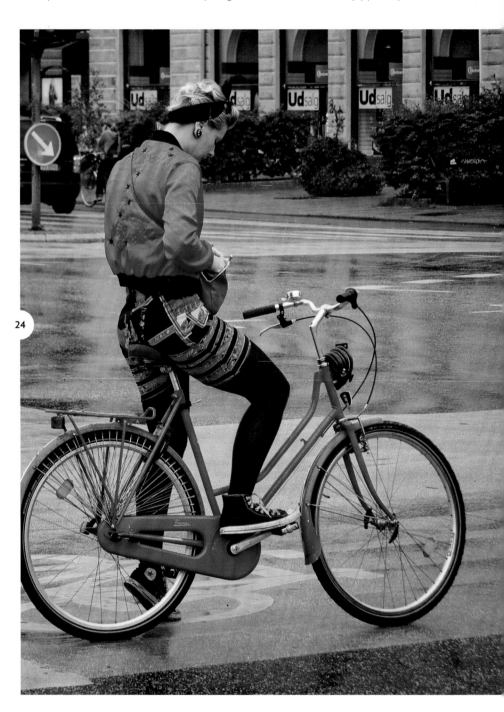

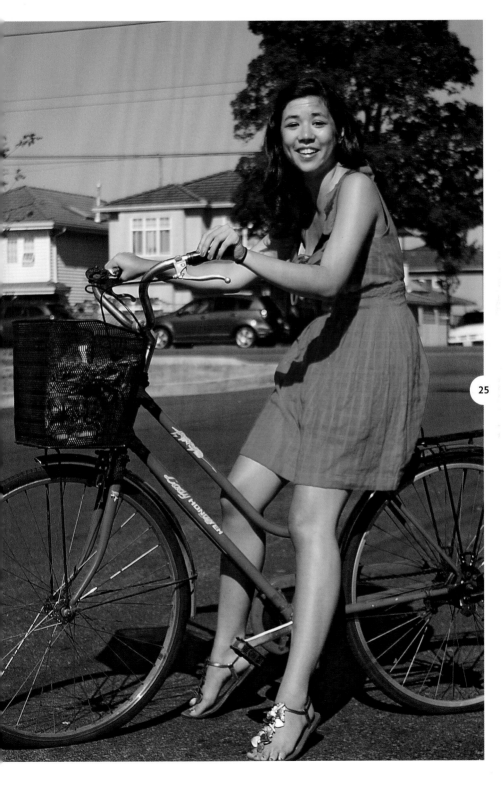

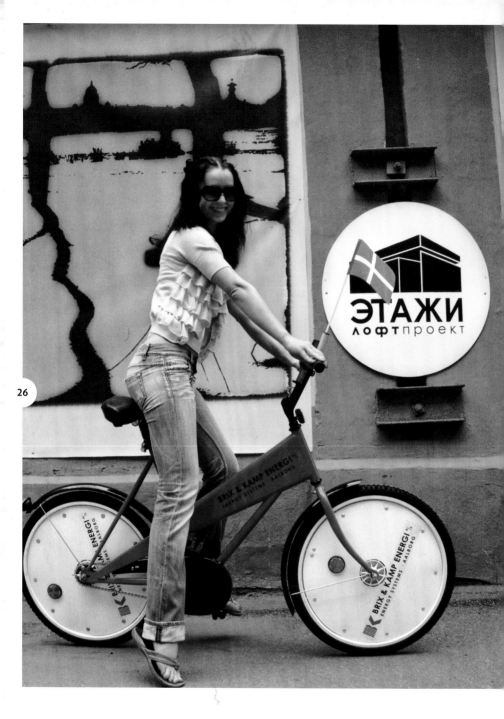

FLYING THE FLAG In Russia, Citizen Cyclists rule the streets, with Moscow and St Petersburg both joining the Cycle Chic family. A Copenhagen cycle-share bicycle on tour in St Petersburg (above).

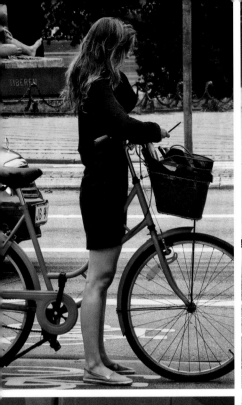
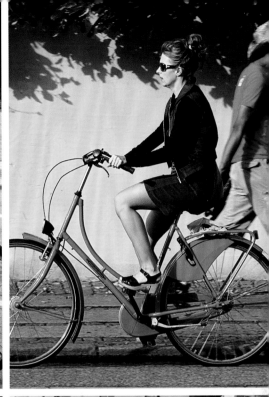
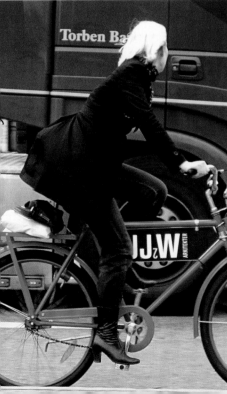
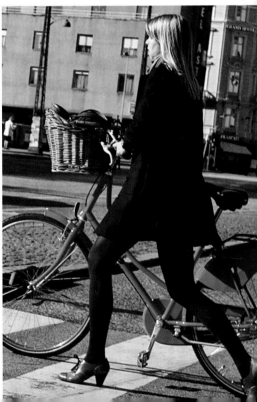

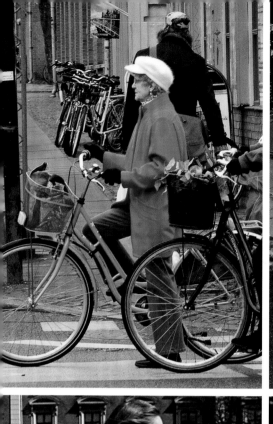
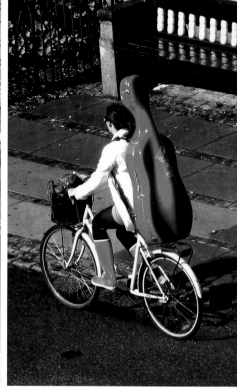
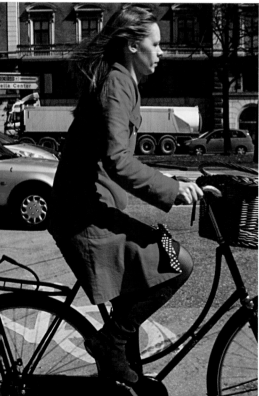
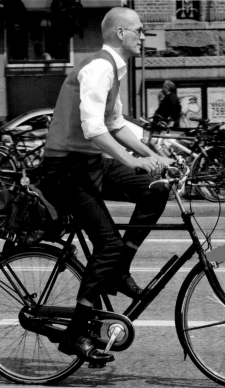

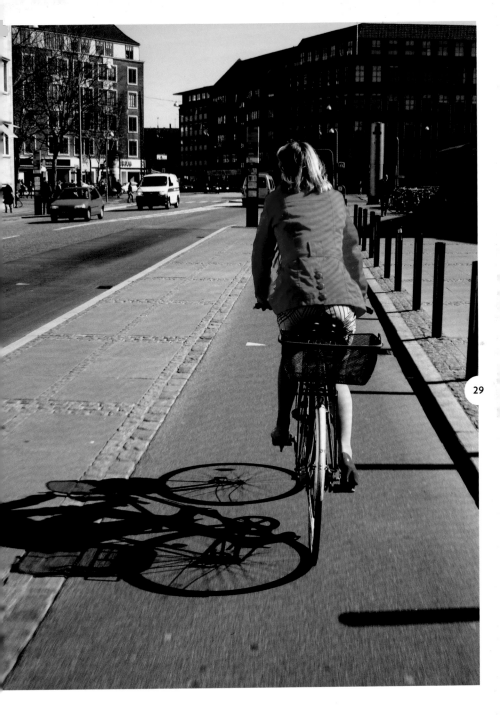

BANISH THE BLUES 'Red is the ultimate cure for sadness,' said the American fashion designer Bill Blass. I couldn't agree more. Even the cello case of this Copenhagen cyclist, paired with scarlet wellies, becomes a fashion accessory.

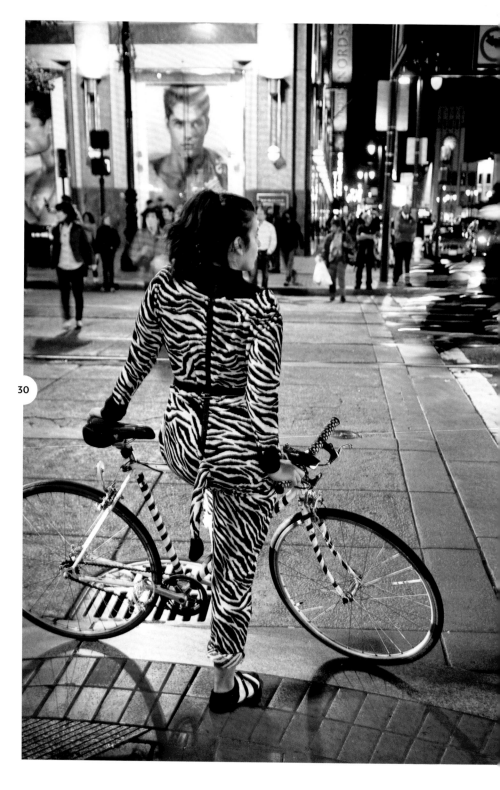

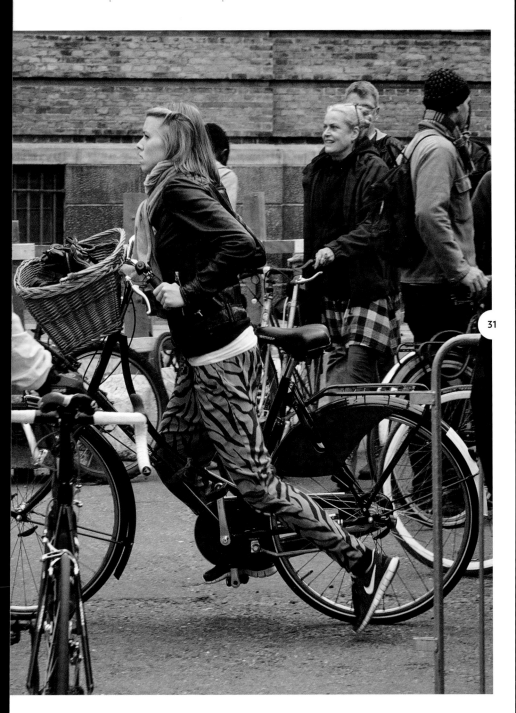

31

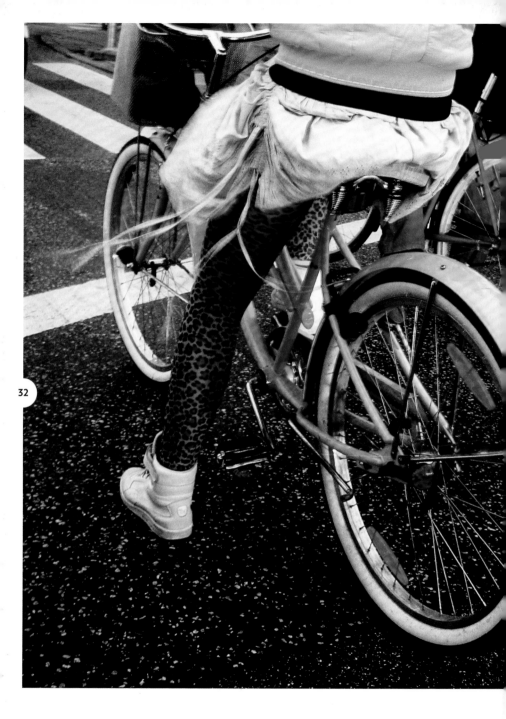

JUNGLE CATS Rocking the full-on leopard look in San Francisco (opposite), one cyclist accessorizes her look with a friend in a tutu. In Copenhagen (above), leopardskin leggings are offset by a bike in bubblegum pink.

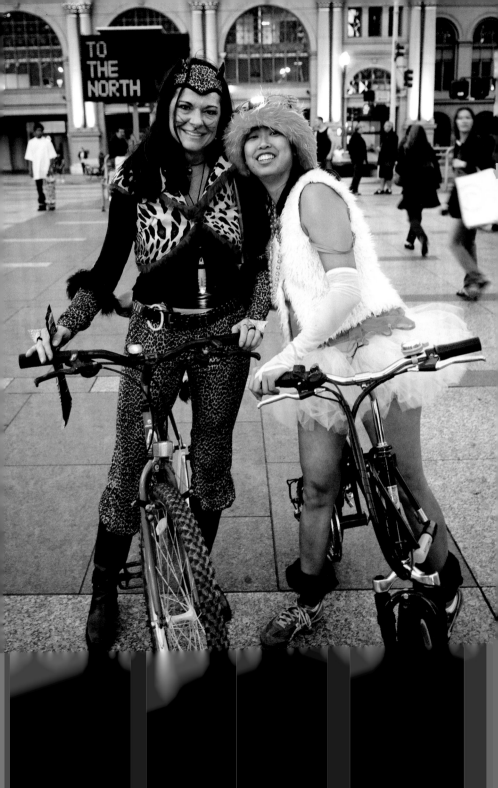

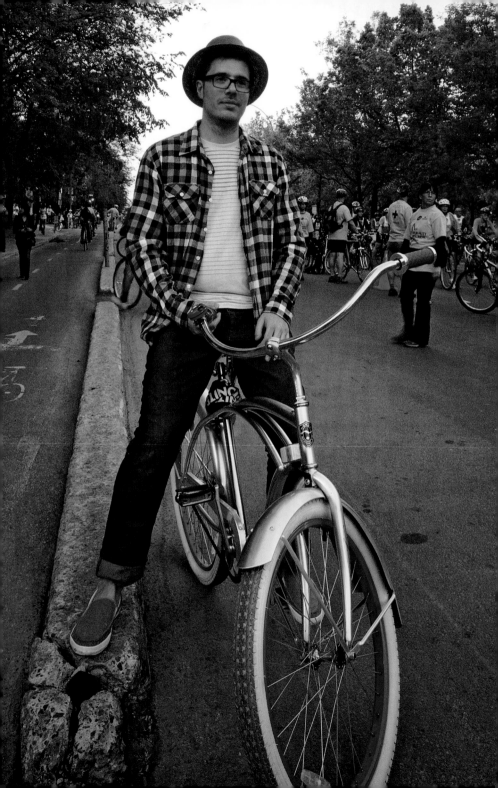

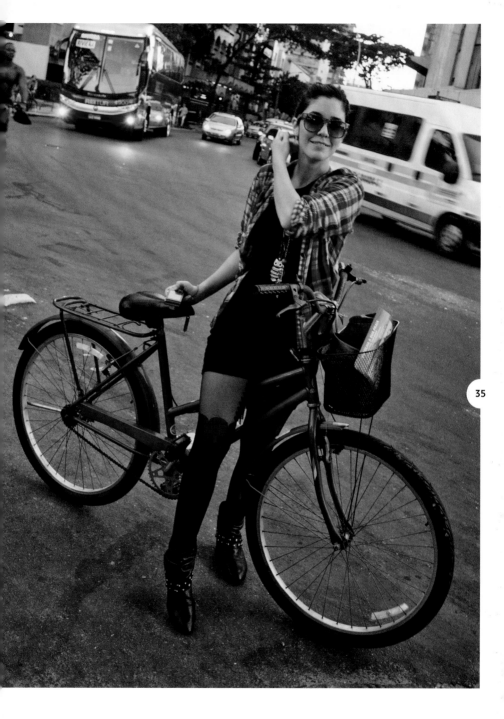

URBAN CHECKLIST Let's face it, the bicycle is reintroducing cool –
and the checked shirt – to the traffic equation around the world,
from Montreal (opposite) to Rio de Janeiro (above).

BLUEPRINT FOR SUCCESS Blue rolls around Riga, Latvia (below), and hurtles through downtown Ottawa (opposite). In keeping with other cities around the world, Ottawa has opened an inaugural stretch of separated cycle track.

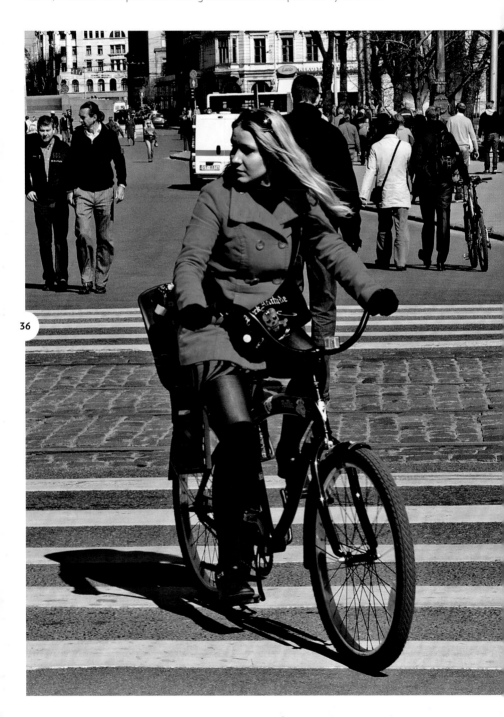

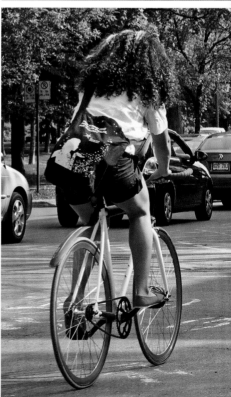

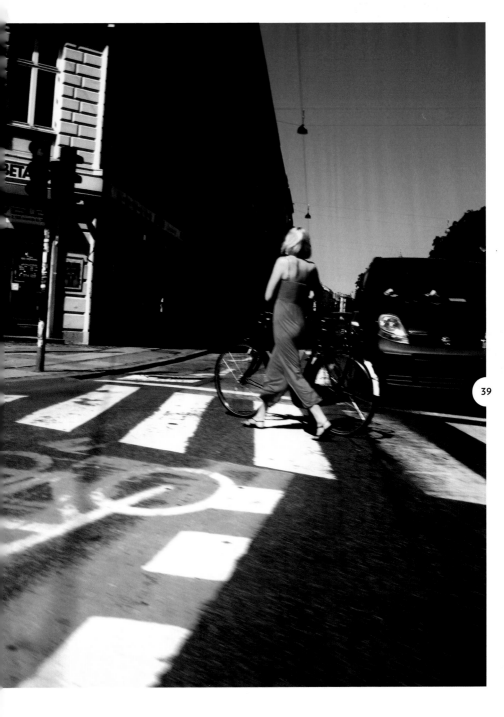

39

MOODY BLUES I've always thought that an operatic soundtrack best suits Cycle Chic, but if we have to sing the blues, this is how we do it. Feeling blue in Copenhagen and Montreal (opposite, bottom right).

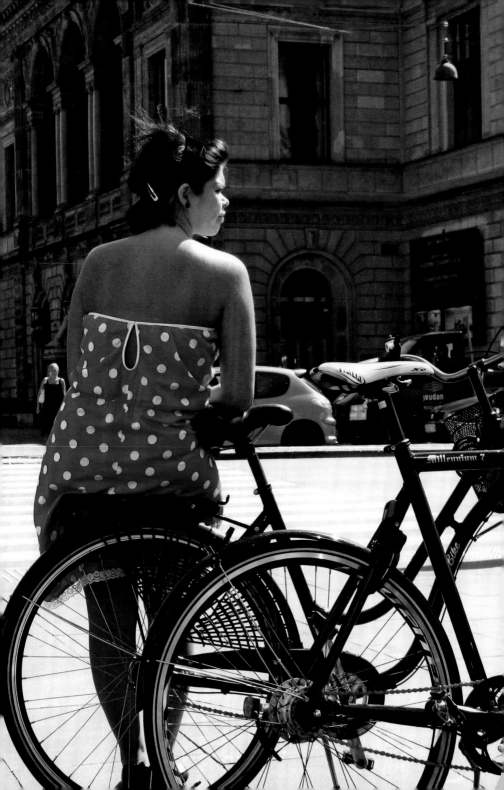

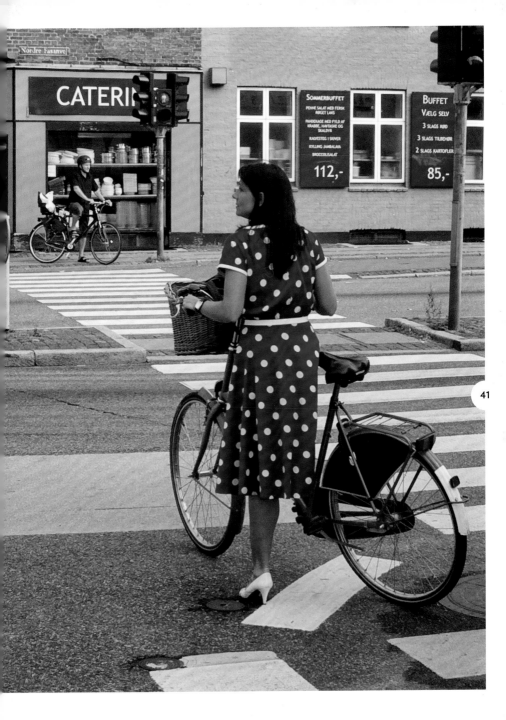

41

GOING DOTTY While cities work towards creating a network of safe, separated bicycle infrastructure, fashionable cyclists are connecting the dots. A colourful bicycle and basket at the front add to the feminine chic in Copenhagen (above).

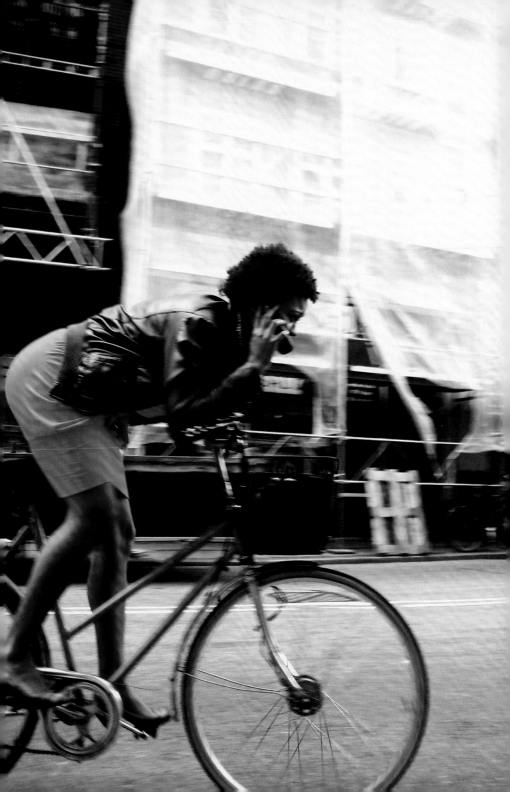

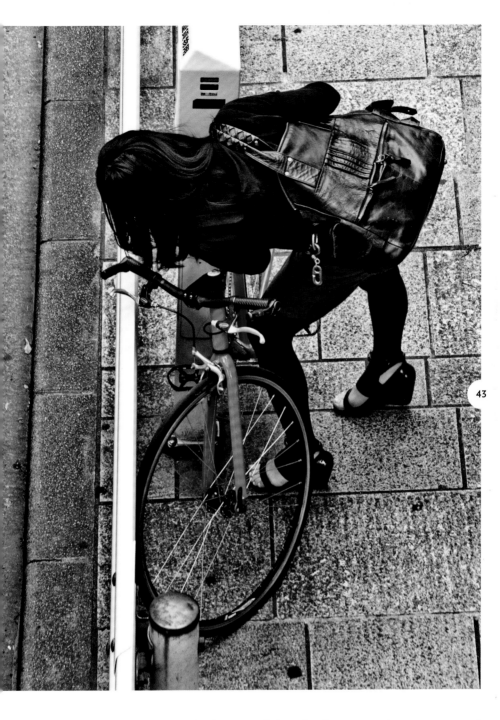

43

WELL HEELED Adding some fashion flamboyance to the mean streets of Copenhagen (opposite) and Tokyo (above), which reaches a respectable number four on Copenhagenize's index of bicycle-friendly cities.

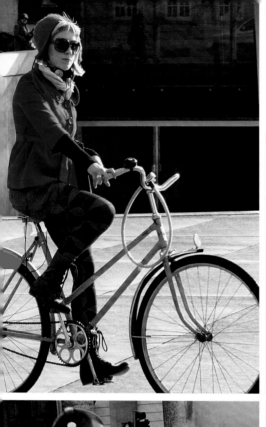
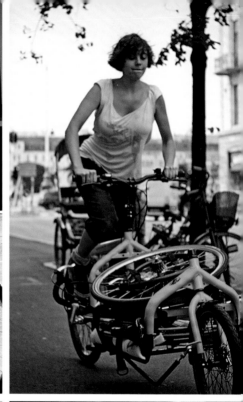
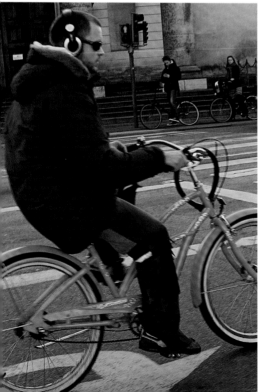
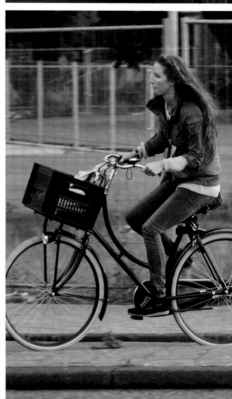

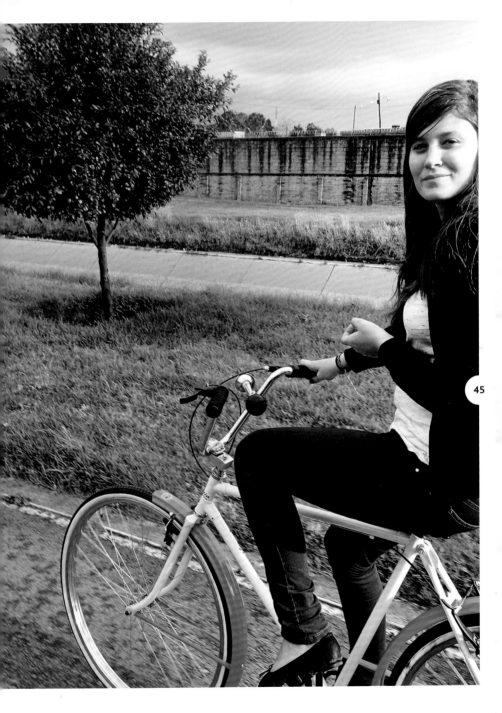

45

ORANGE CRUSH No wonder this cyclist in Bogotá (above) is happy.
Each Sunday and holiday, the city's main streets are closed to cars from
7am to 2pm, and given over to cyclists, pedestrians and street performers.

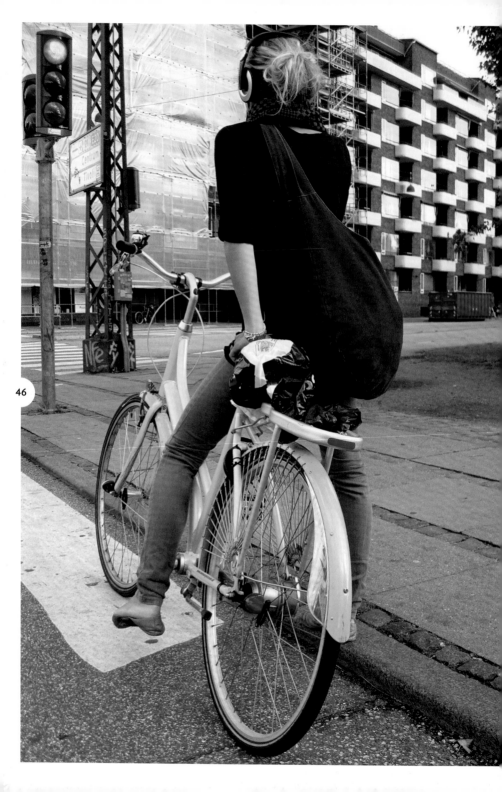

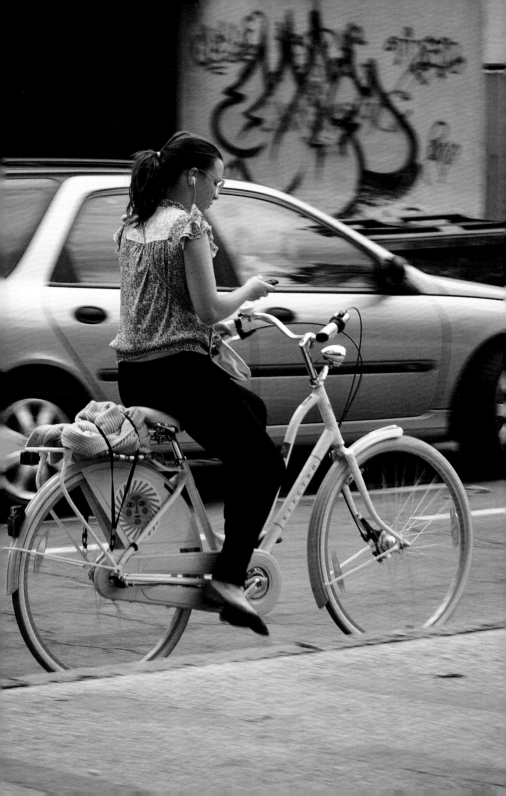

'THE STEEL HORSE FILLS A GAP IN MODERN LIFE. IT IS AN ANSWER NOT ONLY TO ITS NEEDS, BUT ALSO TO ITS ASPIRATIONS. IT'S QUITE CERTAINLY HERE TO STAY.'

LE VÉLOCIPÈDE ILLUSTRÉ, 1869

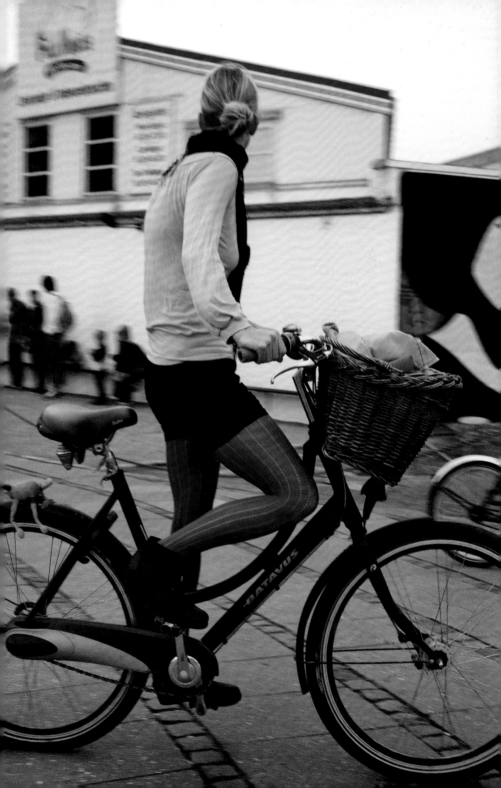

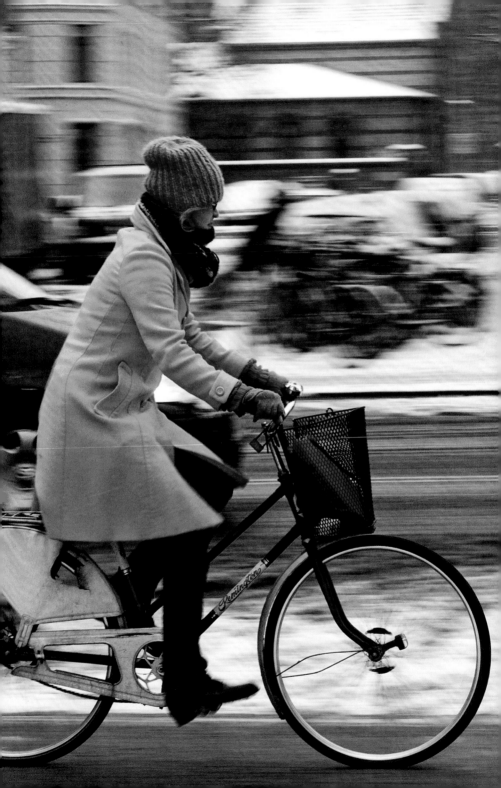

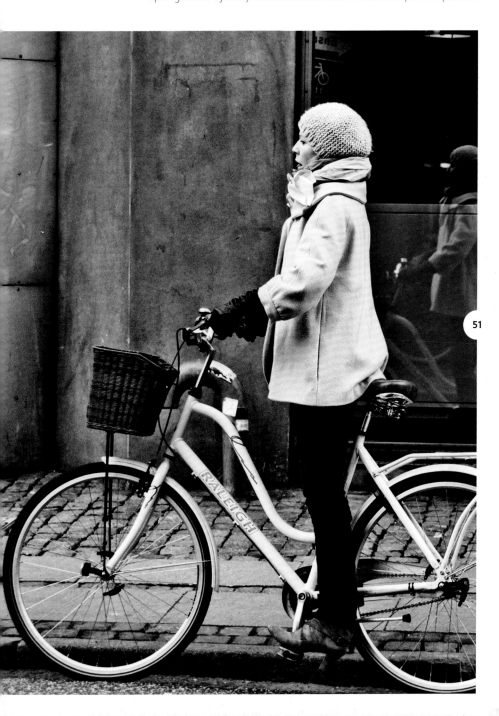

52

BRIGHTEN YOUR DAY Less mellow yellow and more red hot in (clockwise, from above) Lisbon, Copenhagen, Washington, DC and Bordeaux, where the more usual wicker basket simply won't do.

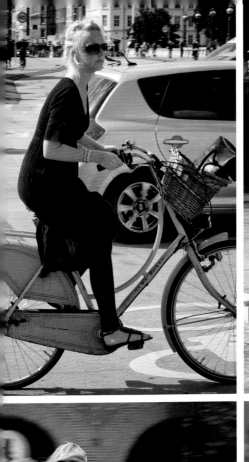
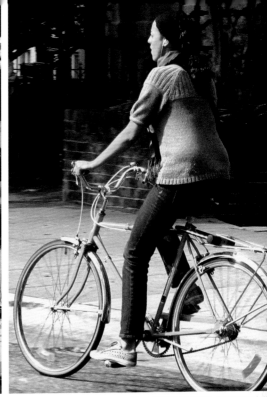
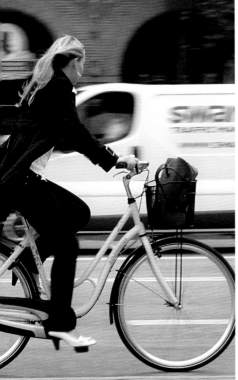
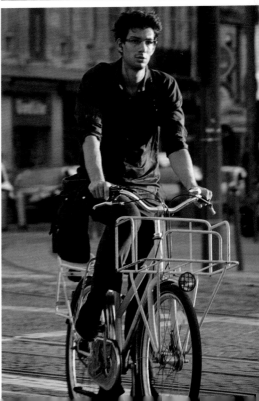

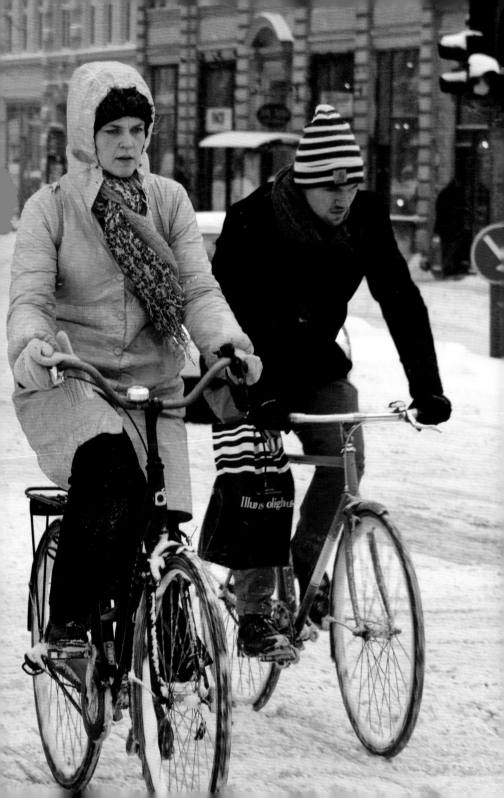

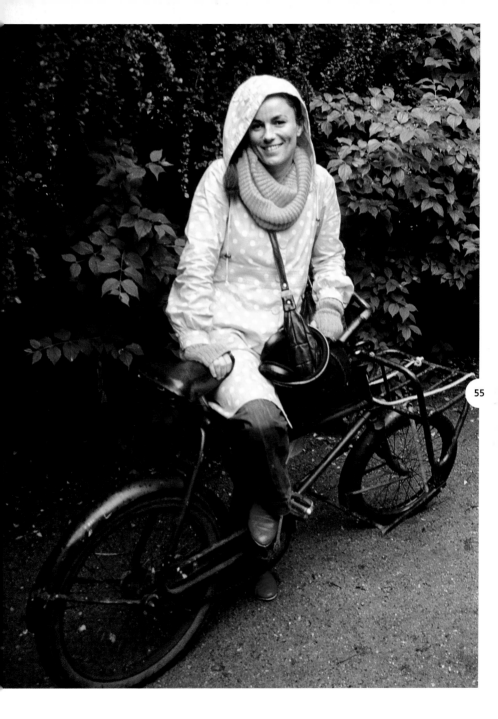

HOT SPOTS Bicycling isn't just for summer, as these intrepid Copenhageners show. Come rain, sleet or snow, light up your life with a warm yellow jacket (yellow mittens optional). You'll light up your city, too.

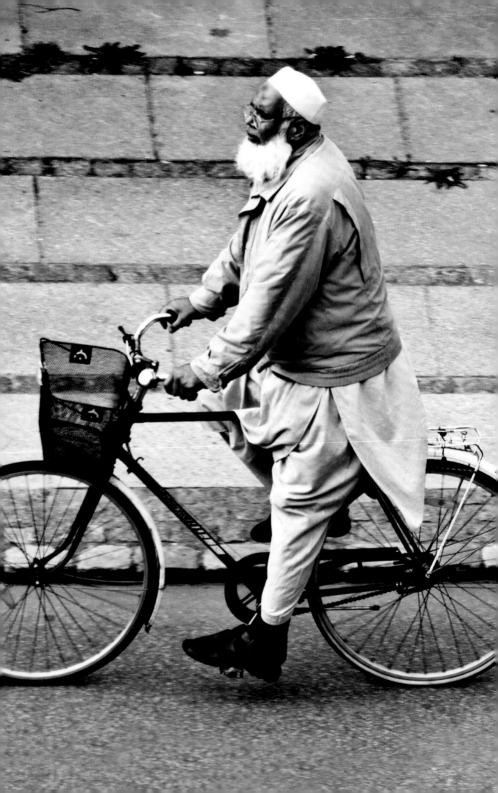

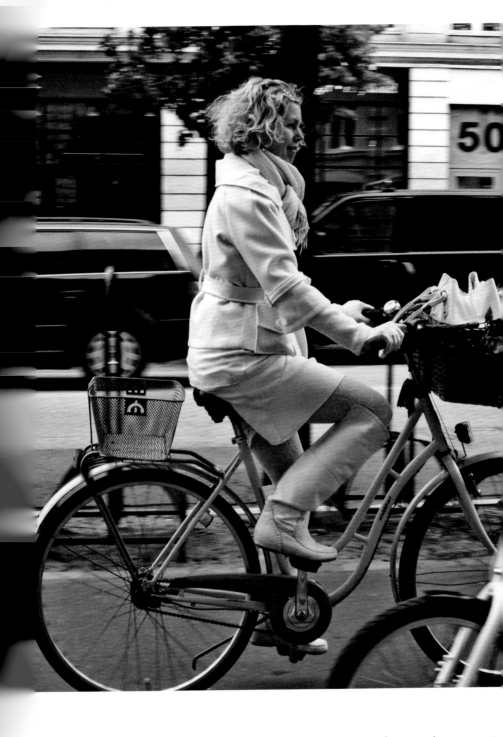

POINT BLANC White is a symbol of purity in countless cultures, and, not surprising it suits the Citizen Cyclist rather well. Fenders, however, are recommend

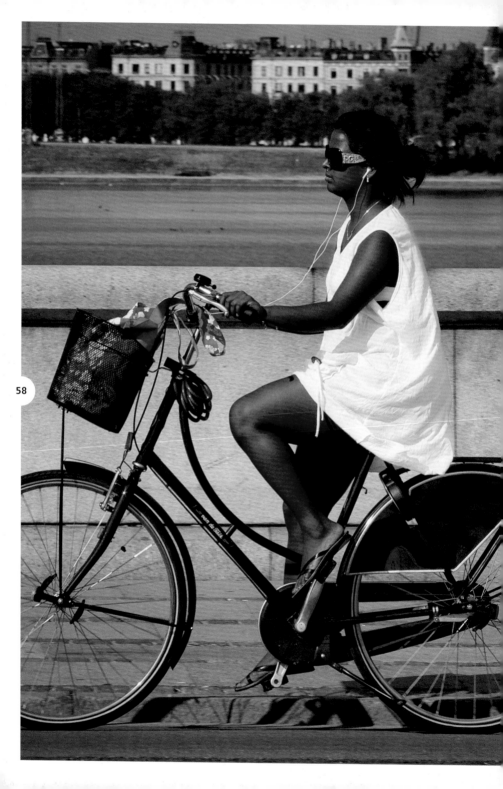

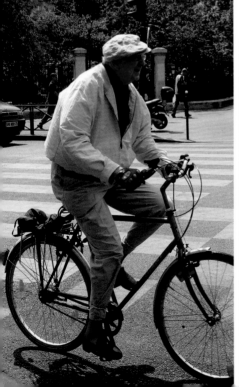
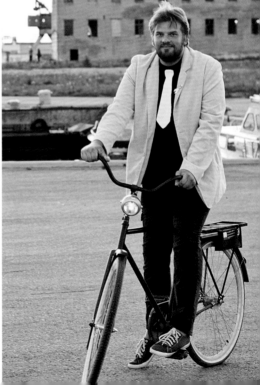

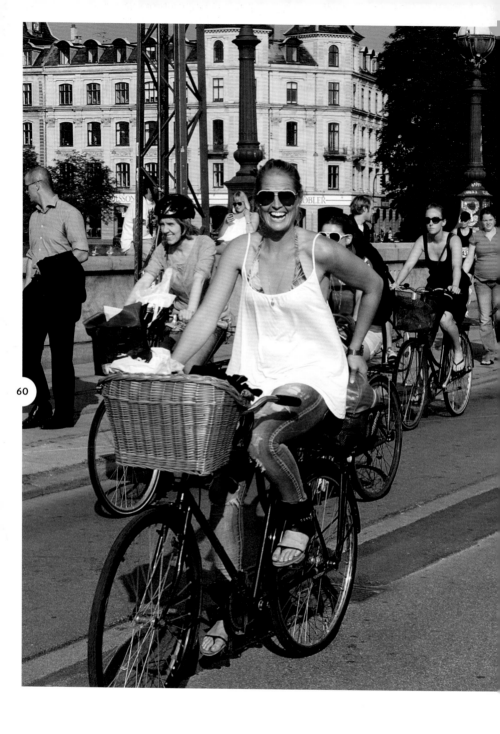

60

JOY UNCONFINED Cycling makes the people come together in Copenhagen (above). But in São Paulo (opposite), they just want to break free.

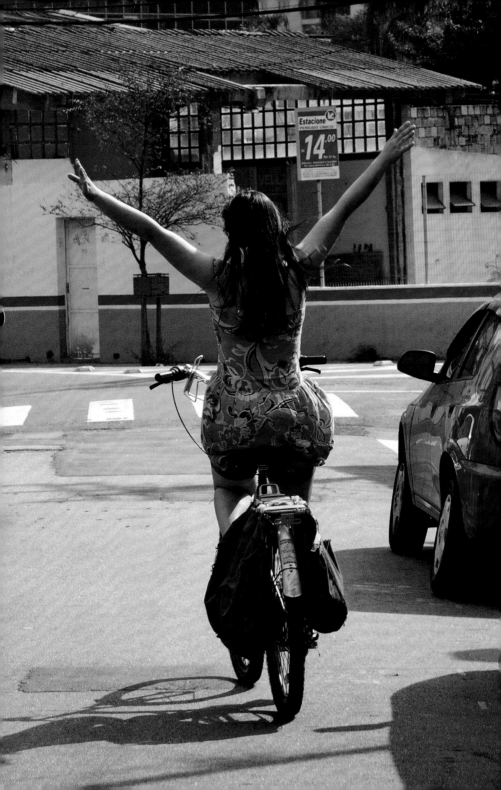

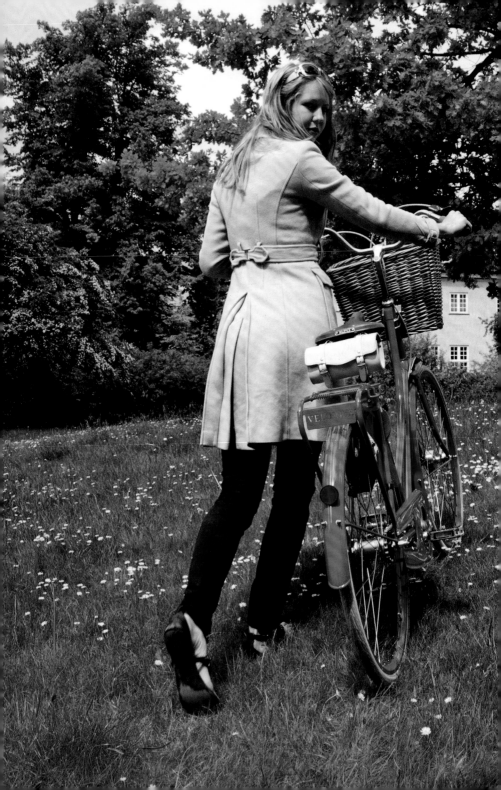

OUT AND
ABOUT

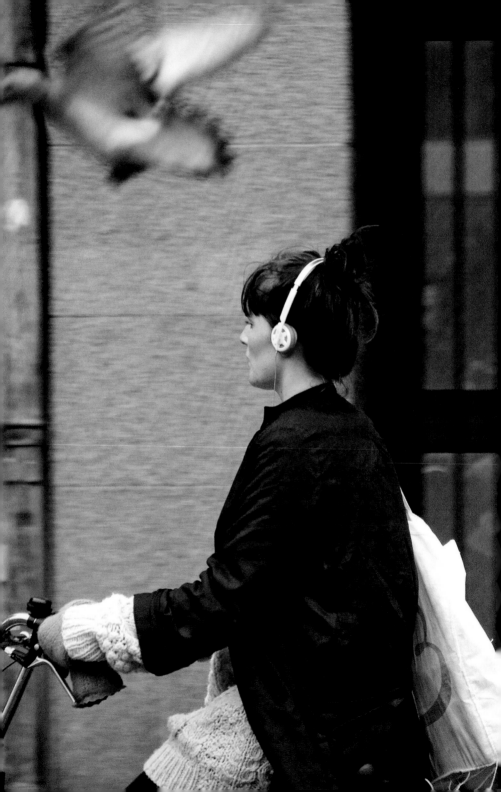

The word 'environment' has developed a rather singular, ecological meaning, but let's not forget the etymology of the word. From the Old French *environer* – to surround, enclose, encircle – it means the nature or conditions in which a person or thing lives. In short, the world around us. Cities are a feast for our senses. We are constantly touching, smelling, seeing, hearing and tasting everything the urban landscape offers up.

The bicycle contributes immensely to the social fabric of a city. Not only are bicycle users face to face with their urban environment, they are also elbow to elbow with their fellow citizens. Riding along in bicycle traffic in cities like Copenhagen (London, Paris, Bogotá, Gdansk), you can slip into the olfactory slipstream of other cyclists, inhaling the scent of their shampoo or perfume as you glide your way into the city centre. You can check whether you're late for a date by looking up at church towers, and, if you're making good time, check out the guy's shoes next to you on the cycle track. If you're lucky, you'll see a friend and stop for a chat. You lean up against a lamppost while waiting for a red light, listen to someone whistling or humming as they pass, and taste the rain and snow on your lips as you head home from work. And I'm quite convinced you can taste sunlight, too.

This is the touchy-feely chapter. Celebrating the way the bicycle acts as a fifth limb, a sidekick, a lifestyle accessory, an urban-living necessity, and how bicycle users are at one with their cities like no motorist could ever be. Isn't that why we live in cities? To soak it all up and feel the pulse?

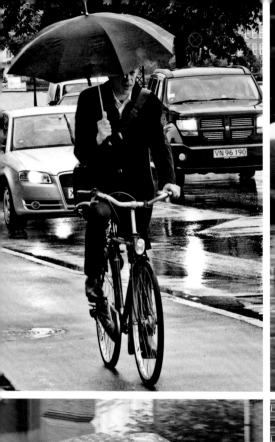
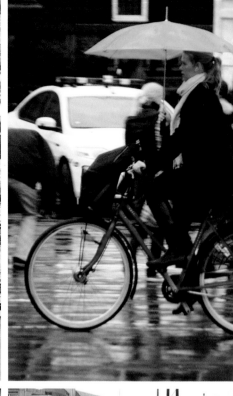
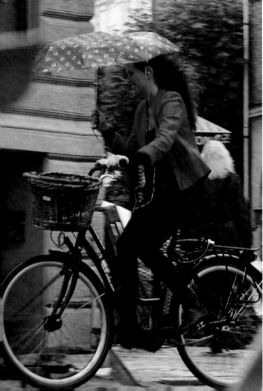
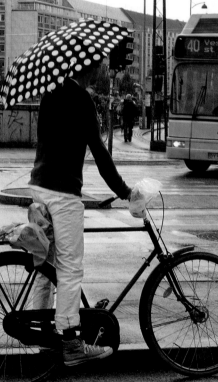

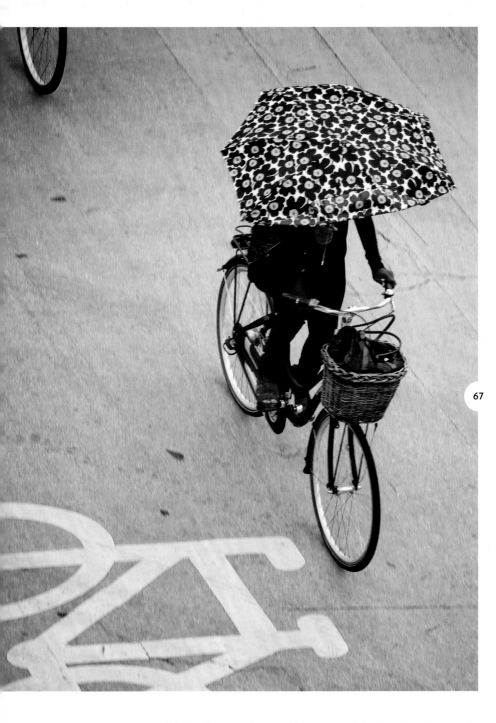

67

FREE REIN Umbrellas complement the poetry of the bicycle rather nicely. Two simple yet effective designs rolling along, hand in hand. It's an elegant counterpoint to the horde of racers in Anjō, Japan (overleaf).

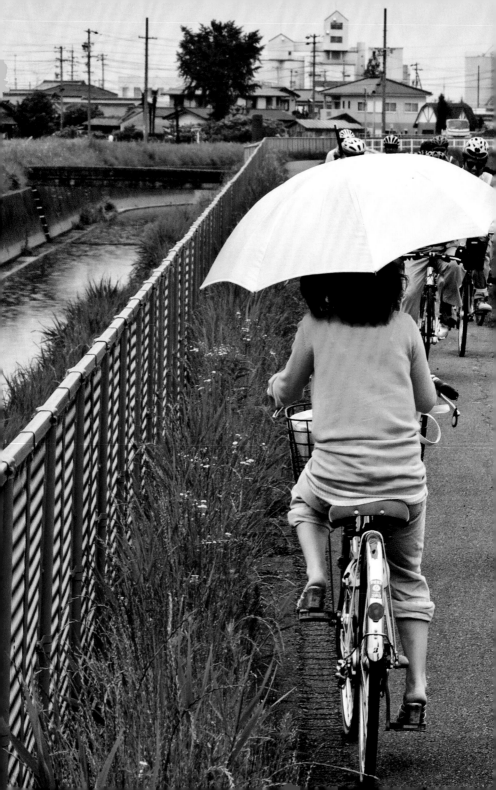

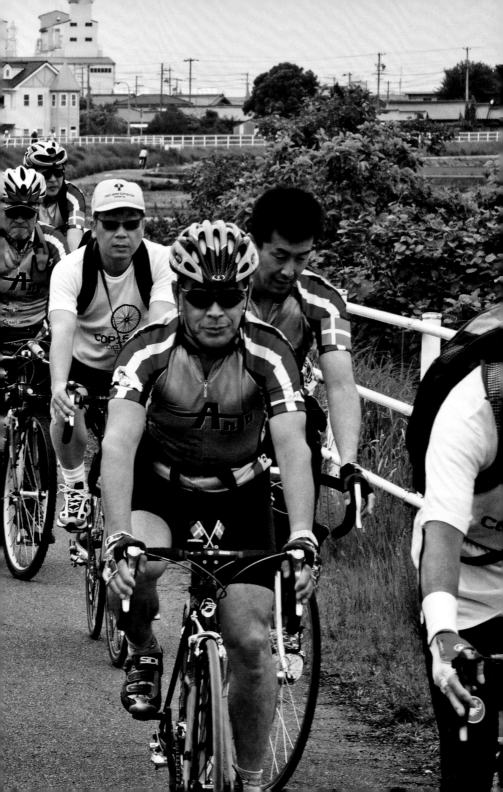

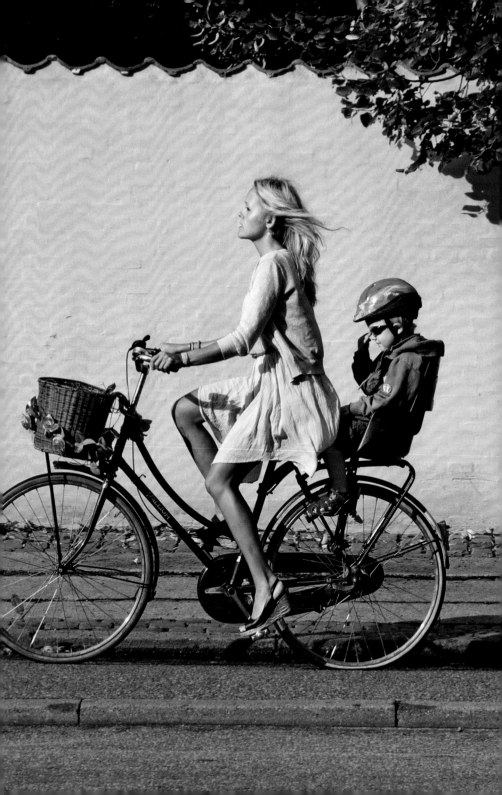

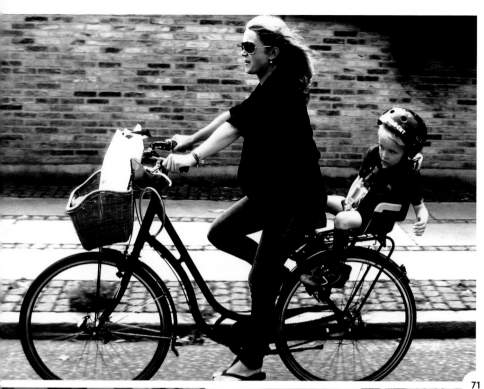

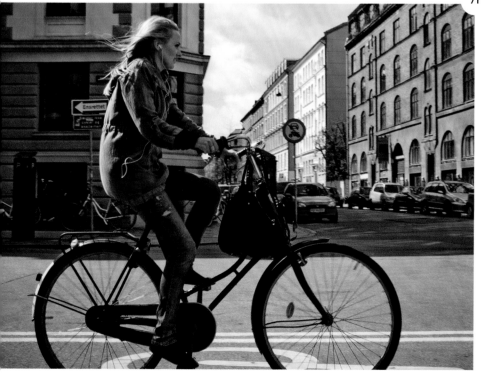

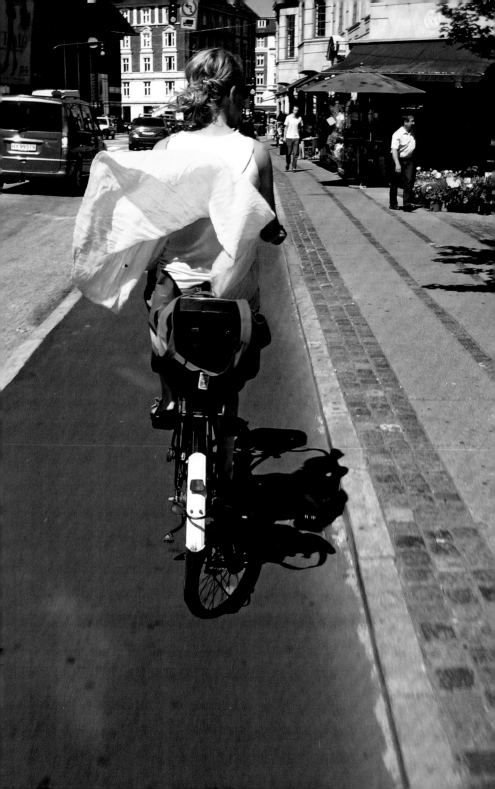

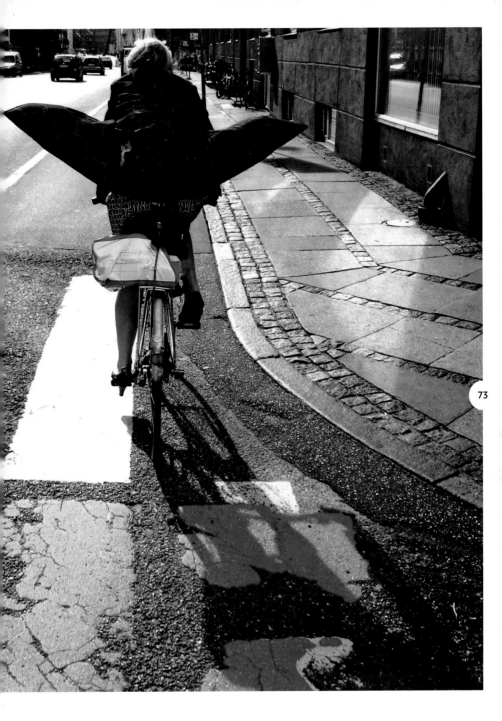

TAILWIND While a stiff wind can be a nemesis to cyclists, it can also serve us well. Slipping into a tailwind increases our speed and gets us to where we want to go all the faster.

'IF I CAN BICYCLE,
I BICYCLE.'

SIR DAVID ATTENBOROUGH

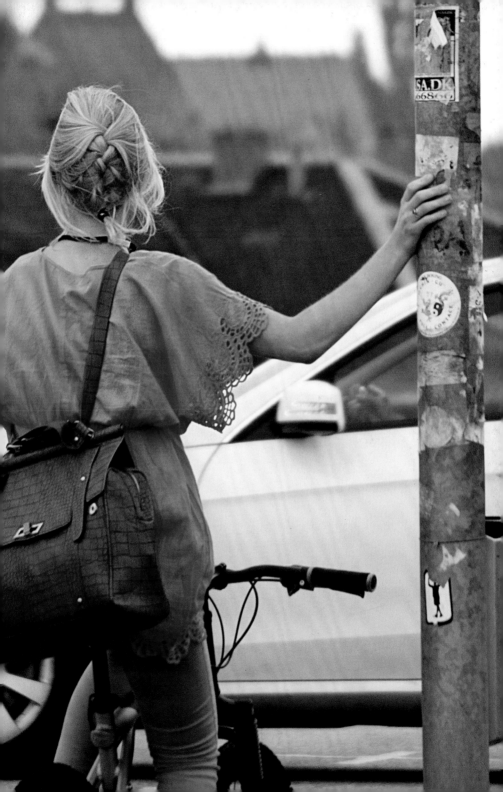

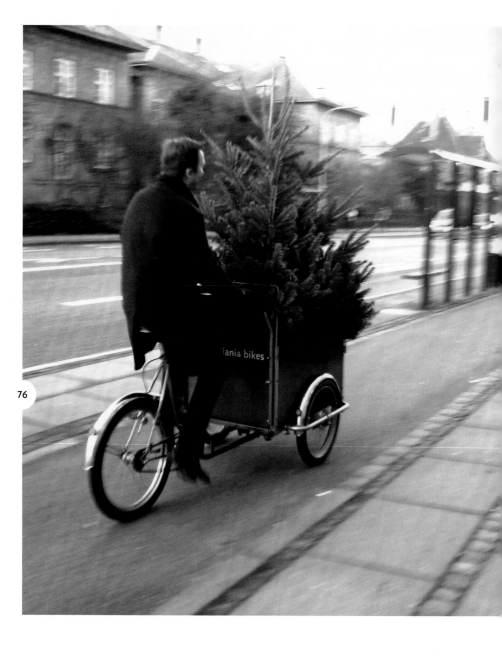

GREEN IN THE CITY While urban cycling can bring you closer to nature, you can always just bring nature closer to you. This gentleman cyclist in Copenhagen (above) has found a novel way to transport a Christmas tree.

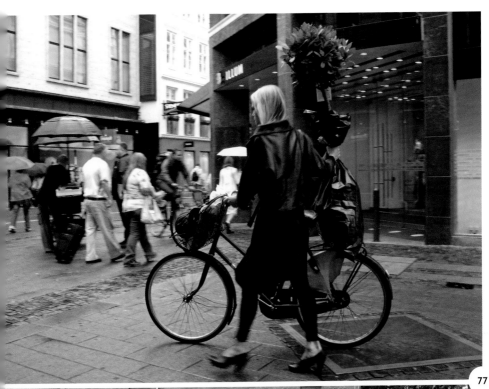

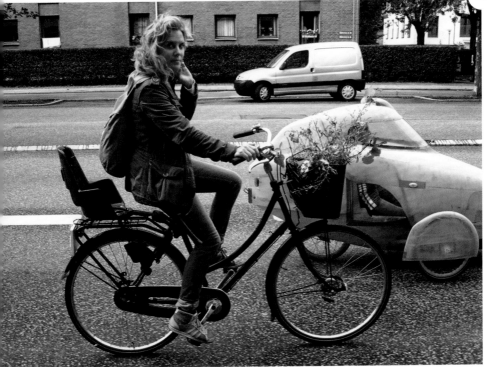

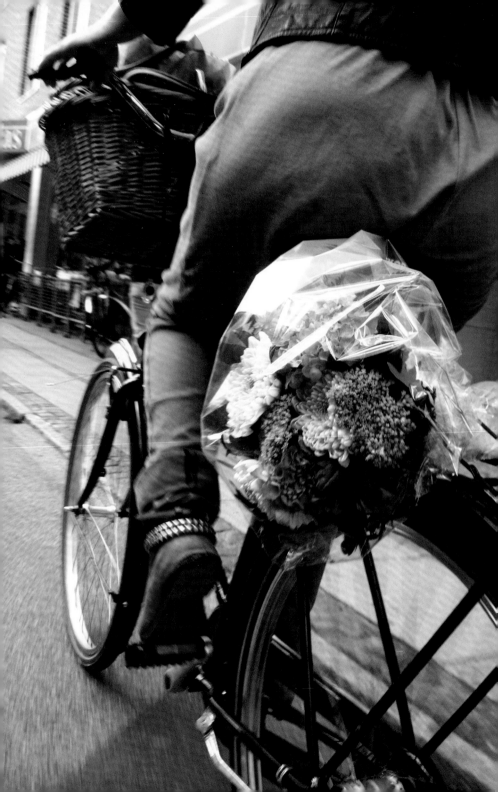

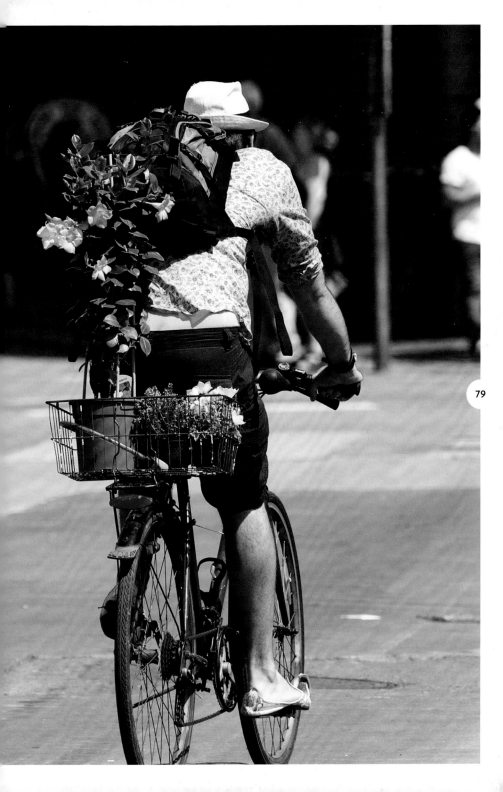

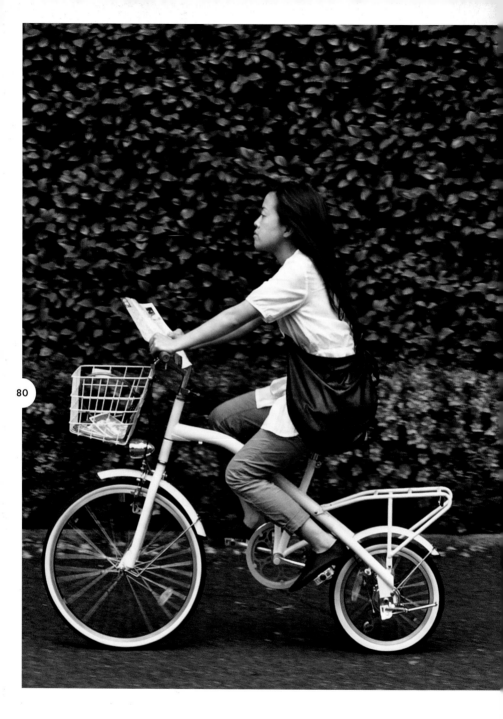

PETAL POWER Floral backgrounds add colour and interest to the city
scene in Copenhagen (opposite) and Tokyo (above). The white bikes,
too, complete with baskets on the handlebars, are stylishly retro..

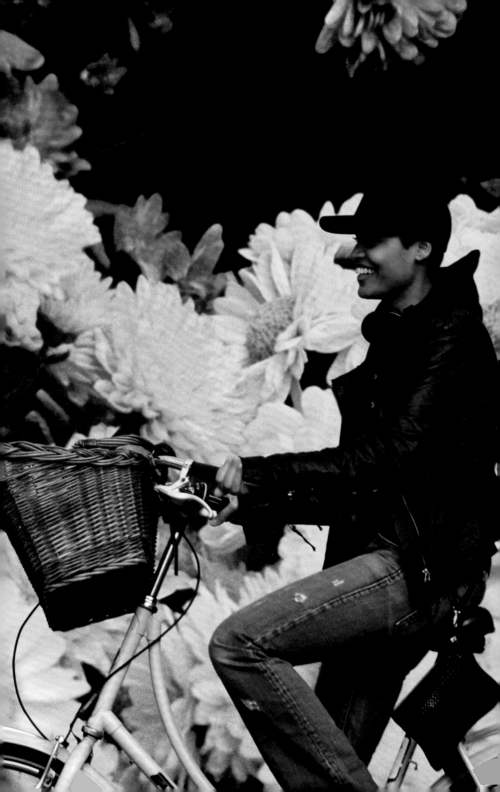

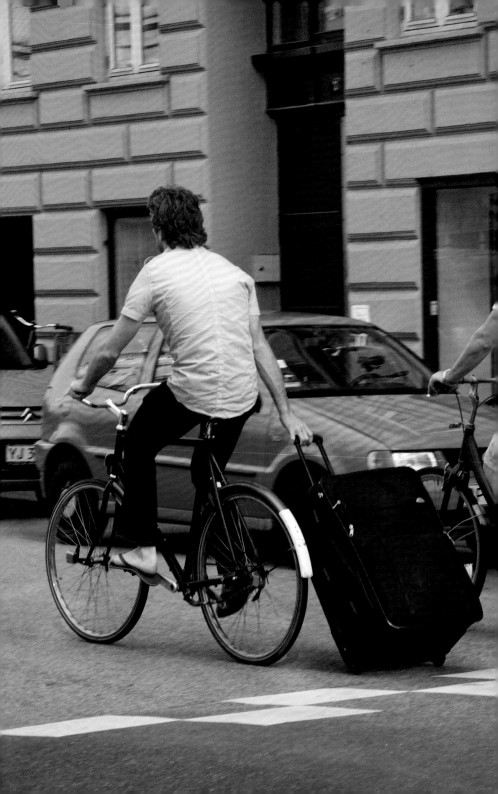

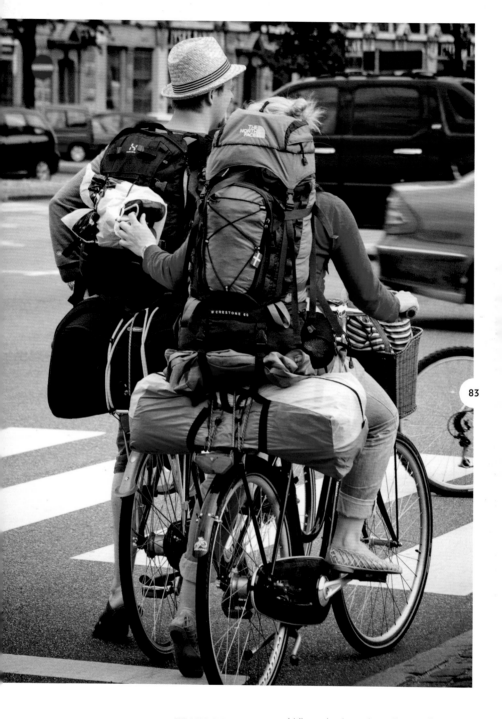

83

TRAIN OF THOUGHT When the bicycle is the quickest way to get around, getting to and from the train station takes on a different character – and presents different challenges.

BAGGAGE HANDLER Those boxes and bags aren't going to move themselves. Creative transportational solutions are pushed to the limit in Fukushima (below) and Copenhagen (opposite).

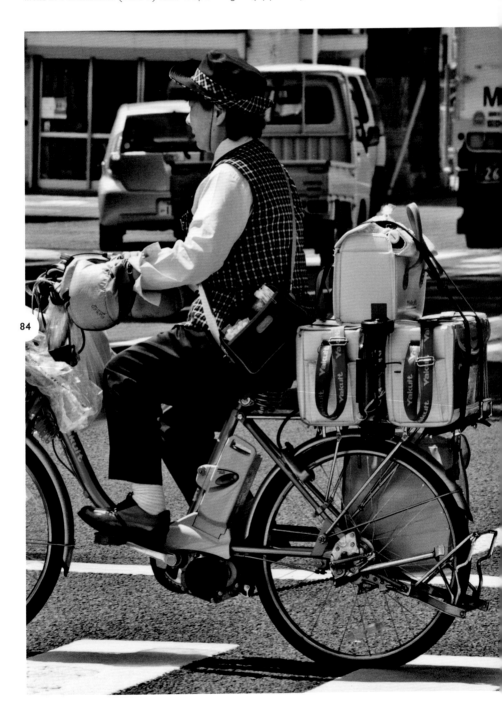

84

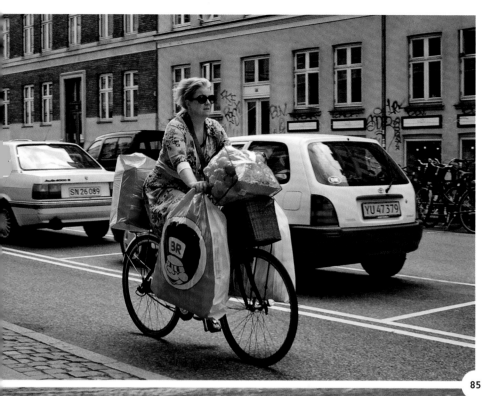

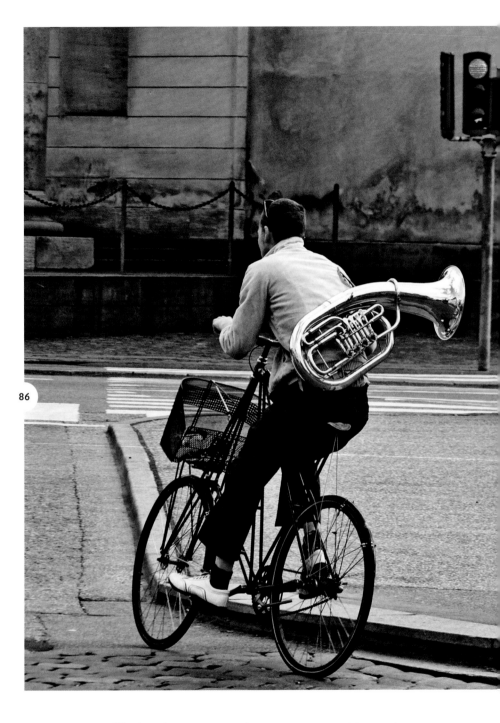

ONE-MAN BAND The bicycle is instrumental in transporting musicians and their kit. How much better if our cities featured these kind of horns, rather than the automotive kind. In Amsterdam (opposite), have bass, will travel.

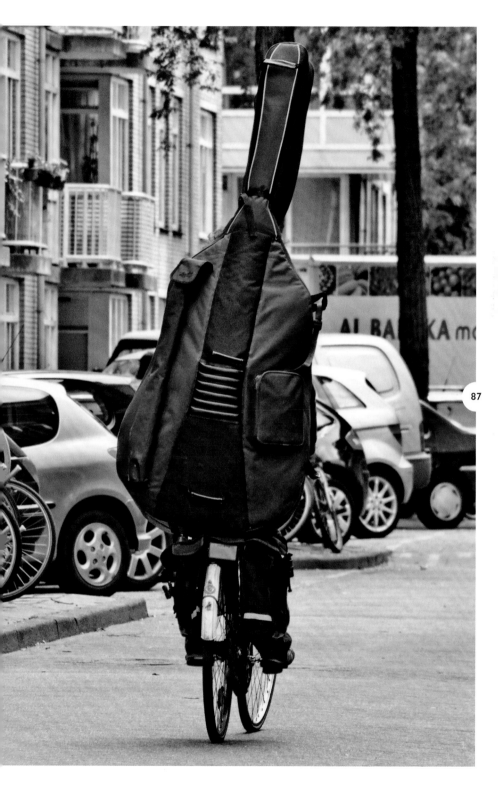

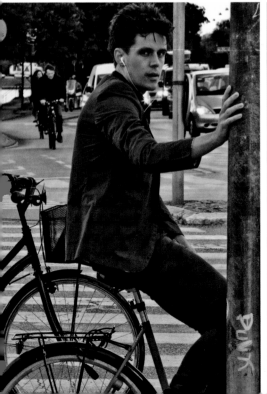

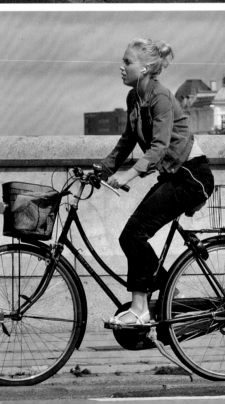

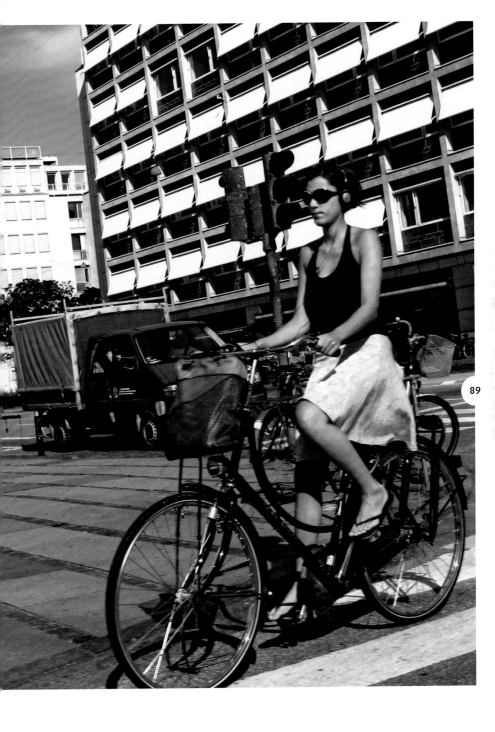

KEEPING SCORE Bicycle traffic is an urban ballet of human-powered movement, but you're welcome to bring your own soundtrack.

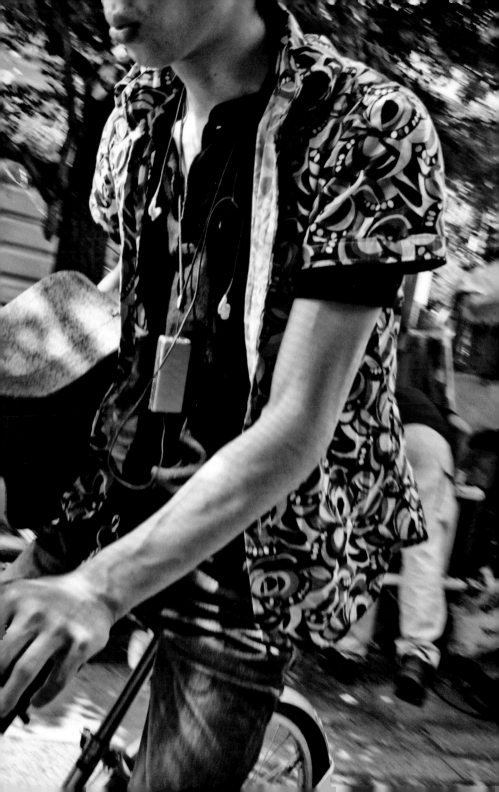

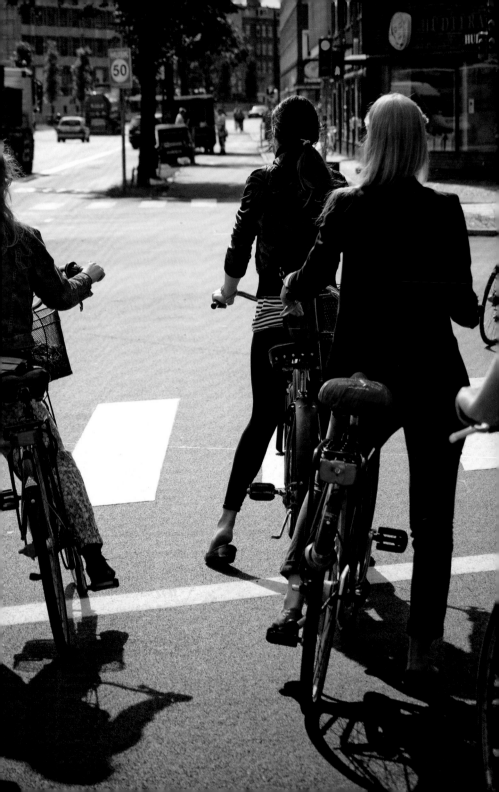

'PHOTOGRAPHY AS A FAD
IS WELL-NIGH ON ITS LAST LEGS,
THANKS PRINCIPALLY TO THE
BICYCLE CRAZE.'

ALFRED STIEGLITZ,
THE AMERICAN ANNUAL OF PHOTOGRAPHY, 1897

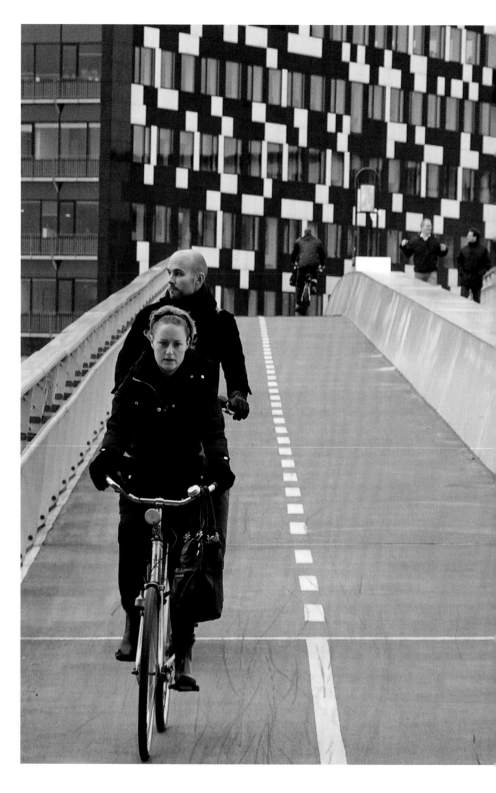

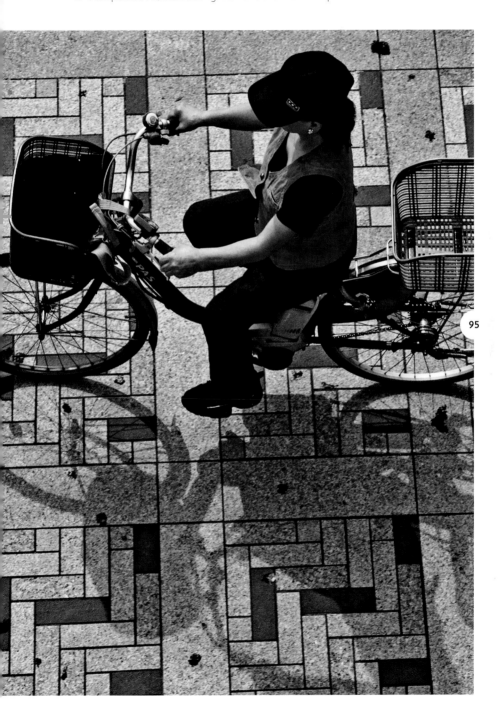

95

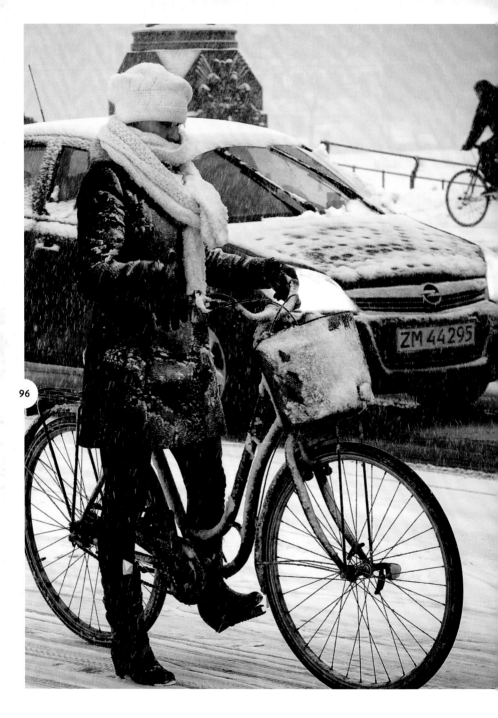

SNOW TIME LIKE THE PRESENT Eighty per cent of Copenhagen's cycling population use their bikes throughout the winter. It's the quickest way to get around, even in a snowstorm.

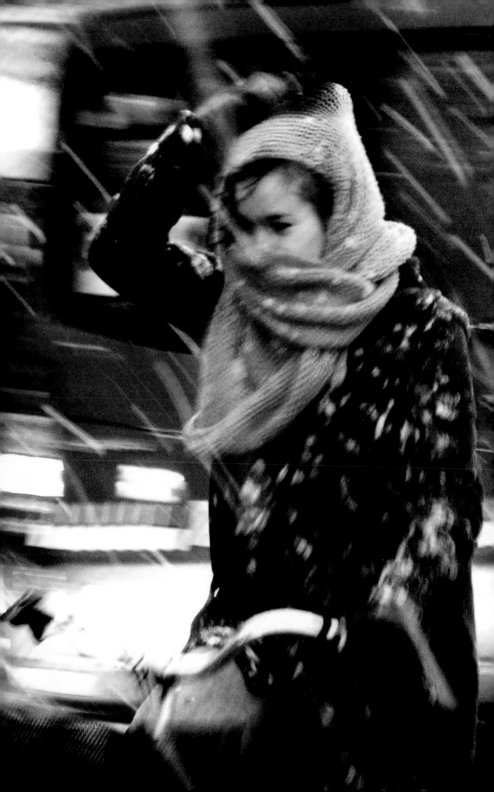

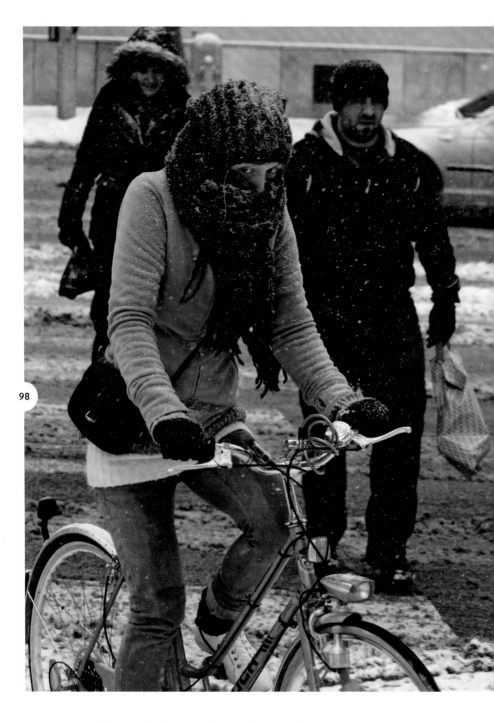

MAD HATTER Despite the bitter cold, winter brings with it a fantastic new crop of hats (witchy in Copenhagen; opposite, top) and scarves (all-encompassing in Vienna; above).

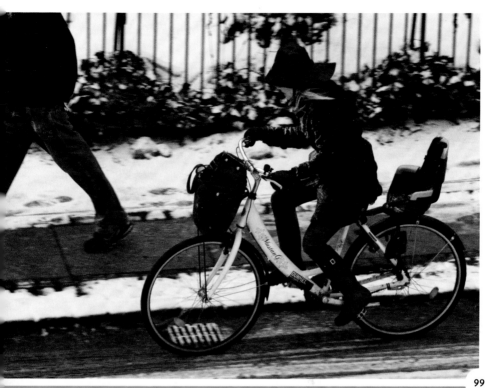

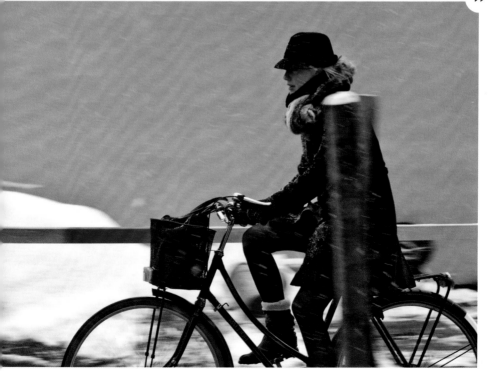

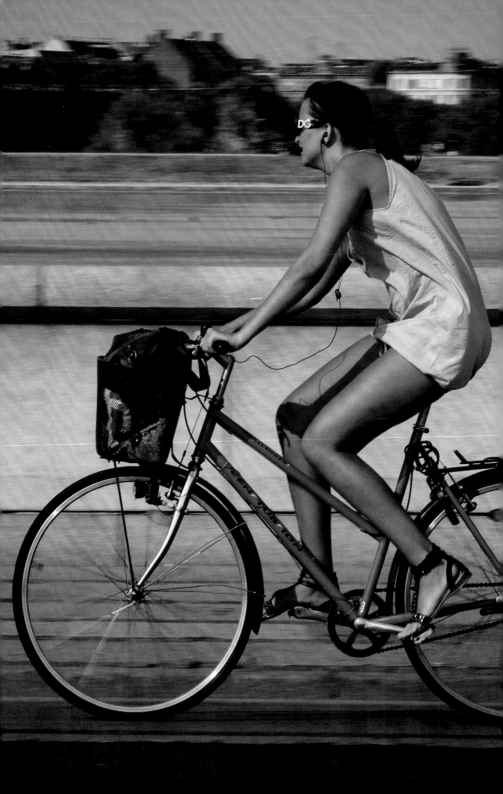

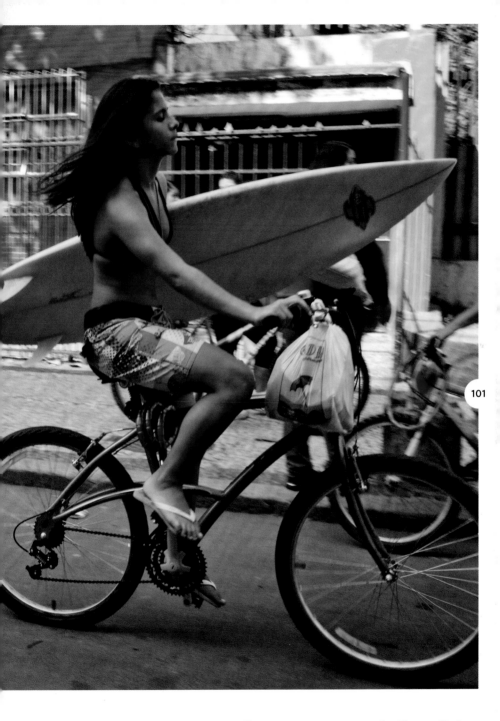

HERE COMES THE SUN Summertime is prime time for Citizen Cyclists, whether heading home from the beach in Copenhagen (opposite) or venturing out to catch some waves in Rio de Janeiro (above).

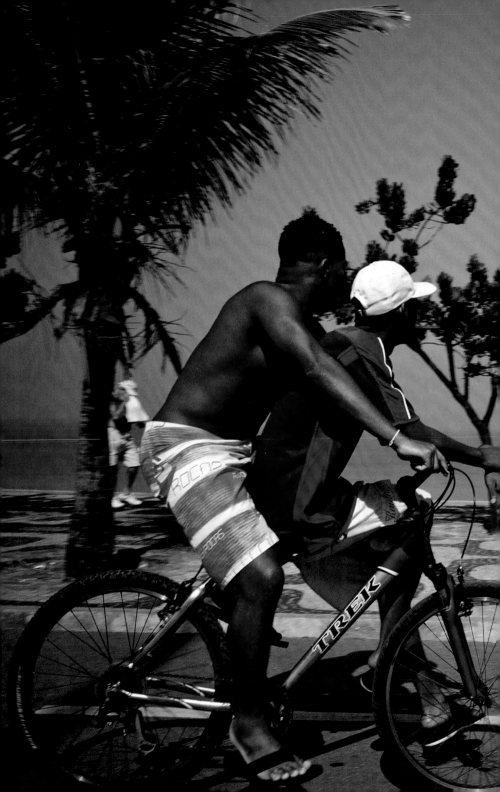

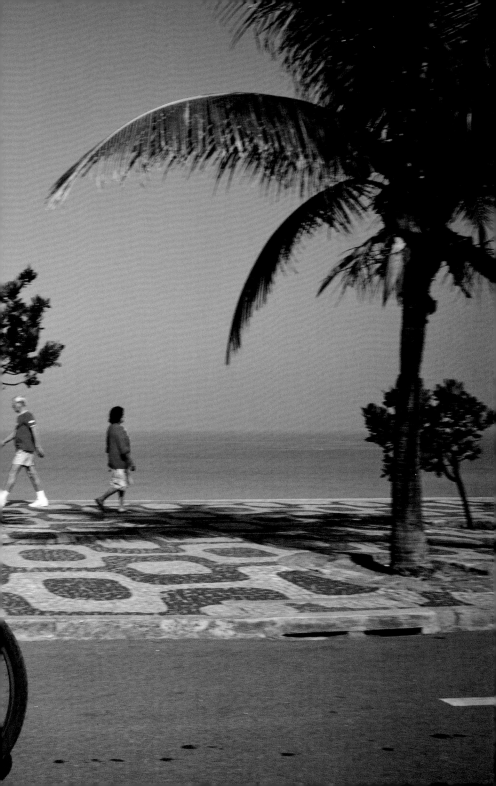

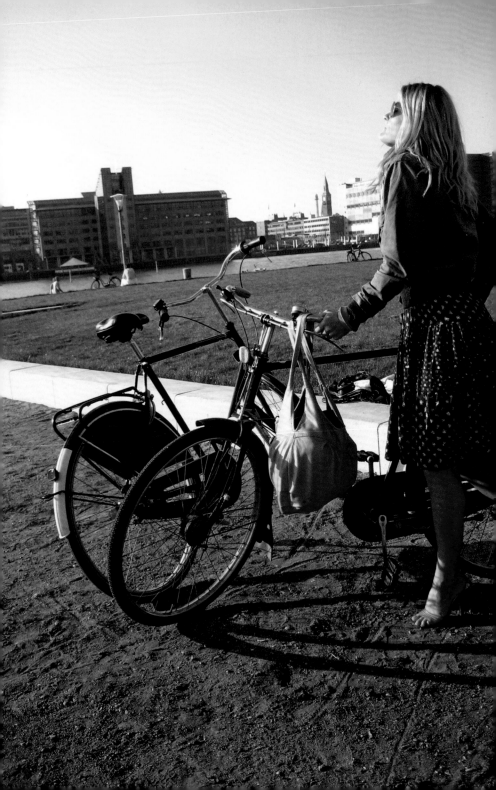

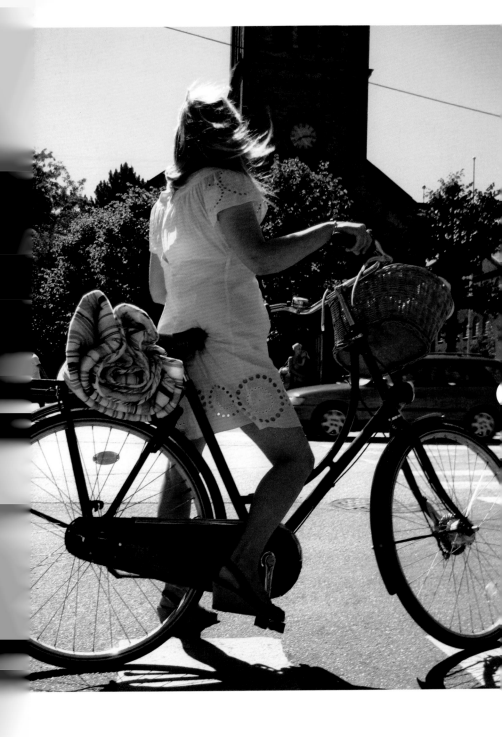

BRIGHT SUNSHINY DAY Grab your towel, your beach chair, your sun crea■ and head off to the beach by bicycle. Knock off work early and go for a swi■

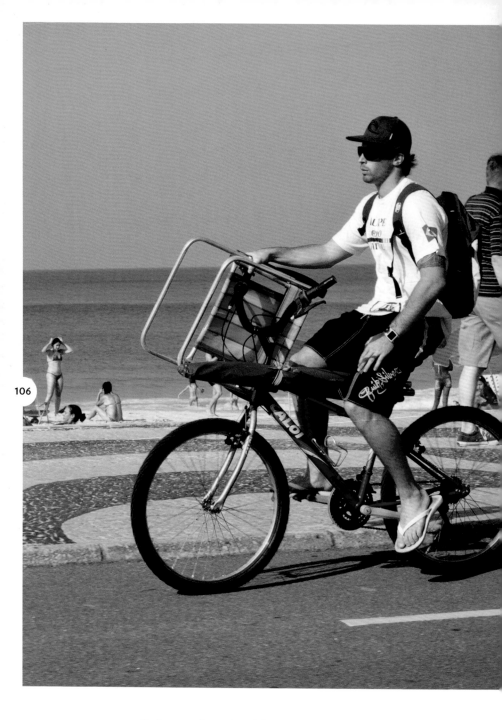

GIRL FROM IPANEMA Rio's magnificent beachfronts offer sun, surf and great views. But who's looking at the water? From the Ipanema beach (opposite), the islands of the Cagarras Archipelago can be seen rising up from the sea.

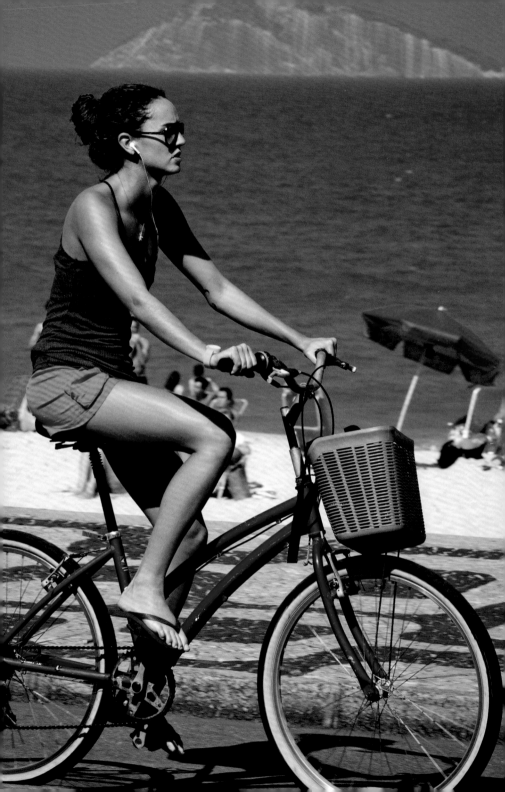

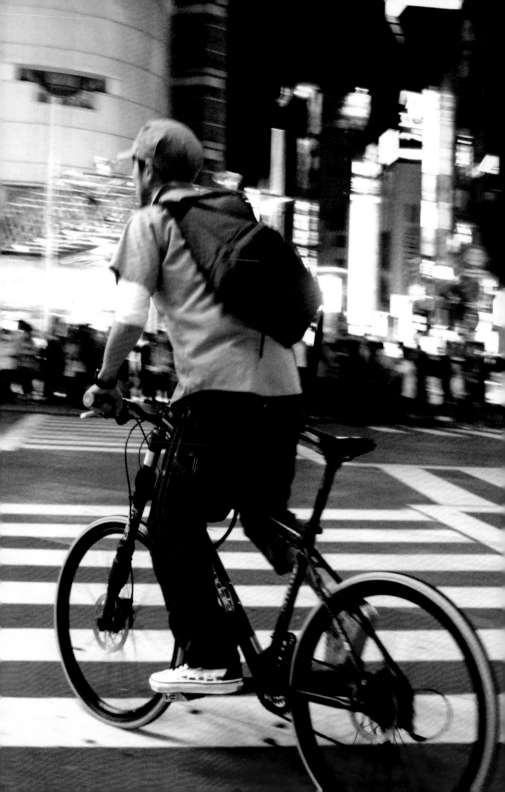

URBAN NIGHTS The nocturnal life of bicycles in cities – light, colour and elegance in motion in Copenhagen (below) and Tokyo (opposite). Bright lights, big city meet the Citizen Cyclist.

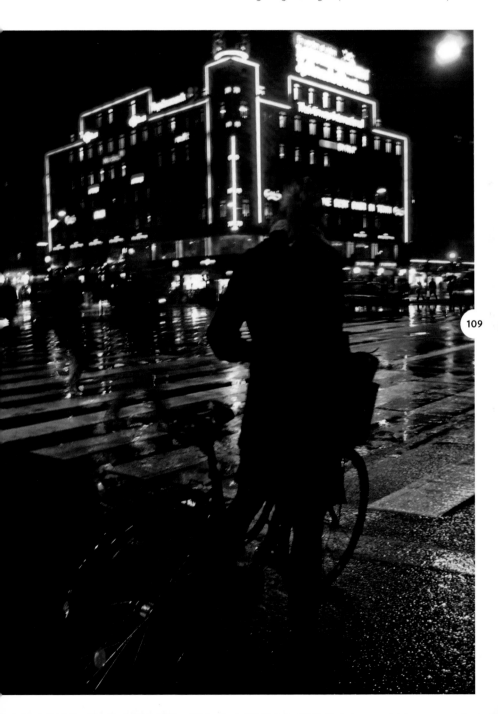

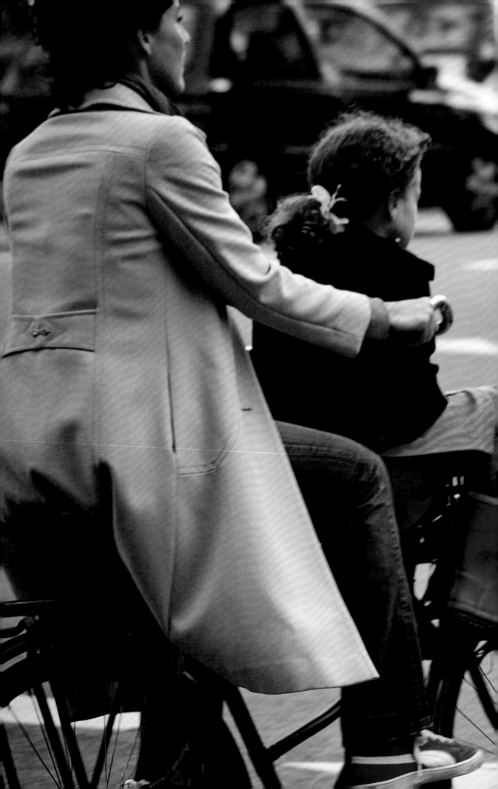

VÉLO À
DEUX

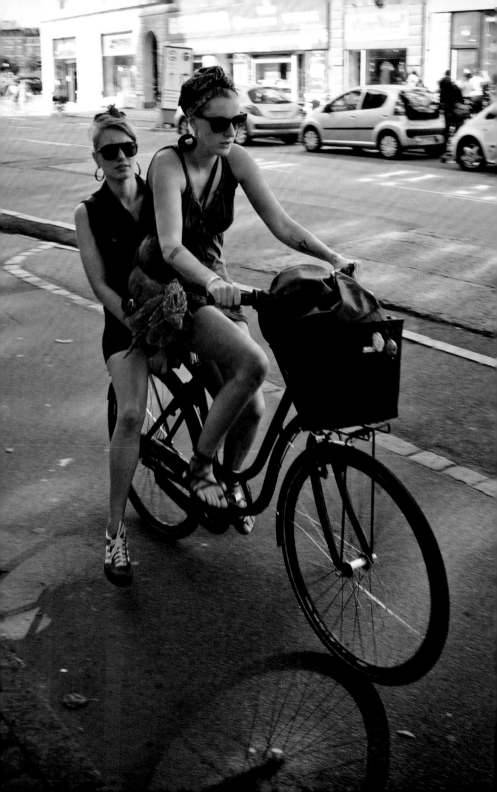

An early model of the bicycle, from around the end of the nineteenth century, was called a 'Sociable' – a kind of tandem on which two people sat side by side as they pedalled. As lovely as that sounds, we now know after 125 years of experience that bicycles are inherently sociable, no matter how many people they seat. It is embedded in their very design, their very soul. Since its invention, the bicycle has brought people together. It is this ability that pushes it beyond being a merely practical, efficient machine that makes our daily lives easier. This is where the bicycle pedals calmly and comfortably into the realm of positive societal change, as well as poetry.

There were tens of thousands of bicycle clubs around the world at the turn of the last century, with the majority being social clubs that revolved around the bicycle. The bicycle could be said to have improved the gene pool, as well, as it provided people in rural areas with an increased mobility radius, allowing them to travel further to find both work and future spouses. The simple fact remains that riding a bicycle together is quite splendid – whether riding in silence or having a conversation, riding side by side or doubling a friend, or transporting your kids in a cargo bike. There are as many interpretations of what 'sociable' is as there are bicycles. Most of them are featured in this chapter.

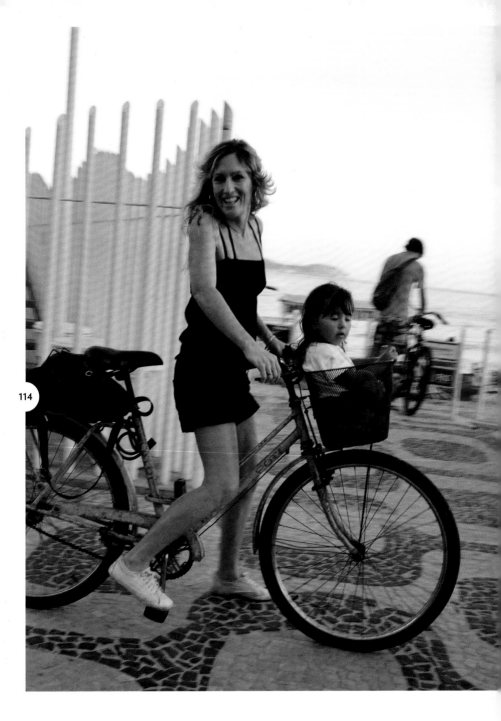

114

ARE WE THERE YET? Young passengers hitching a lift with their parents in Rio de Janeiro (above), Copenhagen (opposite, top left and right), the Catalan city of Lleida (opposite, bottom right) and Paris (opposite, bottom left).

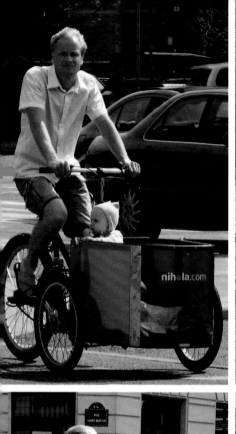
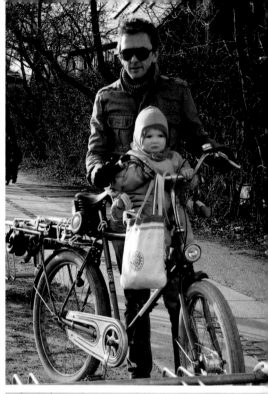
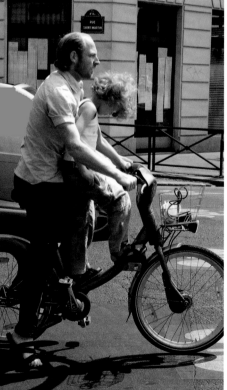
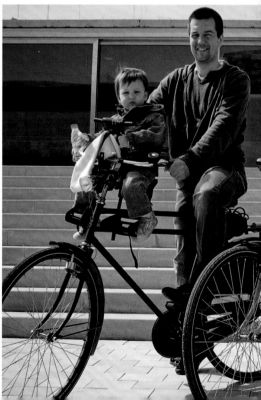

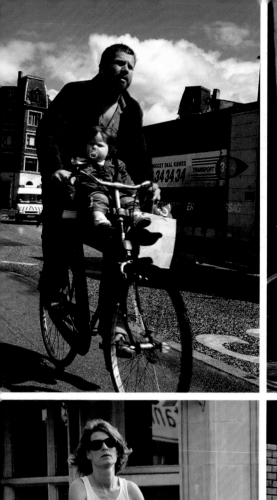
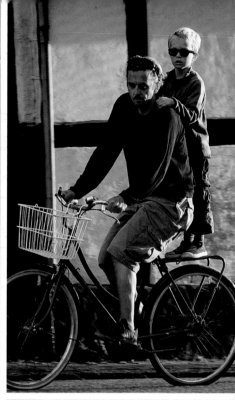
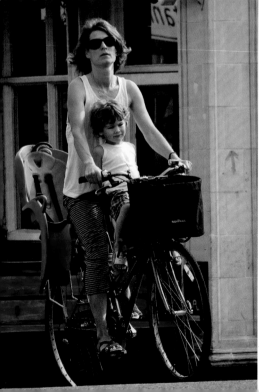
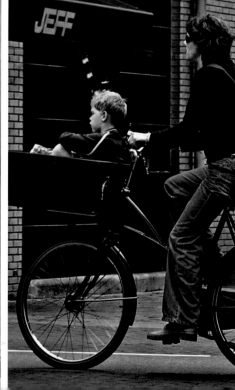

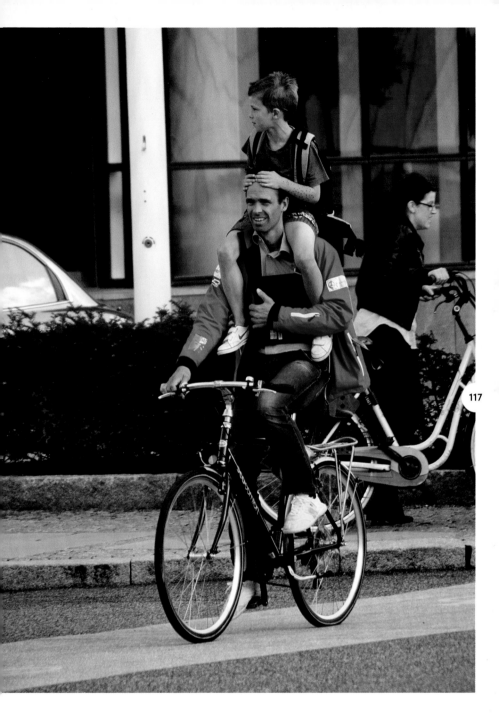

JUST THE TWO OF US There are all kinds of ways to travel with Mum and Dad, from perched on their shoulders, riding pillion on the back rack, or snugly settled on the crossbar. In Amsterdam (opposite, bottom right), a bucket is best.

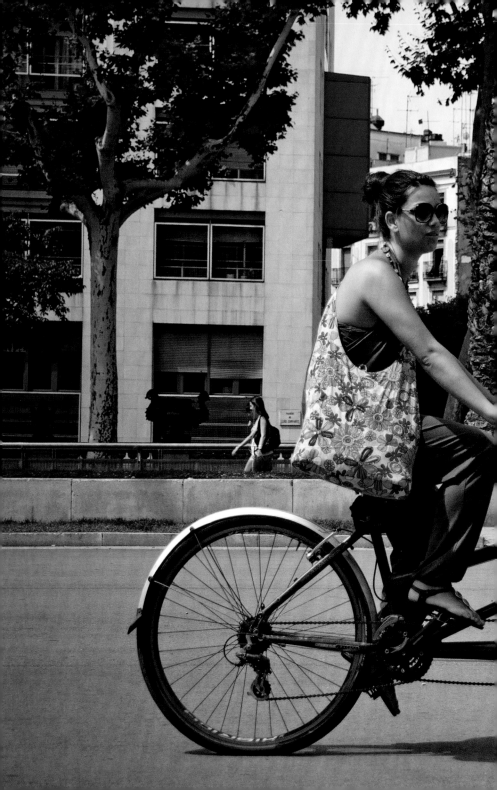

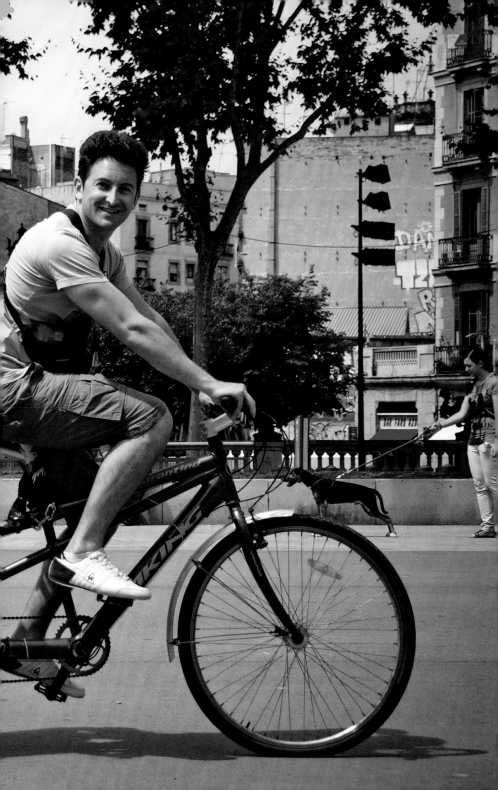

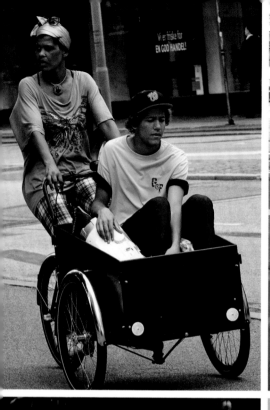
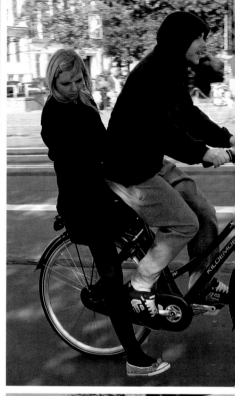
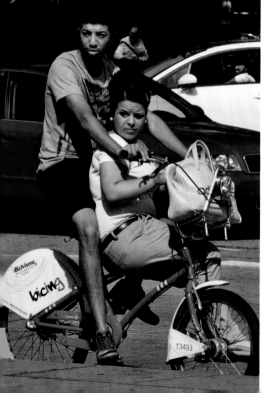
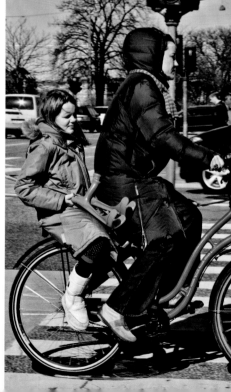

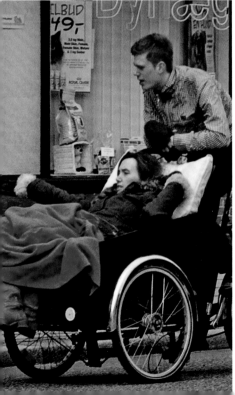

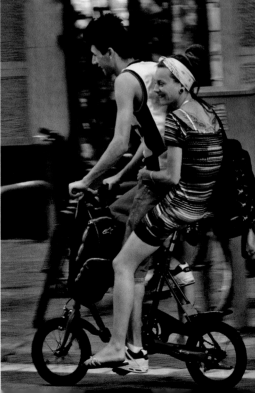

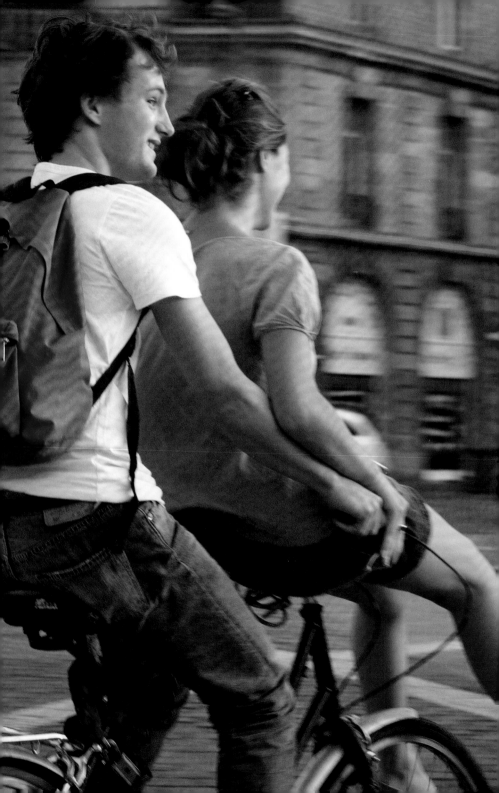

'EVERY TIME I SEE
AN ADULT ON A BICYCLE,
I NO LONGER DESPAIR FOR
THE FUTURE OF THE
HUMAN RACE.'

H. G. WELLS

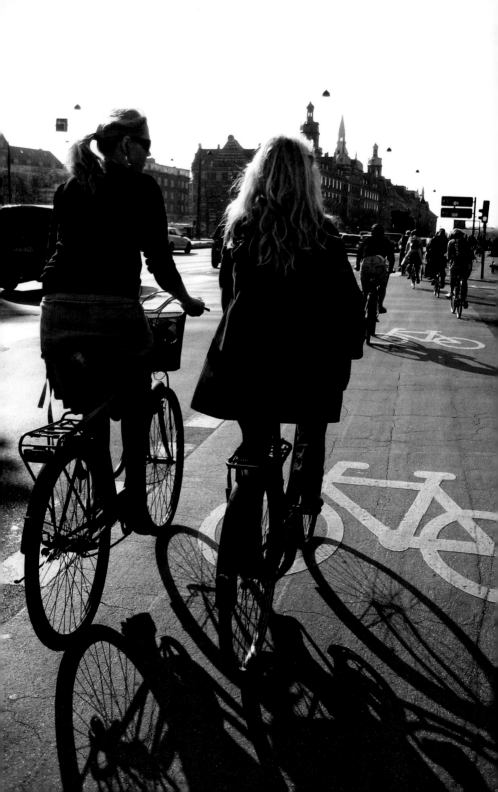

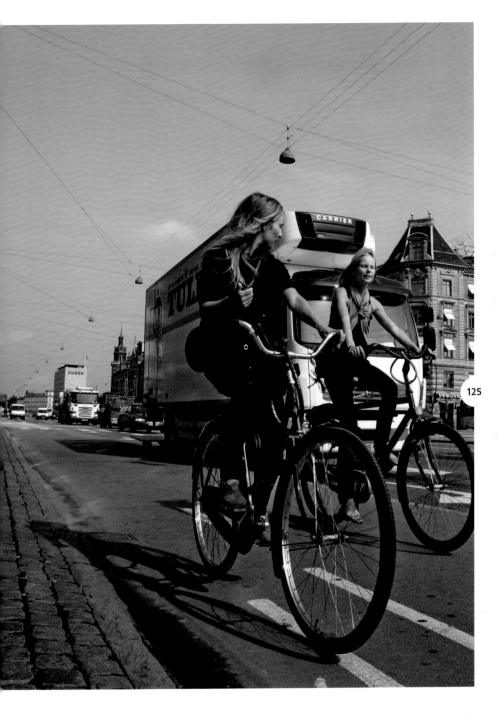

URBAN (RE)PAIR The bicycle is often referred to as a means towards social equality. Here, in the urban landscape, it's just social. Lots of people (37 per cent, in fact) ride their bikes to work or school in Copenhagen.

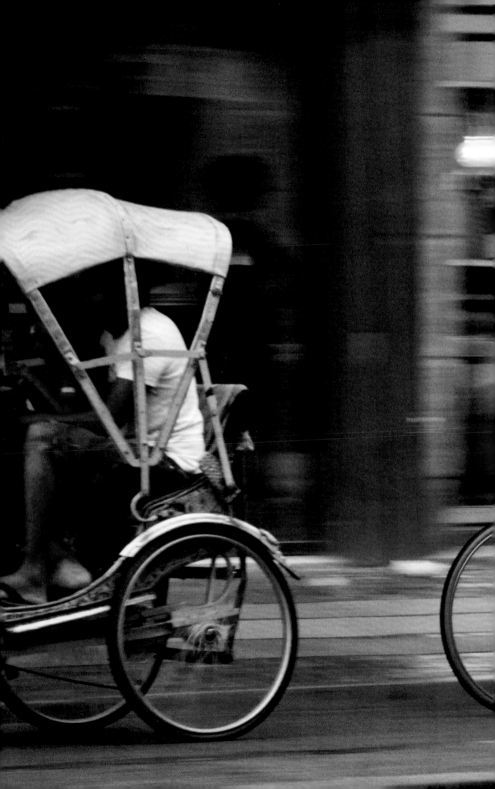

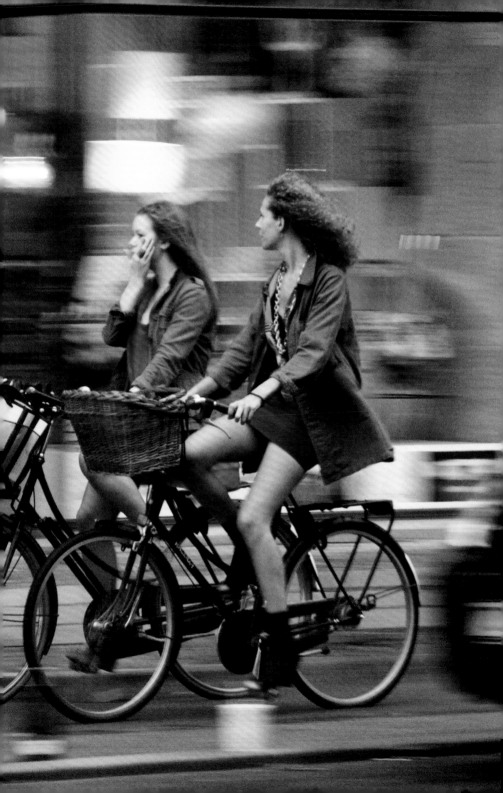

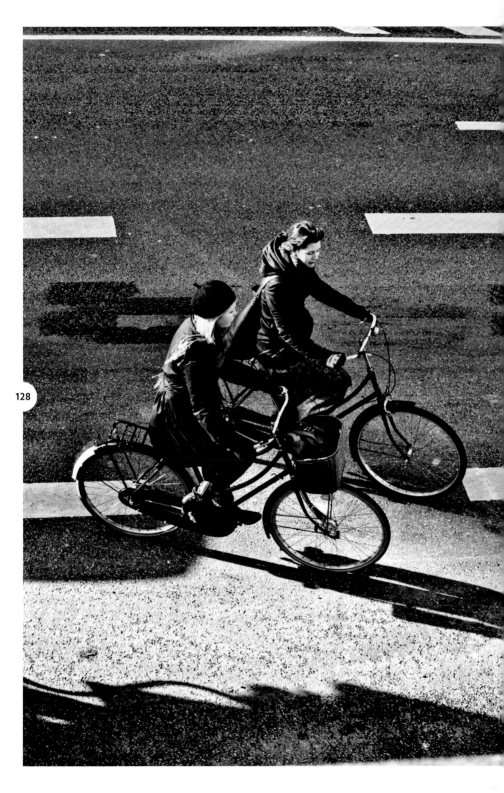

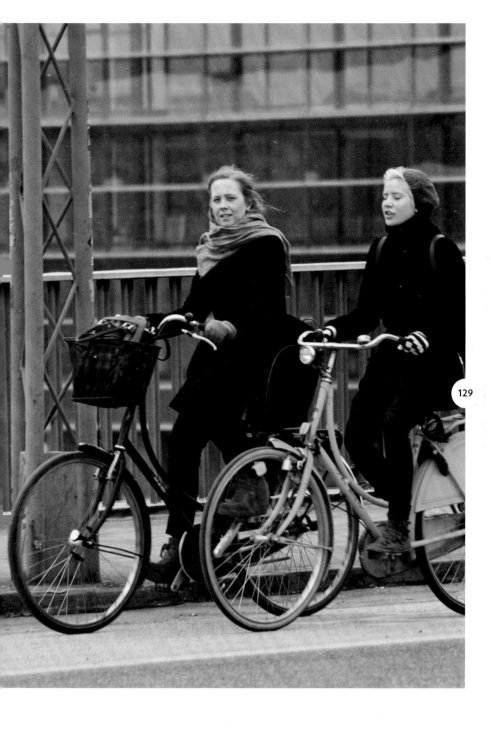

129

TIME FOR A CHAT Gossiping, cycling, laughing, it's all part of the commute.
A continually dynamic, cosy social club, every day of the year.

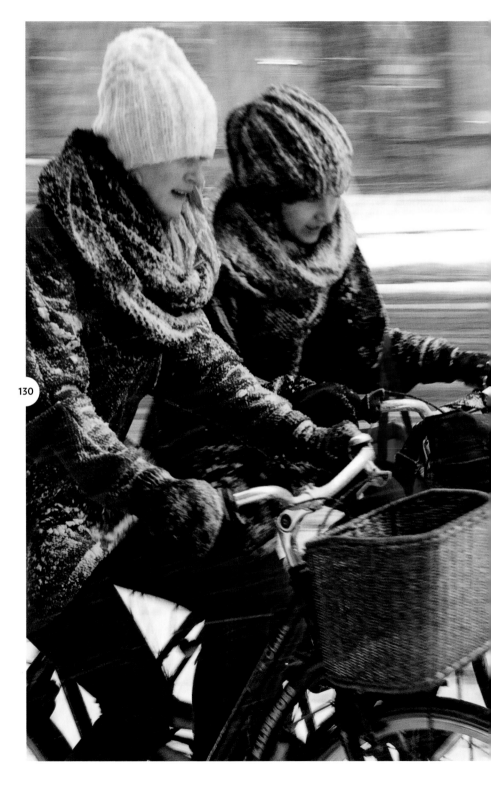

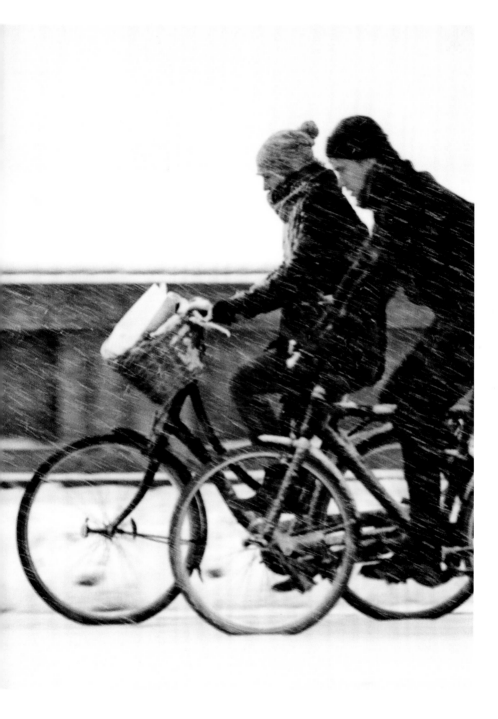

VIKING BIKING A cold journey is always warmer if you've got someone to share it with. In Copenhagen, the cycle tracks are cleared of snow long before the car lanes are – anything to encourage people to ride.

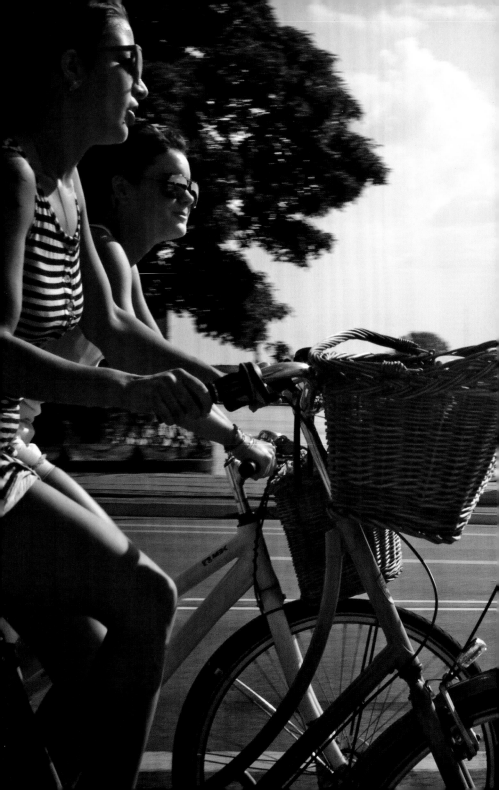

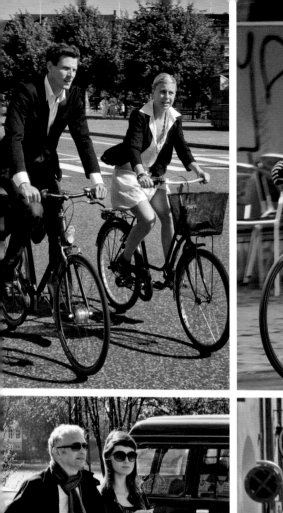
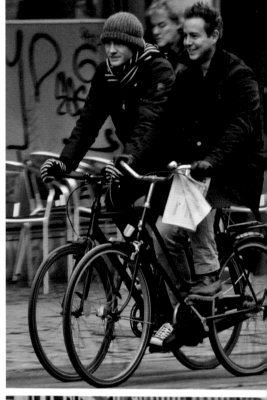
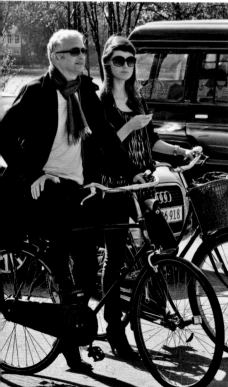

PARALLEL UNIVERSE When you're on to something good, why not try to match your bicycles, as well? What bicycle will you wear today? These two girls in Barcelona (below), one riding a bike from the city's cycle-sharing scheme, opt to match each other.

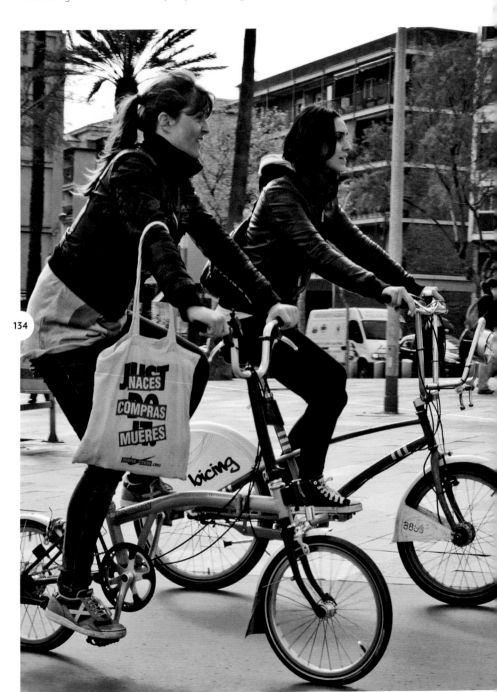

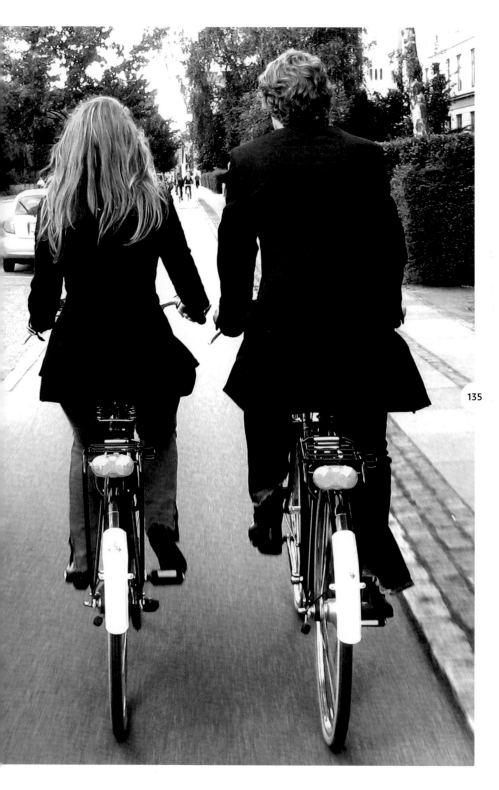

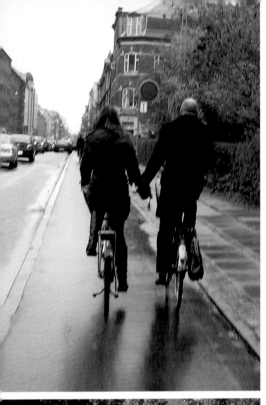
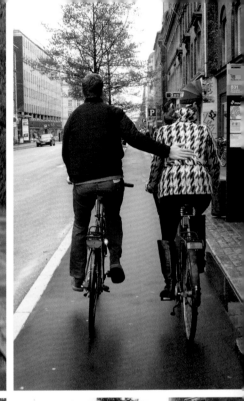
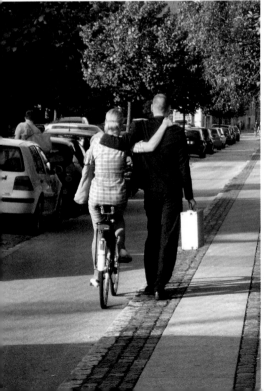
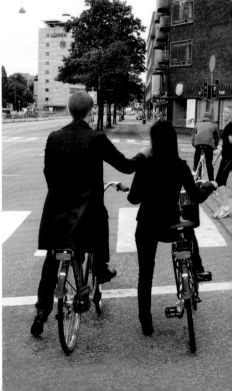

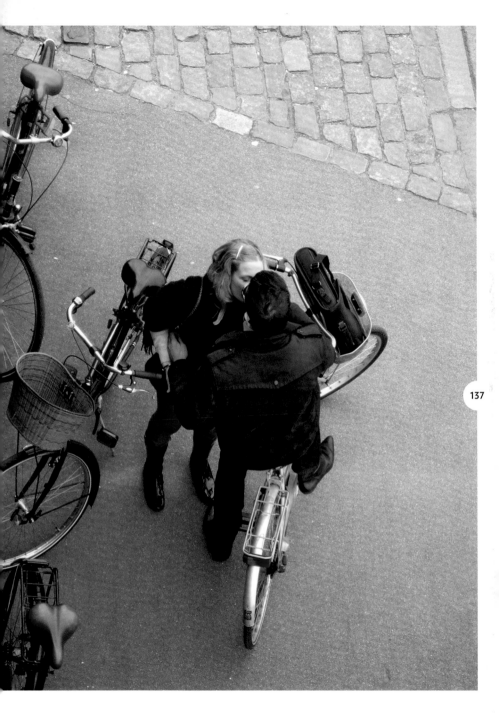

MORE AMORE As the song almost has it, when you cycle down the street, with well laid-out cycle tracks at your feet, you're in love. In a mainstream cycle culture, whatever you're doing, you can be sure that a bicycle plays a key role.

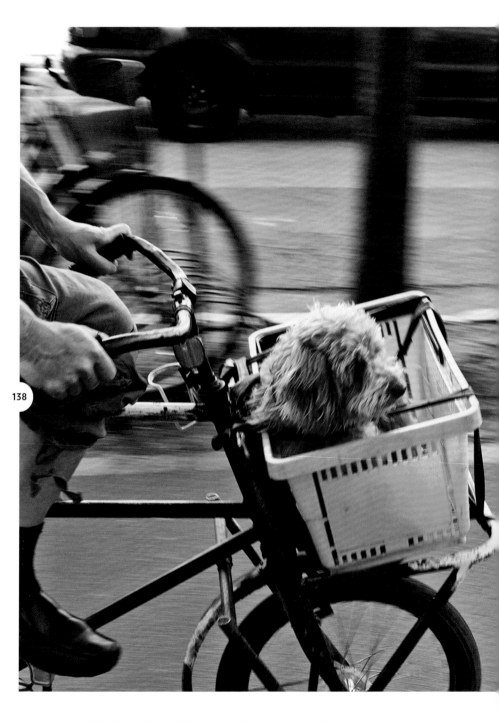

A DOG'S LIFE Man's best friend also makes for a pretty good travelling companion. In Amsterdam (opposite, top), a long-eared pooch forgoes a saunter along the canals for a ride in a bicycle basket.

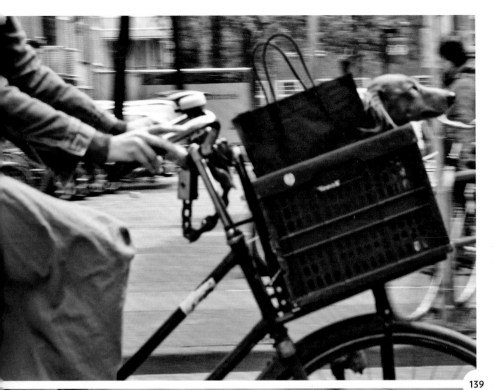

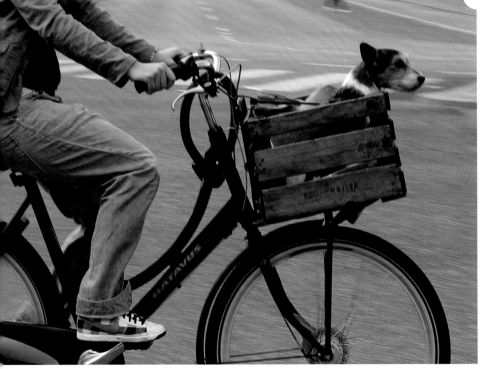

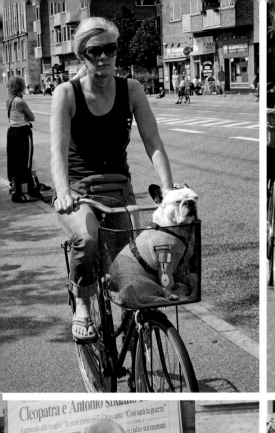
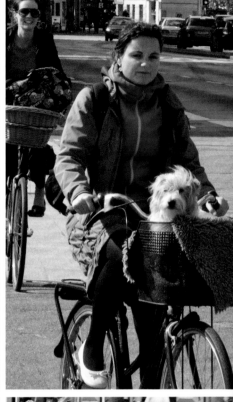
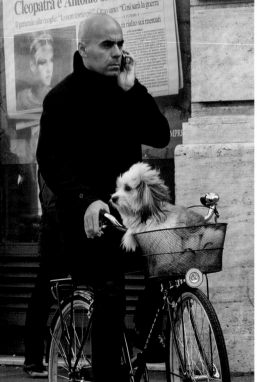
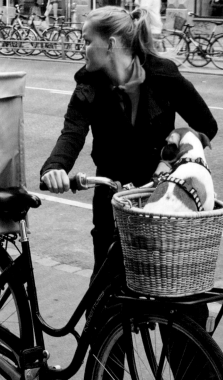

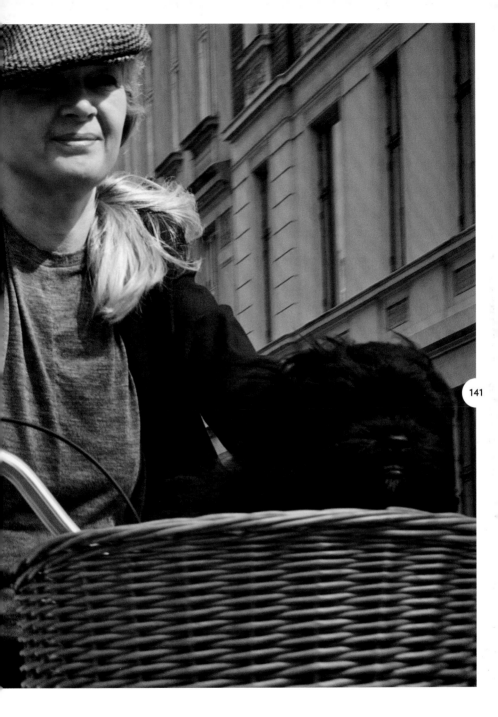

141

WHAT'S IN YOUR BASKET? The cycling version of dogs in handbags. Urban canine mobility may be the new doghouse, but this shaggy little fellow in Rome (opposite, bottom left) is finding his accommodation a bit cramped.

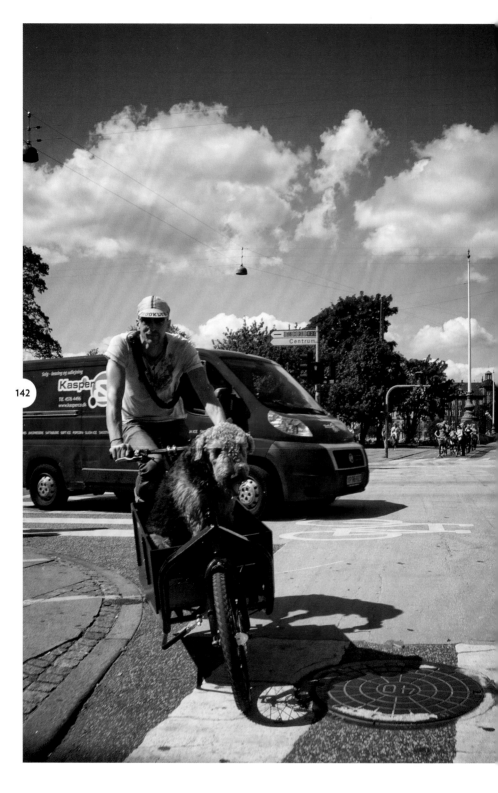

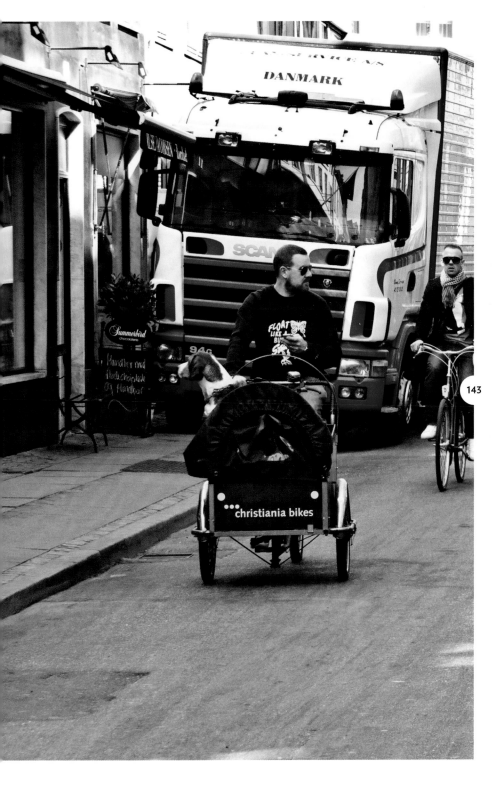

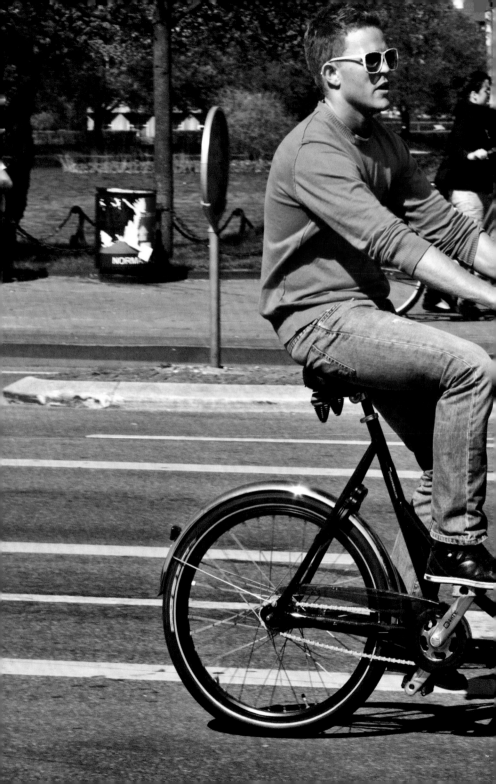

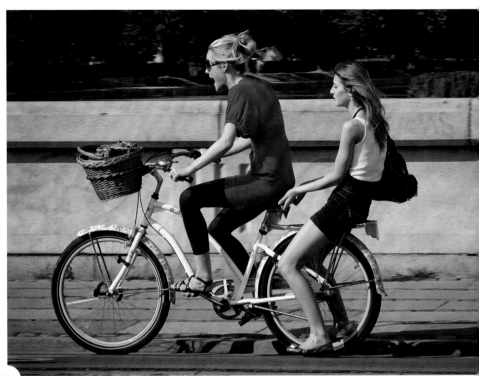

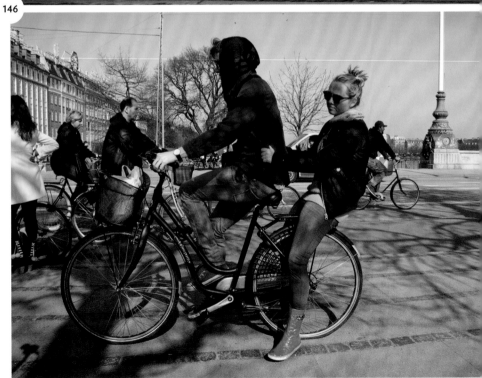

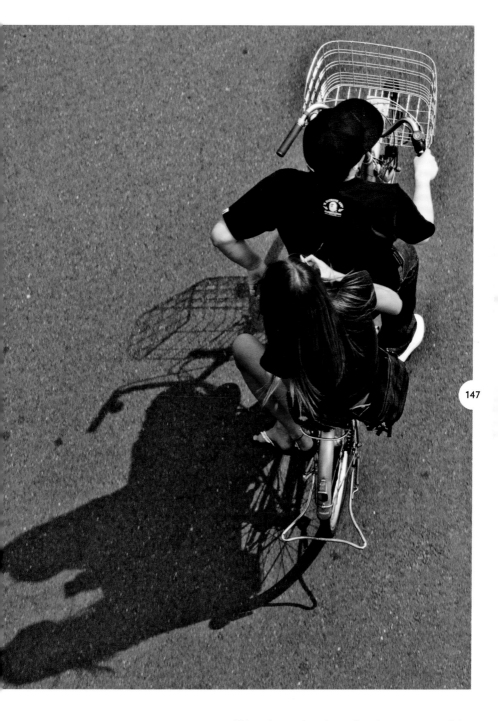

147

DOUBLE VISION I'll bet that within days after the invention of the bicycle as we know it, someone was carrying a friend along for the ride. In Copenhagen (opposite) and Tokyo (above), they make it look so easy.

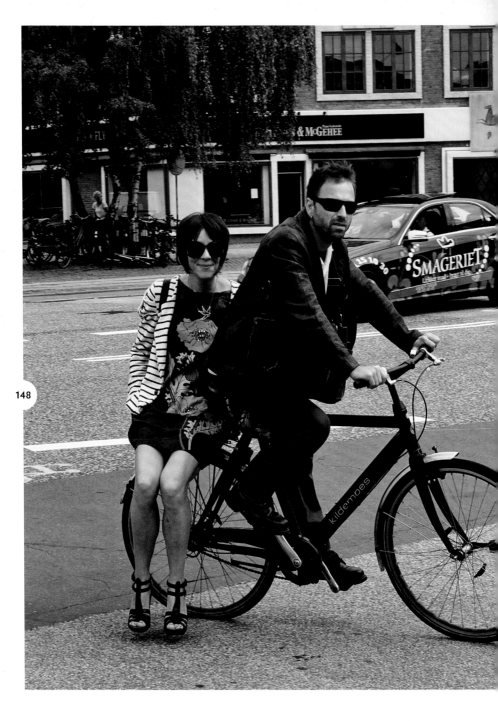

A BICYCLE BUILT FOR TWO Whether you straddle the back rack or hitch a lift at the front, bikes are best with two. In Barcelona (opposite), this Citizen Cyclist chooses to sit side-saddle atop a bicycle from the city's cycle-sharing scheme.

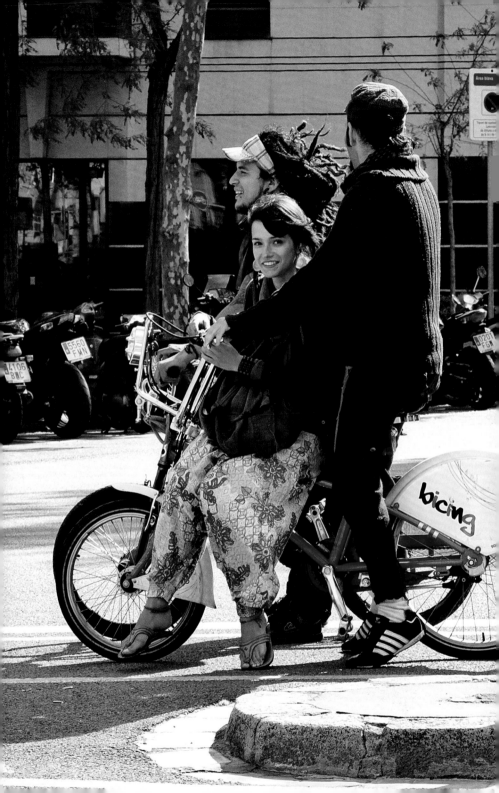

'STYLE OVER SPEED.
ELEGANCE OVER EXERTION.'

CYCLE CHIC SLOGAN

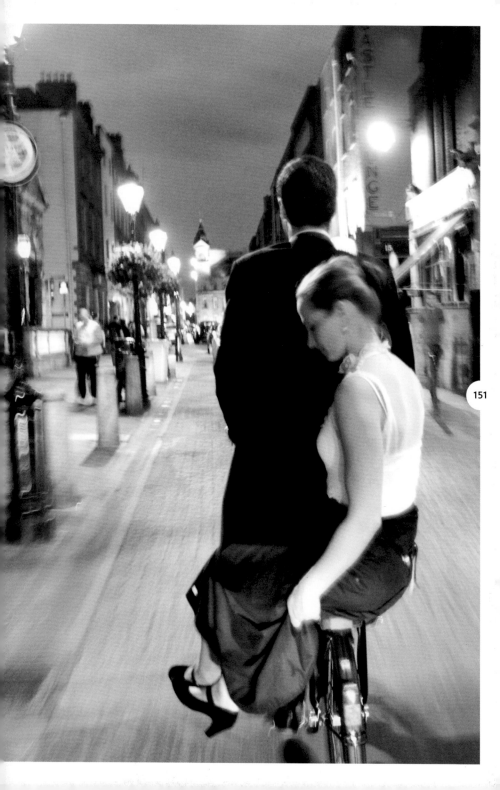

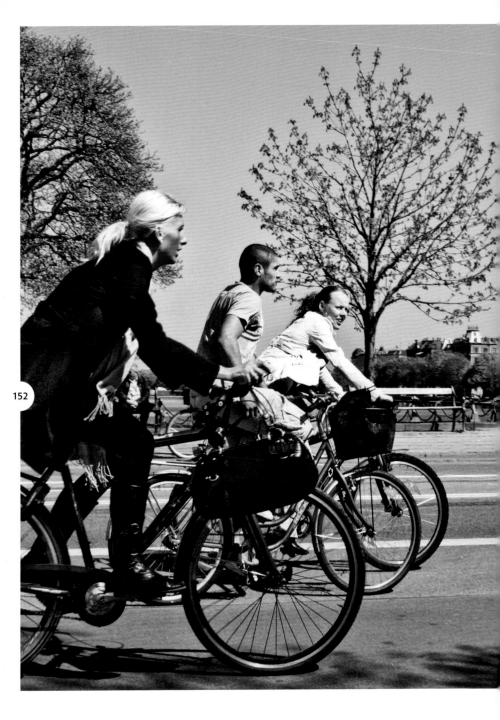

THREE IS NEVER A CROWD Copenhagen's well-organized bicycle culture is gaining international fans. Russian president Dmitri Medvedev was so impressed that he took 14 city bikes back to St Petersburg for public use.

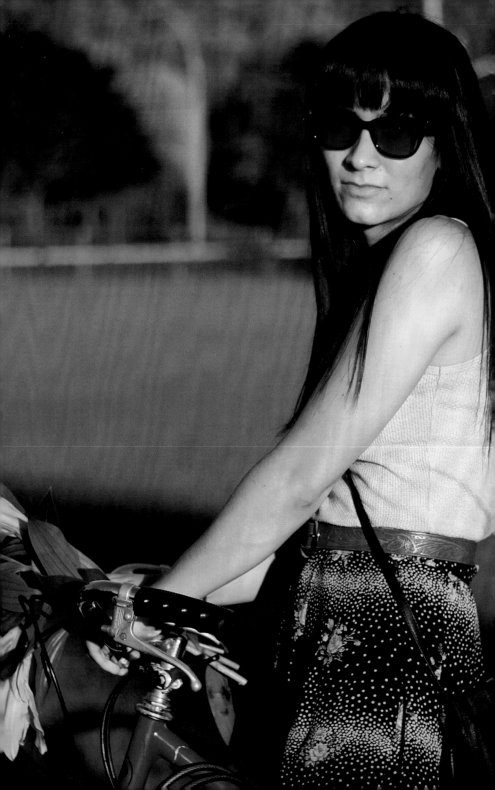

DRESS ME UP, DRESS ME DOWN

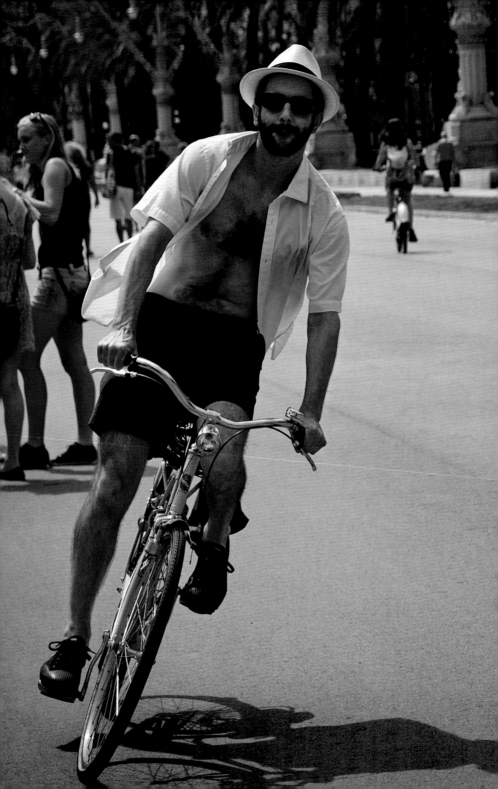

Cycle Chic is not about the bicycle. It's about you, on the bicycle. I like a handsome or a pretty bicycle as much as the next person, but the person riding it will always be the focus. When Cycle Chic first took off in 2007, it was quickly labelled as a fashion or street-style blog. I found this curious, but I didn't worry too much about it. The street-style genre has taken the world by storm, and if some people find it appropriate to put Cycle Chic into that category, then that is brilliant.

Style is individual, and it is also territorial. The laid-back beach culture in Rio de Janeiro offers up a very different style than the Nordic cool you'll see in Copenhagen. What I see people wearing in Paris will vary from what I see in Berlin – and from the style-savvy streets of Barcelona (opposite), where this effortlessly cool cyclist sports a trilby and shades and carefree, undone pink shirt. Sartorial style doesn't always mean Savile Row. The common denominator in the blogs of the Cycle Chic Republic are that the people that are featured are on bicycles – Citizen Cyclists gracing the urban landscape with their bikes and their personal style.

It is telling that the very first accessory invented for bicycle users back in the 1880s was the trouser clip. The chain guard soon followed, but the goal from the very beginning of Bicycle Culture 1.0, around the turn of the last century, was to make cycling possible in your regular clothes. People would dress for their destination, not their journey. Everyone looks just a little more beautiful on a bicycle – adding some sartorial style to the equation only improves on that reassuring fact.

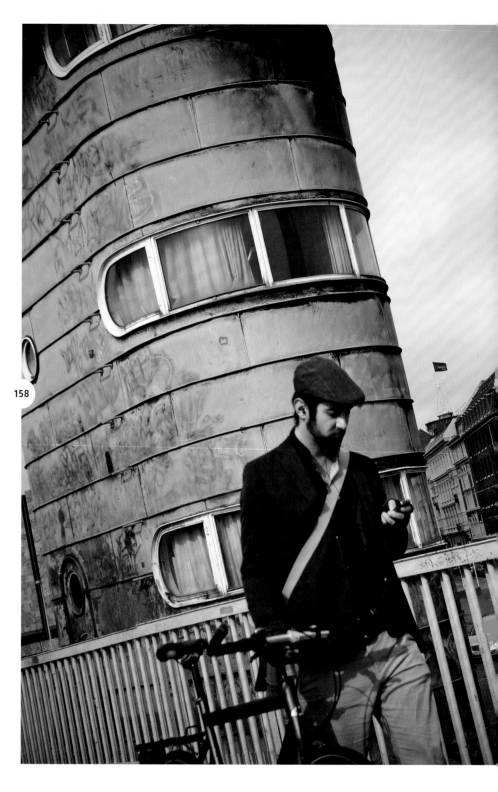

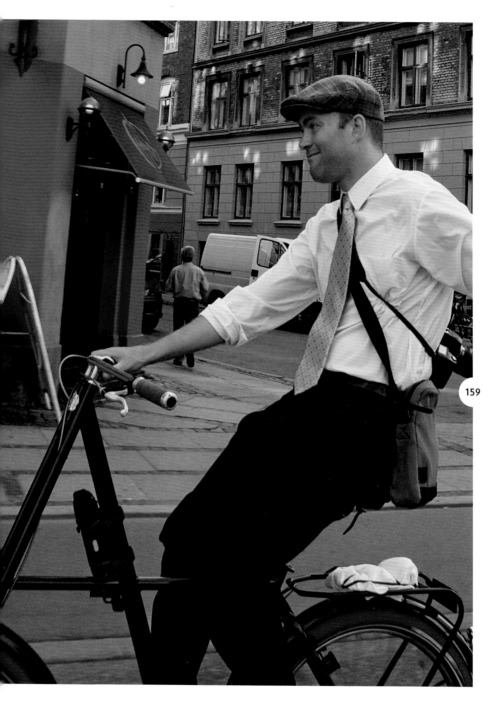

AHEAD OF THE GAME Whatever the bicycle (in this case, the elegant Velorbis Leikier), whatever the city, show your Cycle Chic credentials by eschewing fluorescent vests and opting for the far more sartorially savvy flat cap.

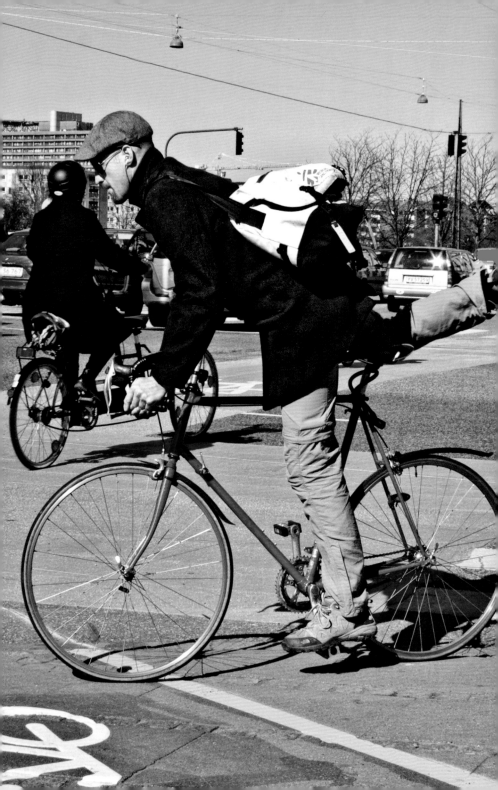

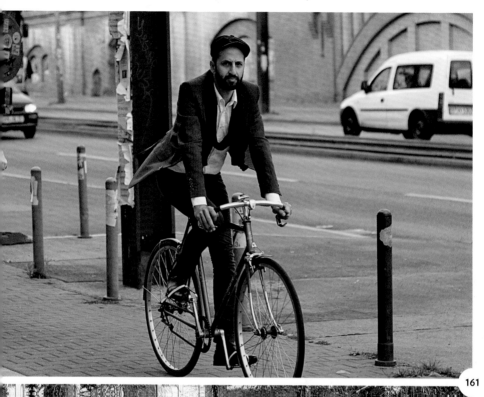

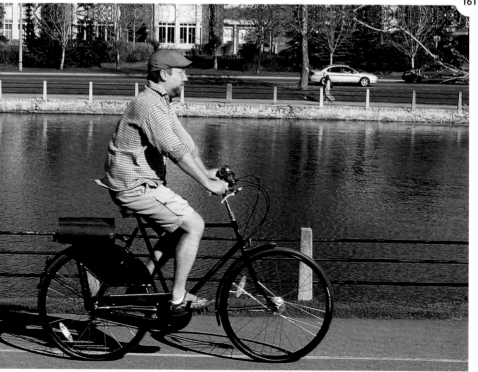

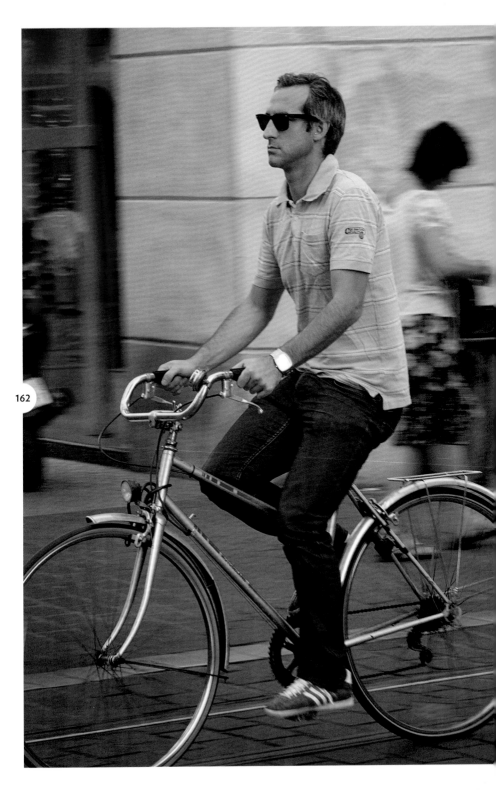

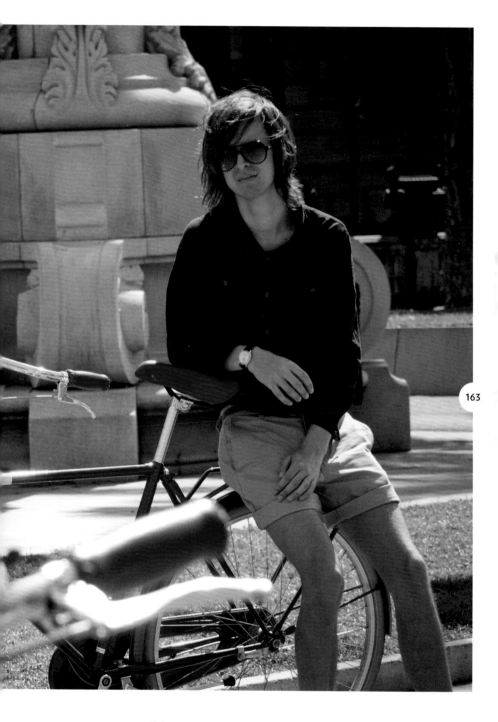

163

SMART CASUAL 'You sit on it either straight-backed, as though at a festive dinner party, or hunched forward, as though you just failed an exam,' noted Johannes Wulff. But in Barcelona (above) and Bordeaux (opposite), the pose is decidedly relaxed.

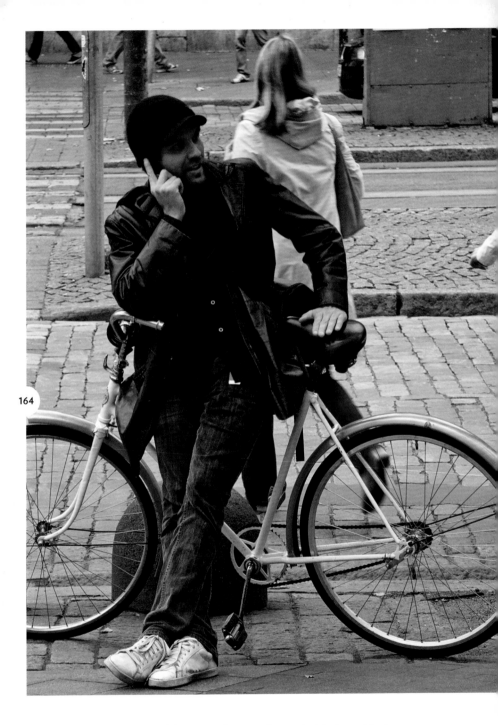

164

MESSENGERS IN MOTION Messenger bags at the ready, black-on-black ensembles assembled, these cyclists are good to go – at least in London (opposite). In Helsinki (above), there are more pressing things to attend to.

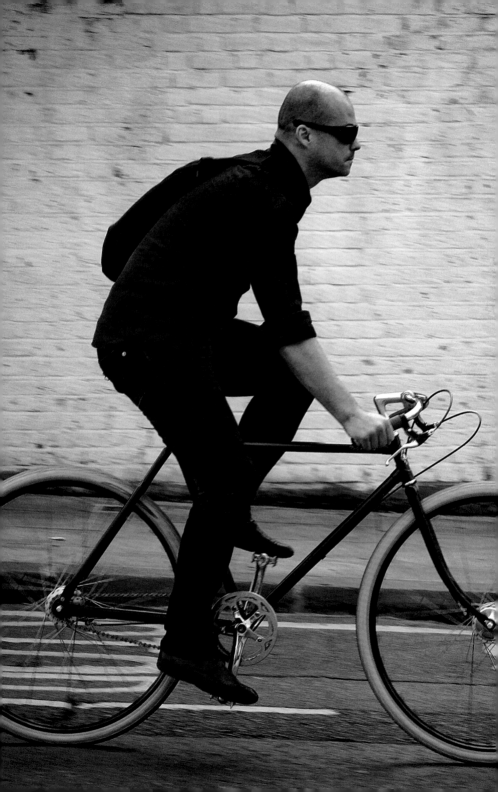

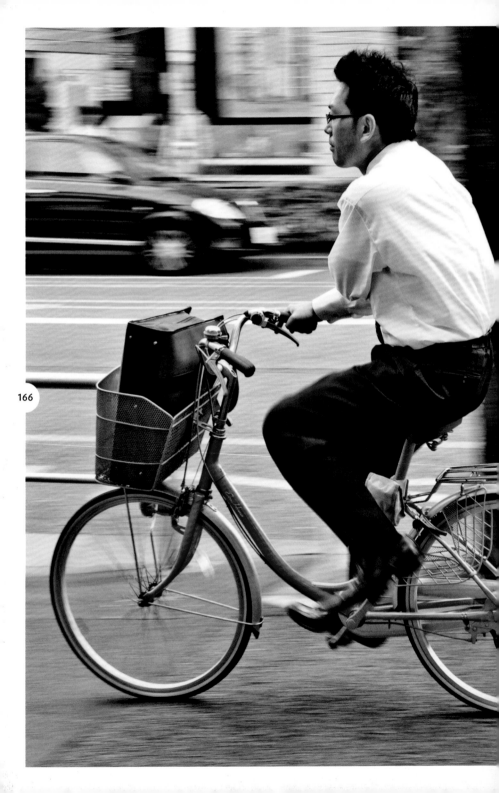

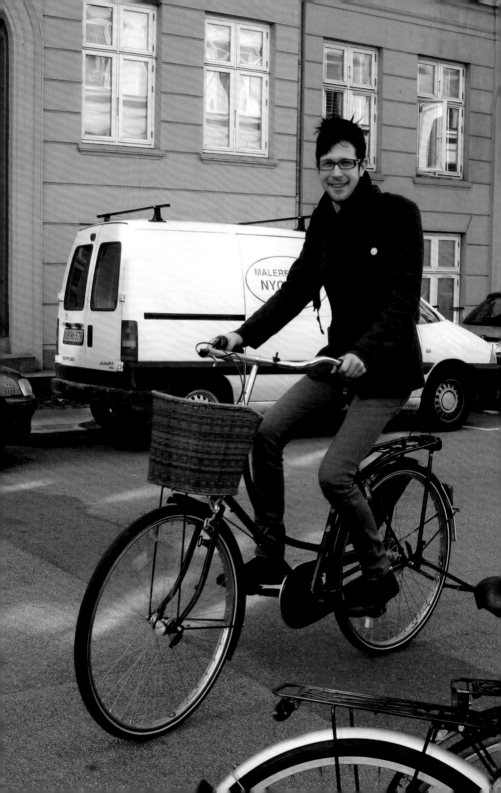

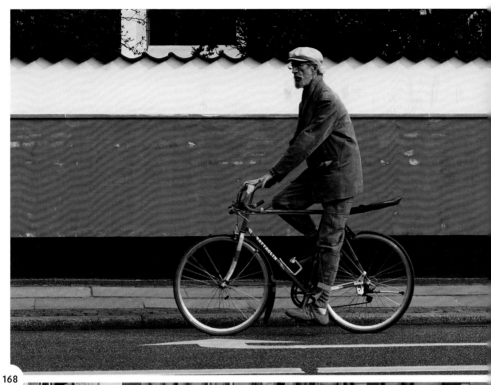

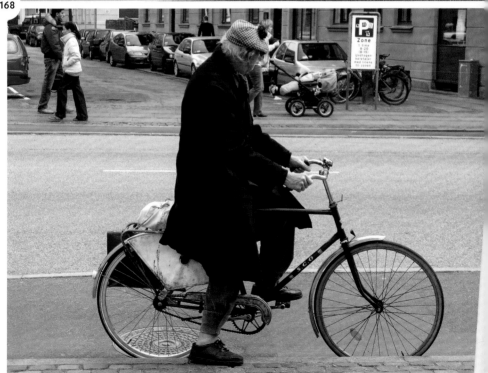

169

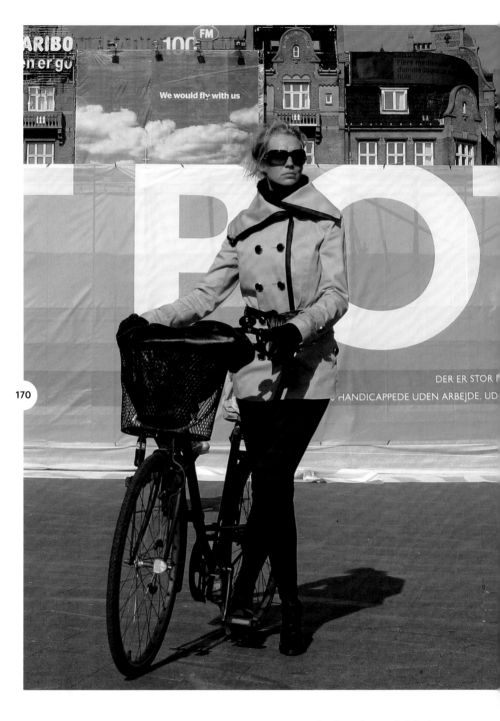

MAKE MINE A DANISH Whether stationary (while waiting for friend) or in full flight (heading off to a café), the bicycle contributes to the urban landscape with flawless aestheticism. And the addition of a neat mac and scarf doesn't hurt.

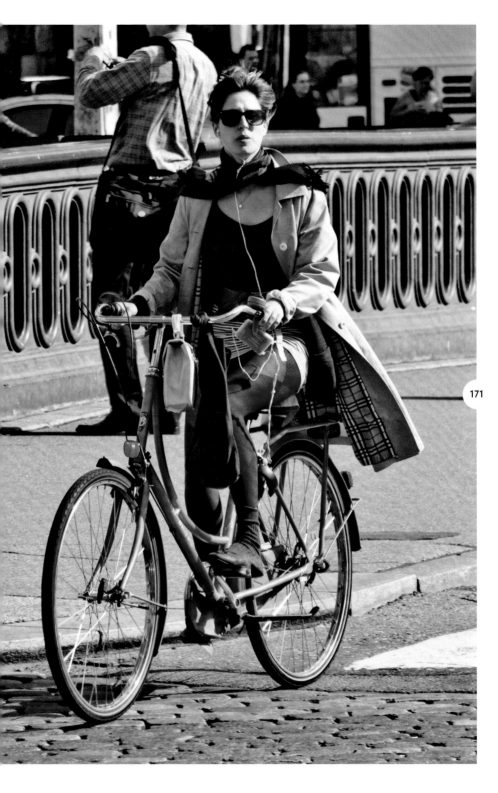

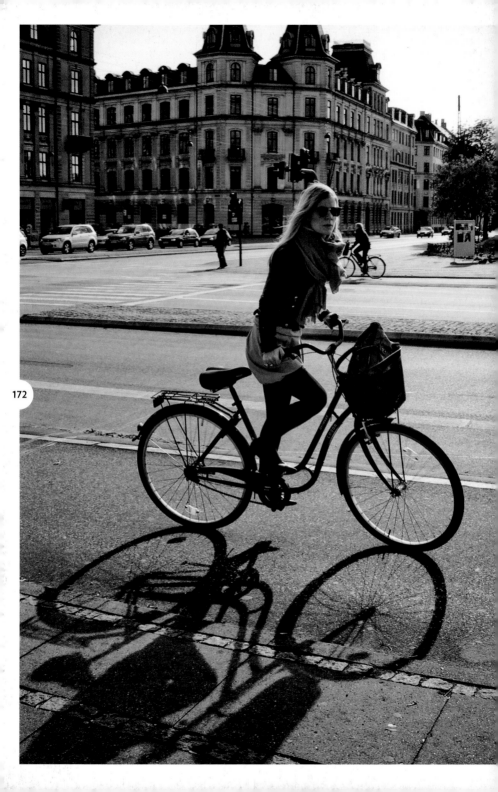

'BICYCLING IS THE NEAREST APPROXIMATION I KNOW TO THE FLIGHT OF BIRDS.'

LOUIS J. HALLE,
SPRING IN WASHINGTON, 1947

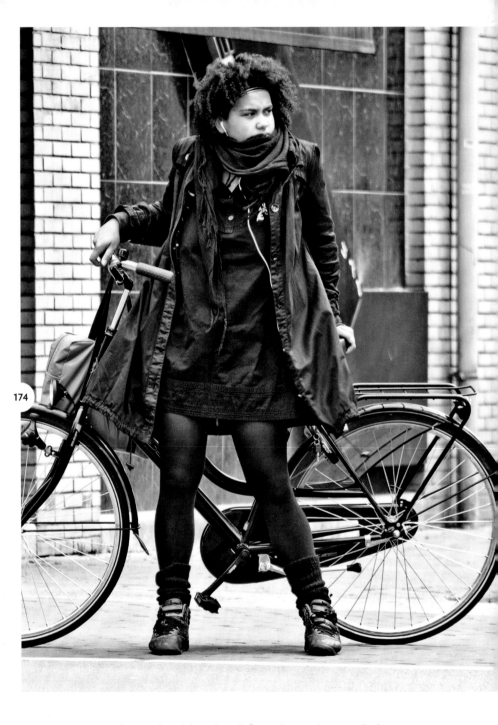

CYCLE PIONEERS Amsterdam (above) and Copenhagen (opposite), the Romulus and Remus of modern bicycle culture. In both of these mainstream cycling cities, over 50 per cent of the cycling population are women.

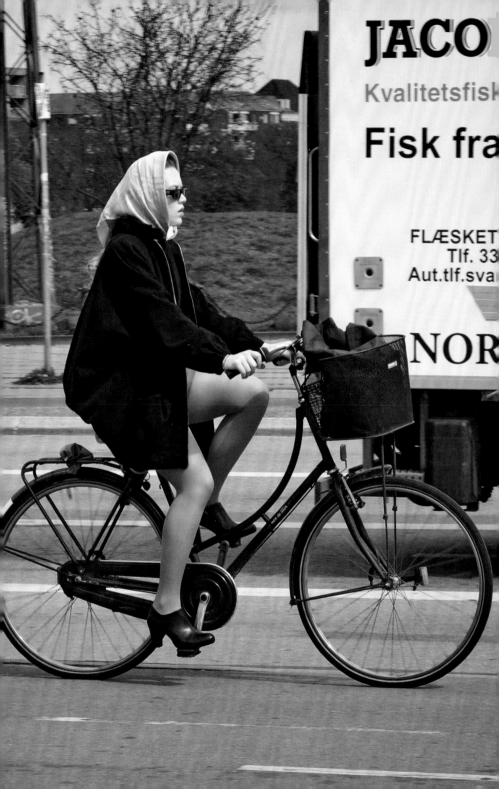

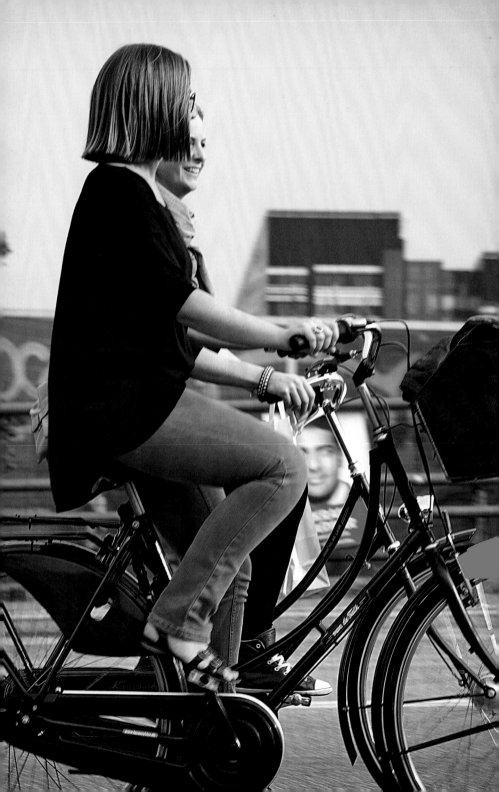

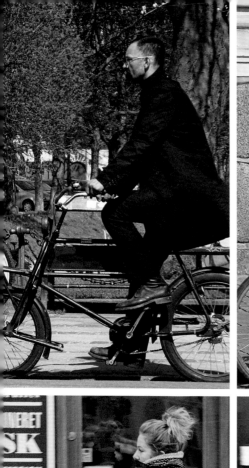
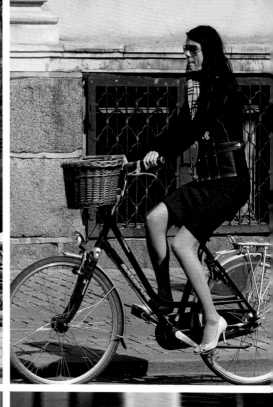

BLACK ATTACK In the summer sunshine or in the depths of winter, head-to-toe black works a treat. Here, four of Copenhagen's half a million cyclists take to the streets in the Vesterbro district (below) and outside Nørreport station (opposite).

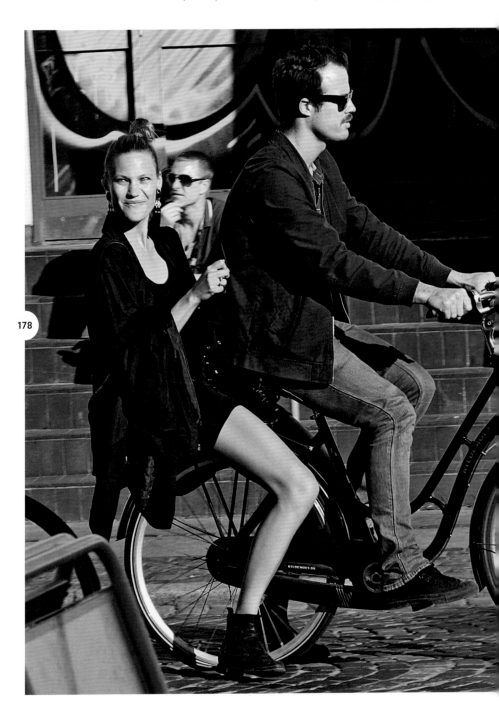

178

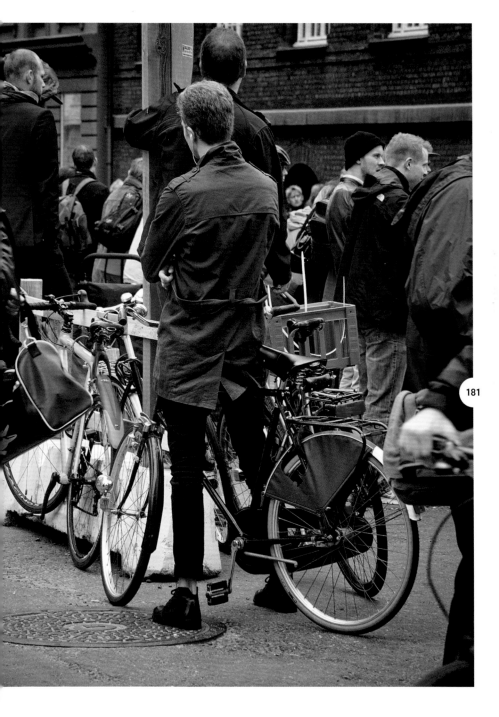

FRONT TO BACK Casual with a hint of structural determination, military jackets look good with everything from skinny jeans to woolly scarves. The plastic glass of beer clutched in this cyclist's hand just adds to the look.

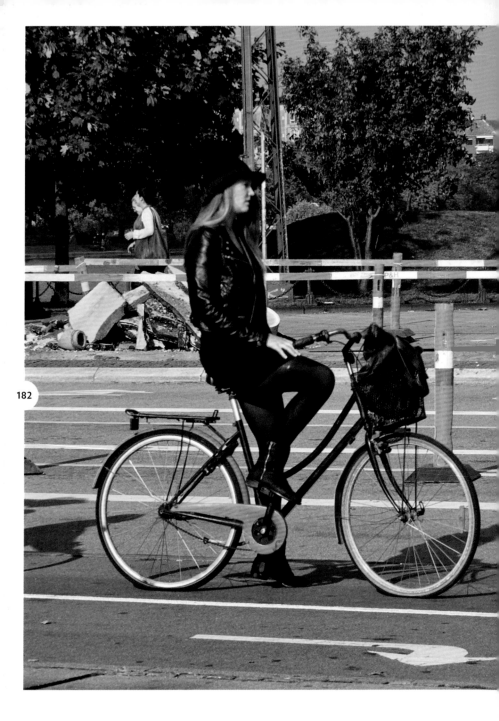

182

ROLL WITH IT A black-leather jacket and rock 'n' roll short skirt and tights provides an edgily cool contrast to the elegance of the bicycle. It's the two-wheeled version of the poetry slam.

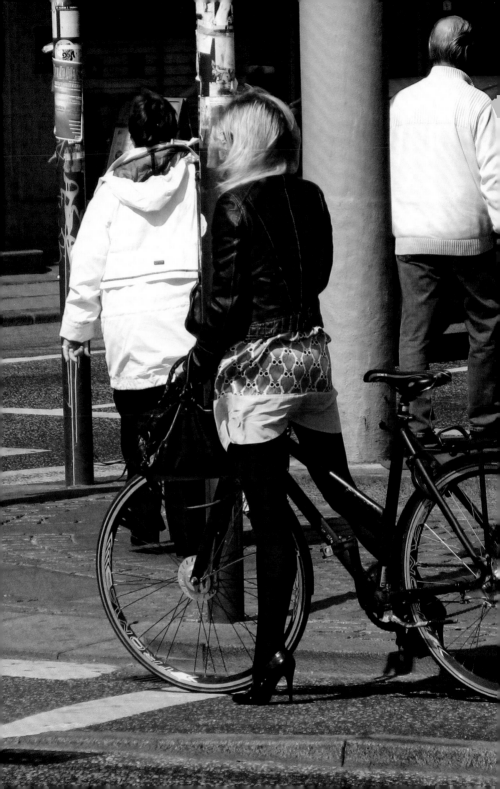

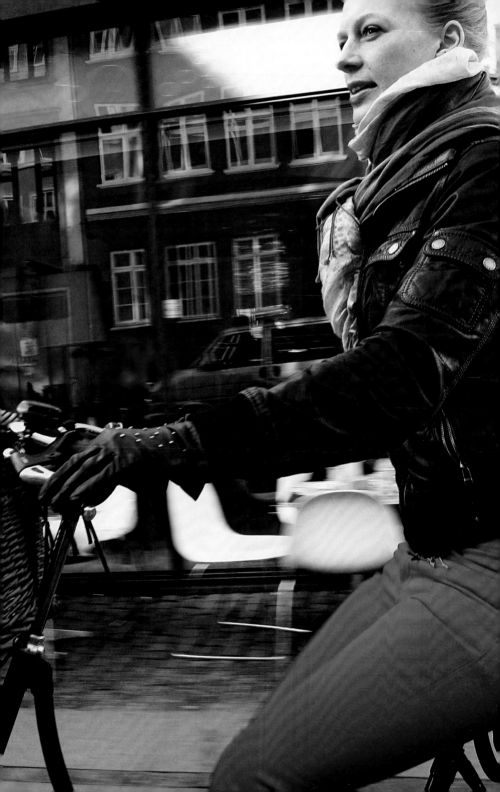

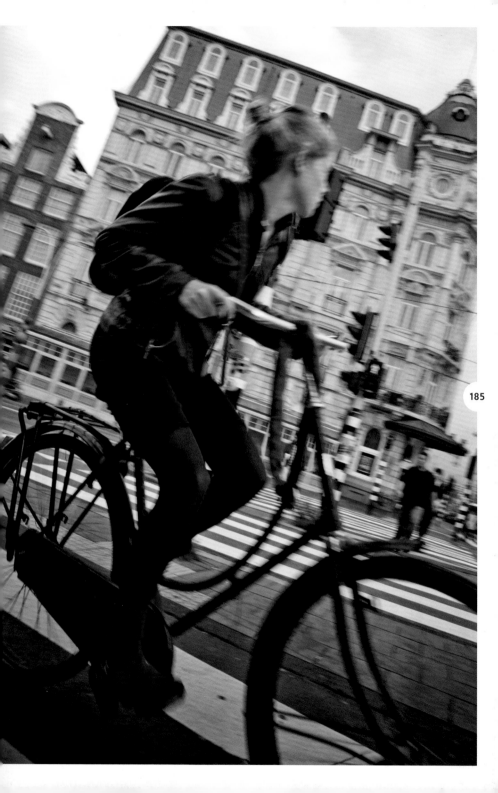

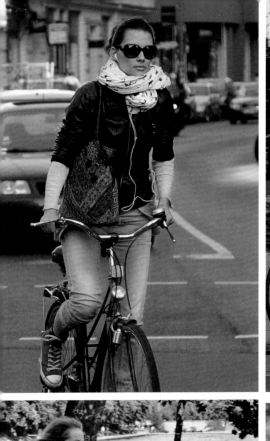
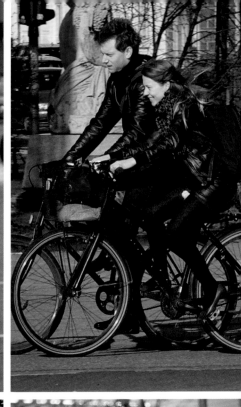
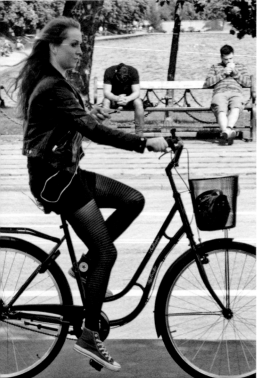
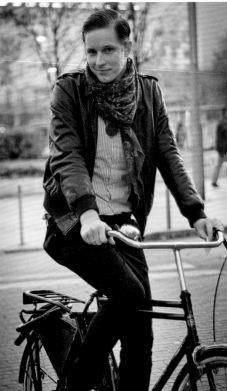

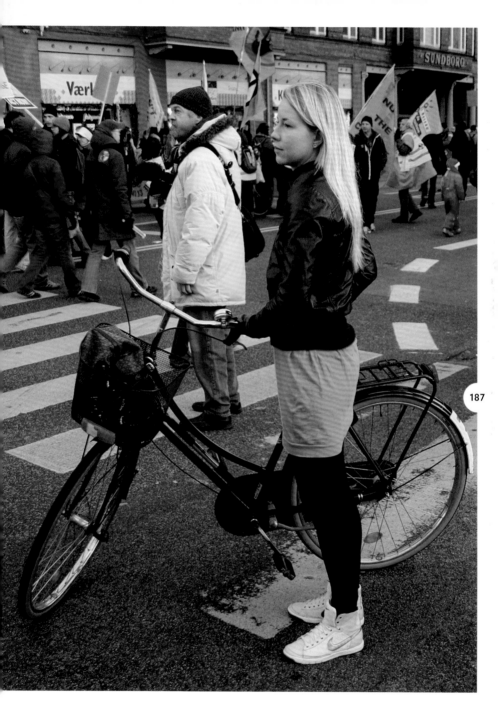

HELL FOR LEATHER Always trendy, always cool. Out and about in Copenhagen, Budapest (opposite, bottom right) and Berlin (opposite, top left), where cycling accounts for 13 per cent of the modal split.

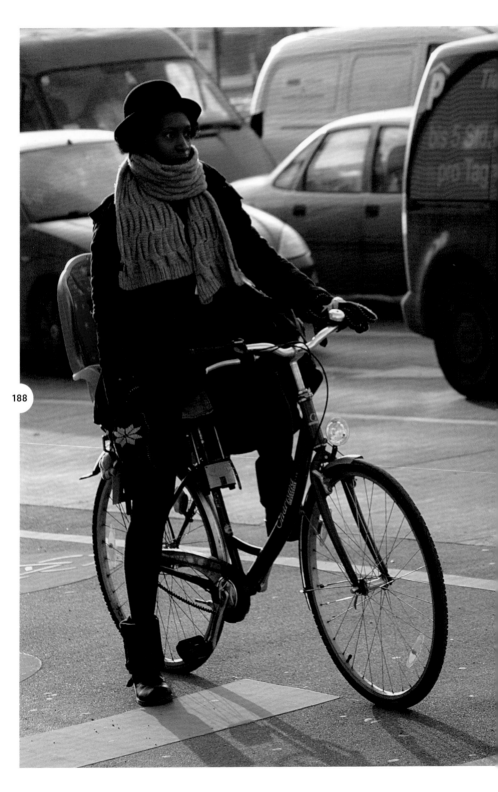

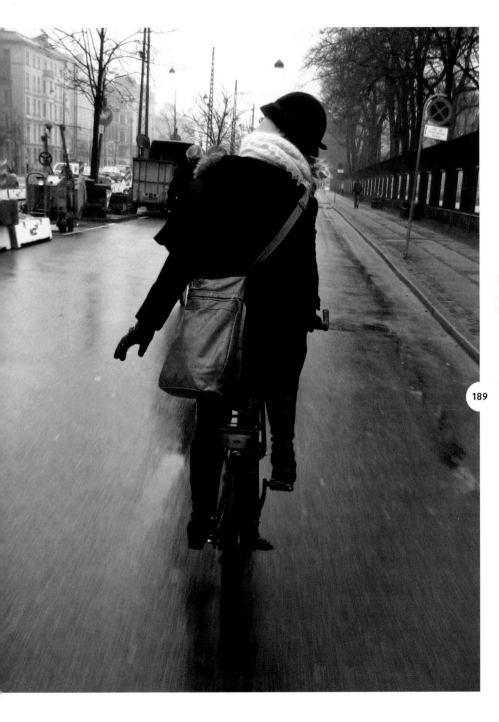

WINTER WHEELS When the moody Nordic winter tightens its grip on the city, the cyclists of Copenhagen (above) are prepared as they cruise along the 1,000 kilometres (621 miles) of bicycle lanes in the greater metropolitan area. In Vienna (opposite), the answer is a giant scarf and elf boots.

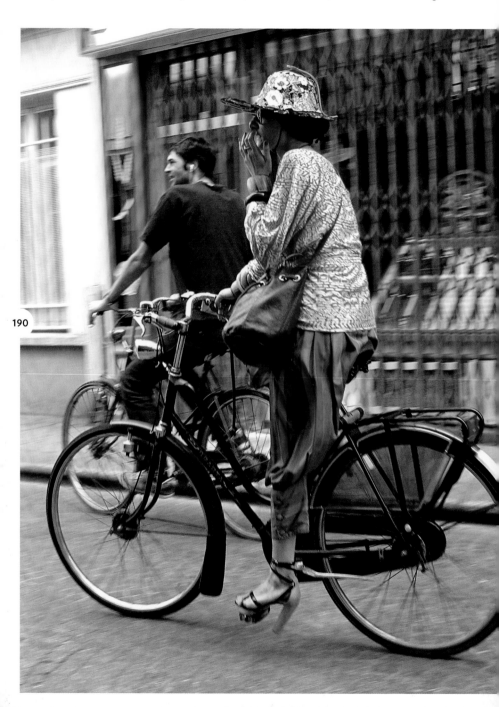

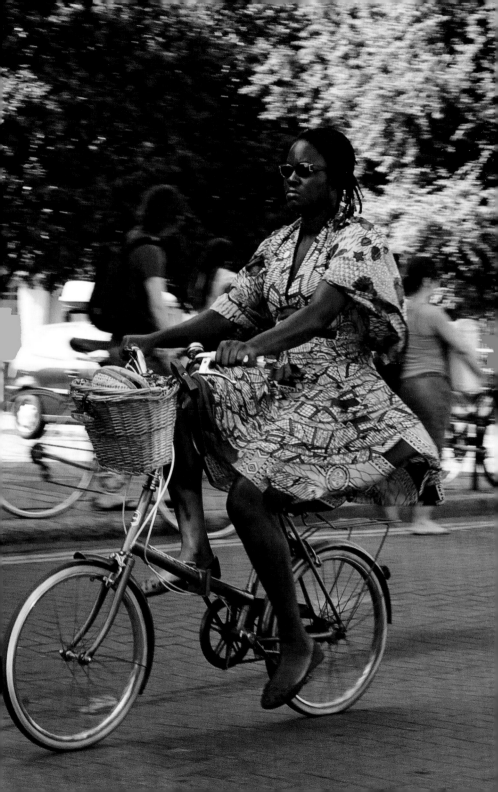

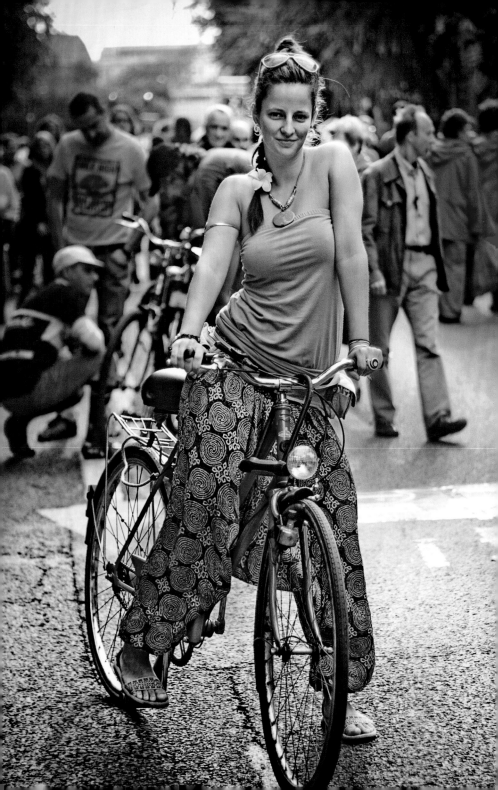

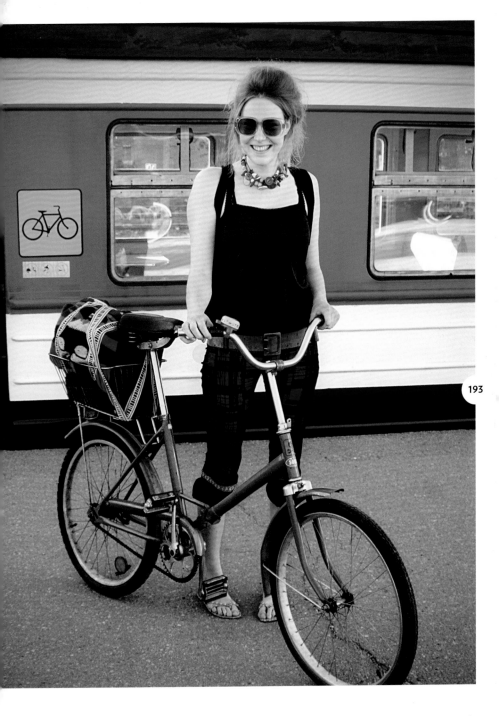

PRETTY IN PRINT Keeping it light and breezy in Budapest (opposite), and peddling the straight and narrow in Tallinn, Estonia (above), a very bike-friendly city, as the sign on the train carriage will attest.

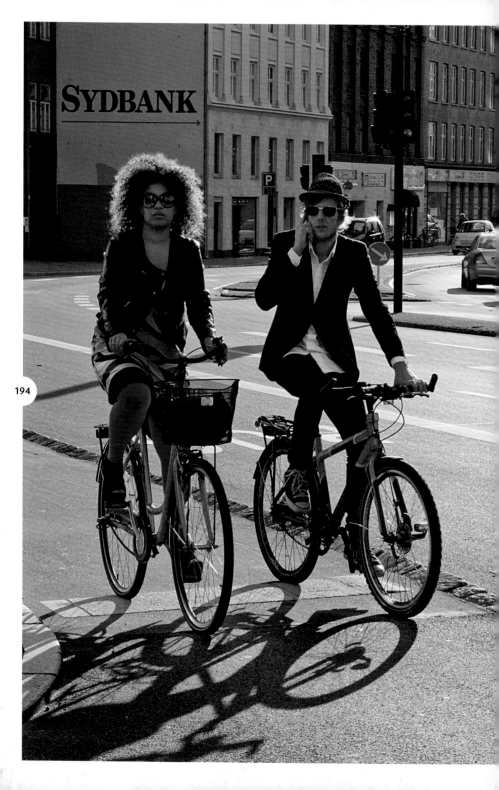

194

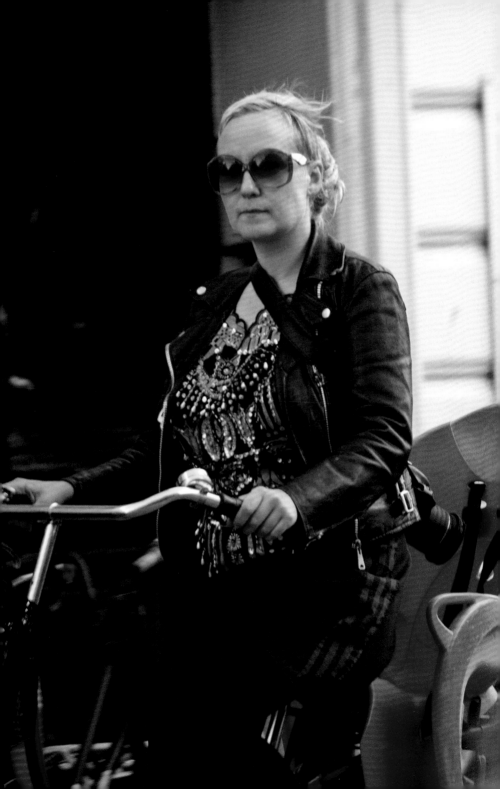

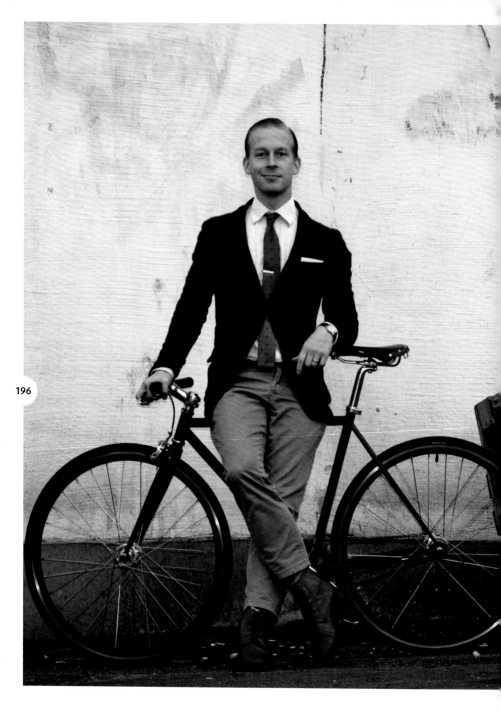

SUITS YOU, SIR Bicycles and gentlemen's leisure wear, inseparable since 1885 and just as suitable for the modern urban metrosexual. This cyclist in Helsinki (above) looks especially dashing in his smart tie and brown ankle boots.

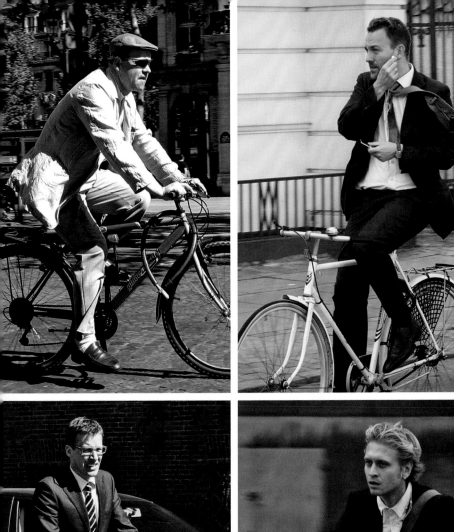
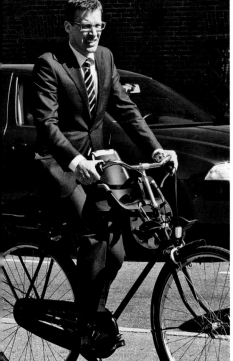
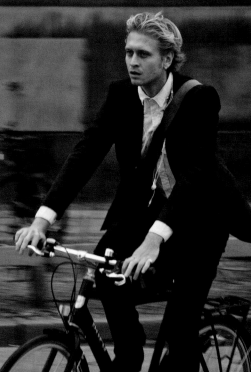

LOOK THE PART Citizen Cyclists look great from any angle. And who says you need a fixie (or fixed-wheel bicycle for the uninitiated) to do a track stand at a red light? Or even a fluorescent jacket, when an elegant tailored number will do just fine.

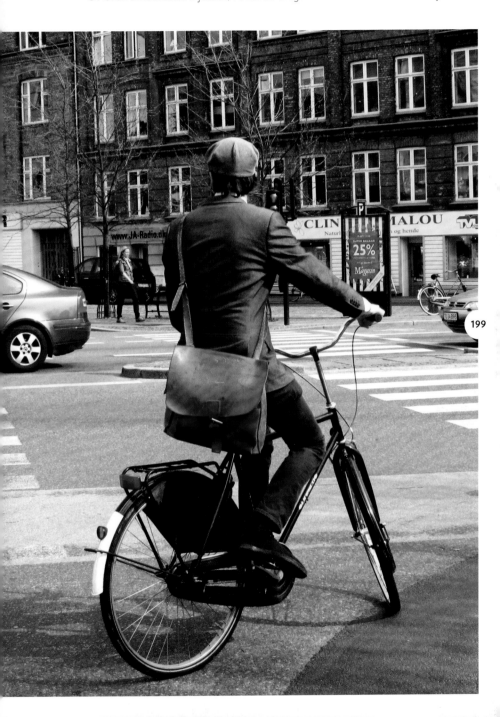

199

TRUE GENT Stand up tall on your bicycle. The Pedersen model, designed by Danish inventor Mikael Pedersen and introduced in 1897, remains one of the finest designs around for gentlemen cyclists.

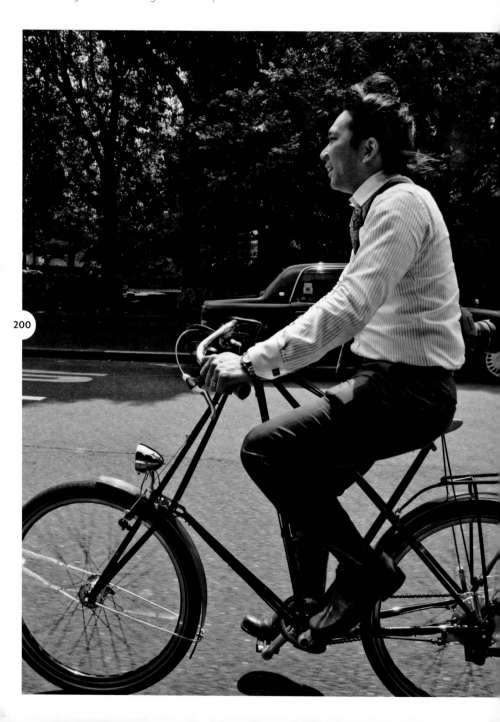

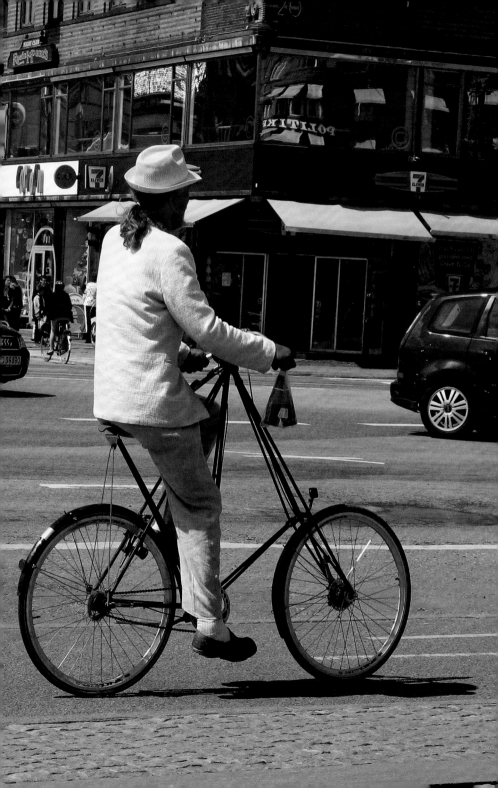

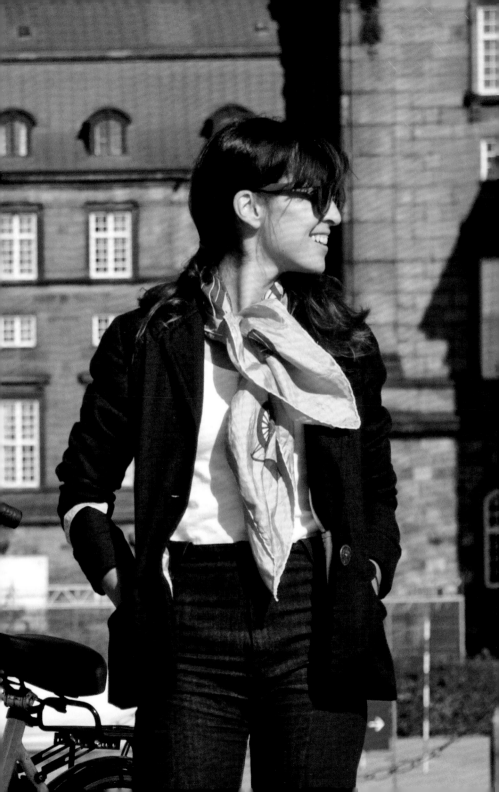

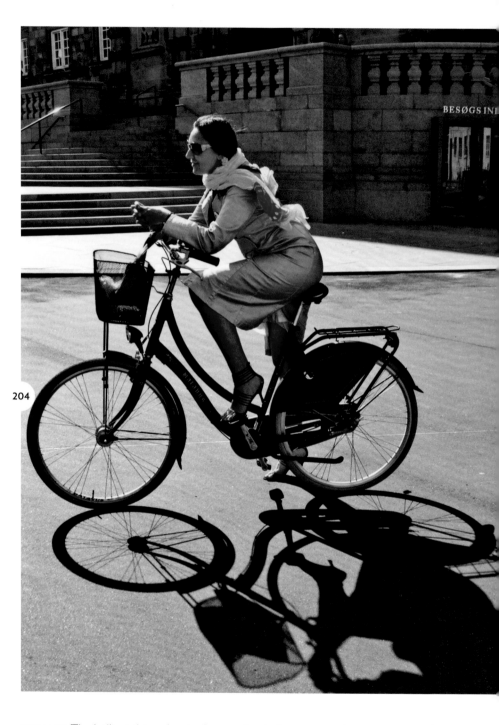

204

BIG MAC The brilliant thing about urban cycling is that you can throw open your closet and find that it's already filled with cycling gear. In both Copenhagen (above) and Helsinki (opposite), the smart money is on a yellow mac. Chic, elegant, understated – every time.

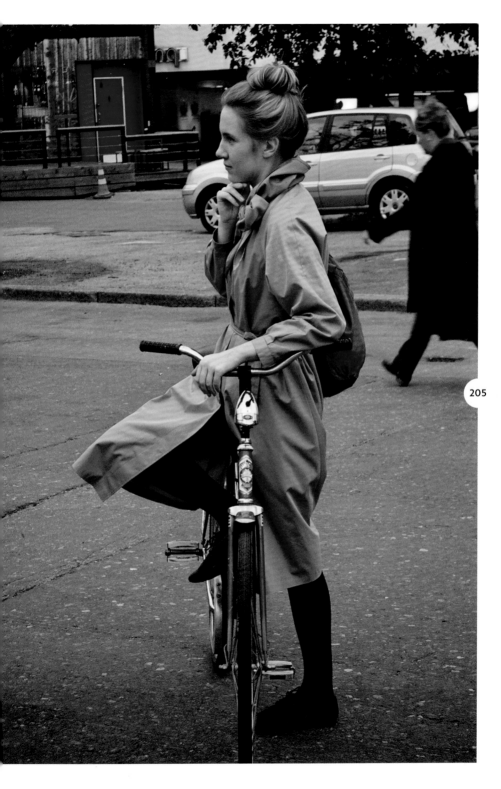

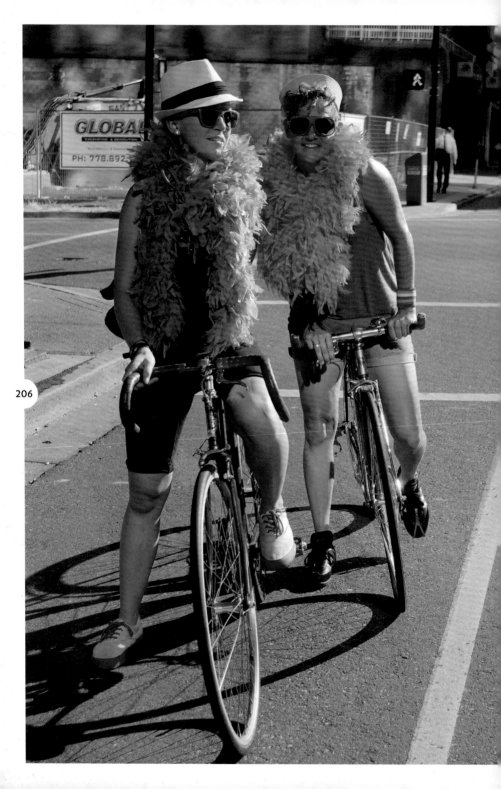

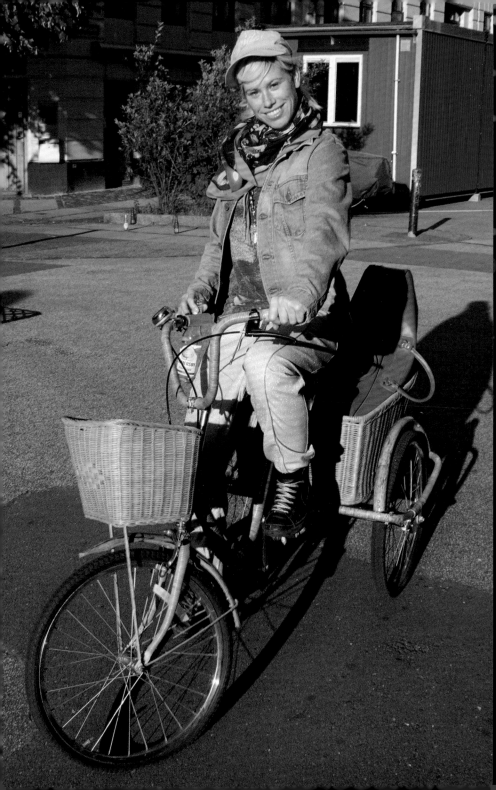

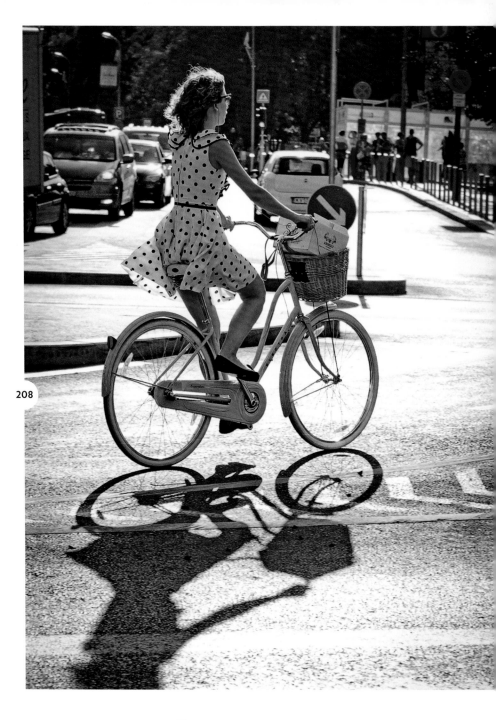

208

IT'S A BREEZE IN BUDAPEST These two cyclists in the Hungarian capital perfectly encapsulate the Cycle Chic credo. And what more fitting place to do it in, as Budapest has been named Eastern Europe's most cycle-friendly city.

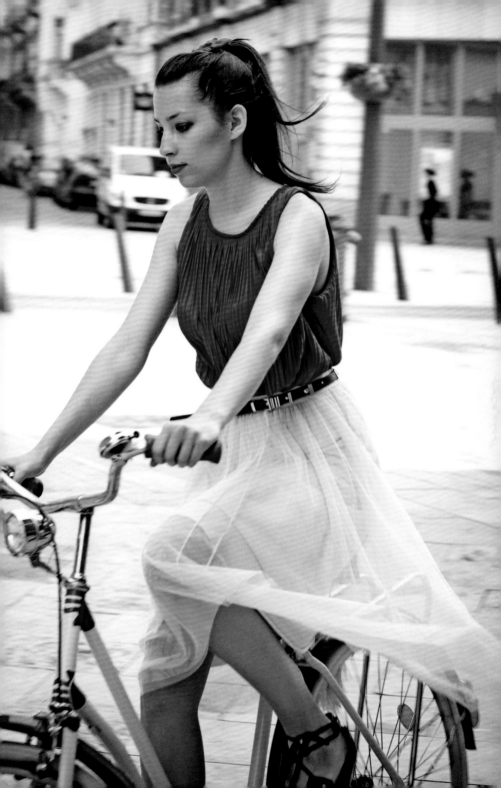

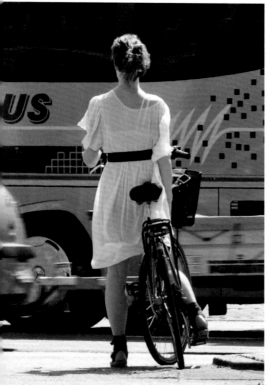
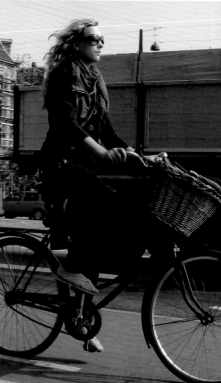

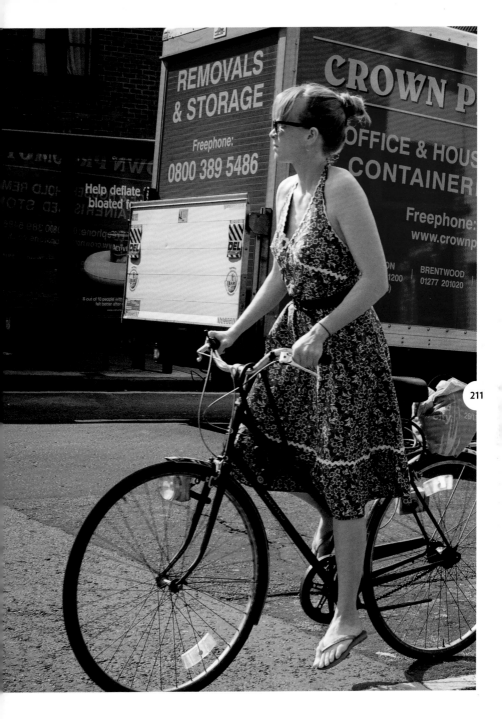

UPRIGHTEOUSNESS Seen here wheeling through the streets of Amsterdam (opposite, top left), London (above) and Copenhagen, it's no surprise that this upright design has been the most popular in the history of bicycle culture.

'THE BICYCLE WILL ACCOMPLISH MORE FOR WOMEN'S SENSIBLE DRESS THAN ALL THE REFORM MOVEMENTS THAT HAVE EVER BEEN WAGED.'

DEMOREST'S FAMILY MAGAZINE, 1895

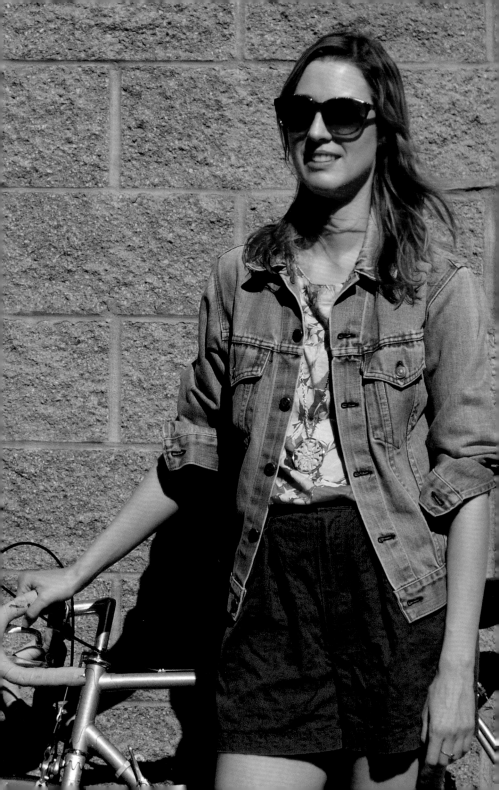

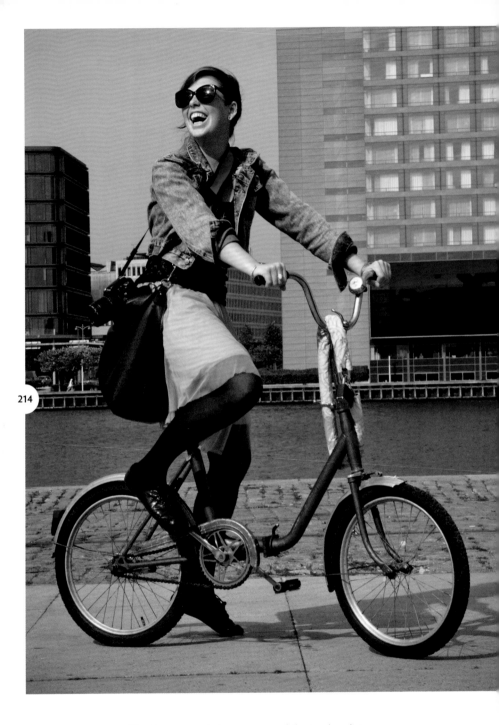

214

SIMPLY SMASHING Getting out and about on your bike is a laugh in Copenhagen (above), and it's not so bad in Helsinki (opposite) either. Cycling chic isn't about speed, but getting from A to B and looking great while you do it.

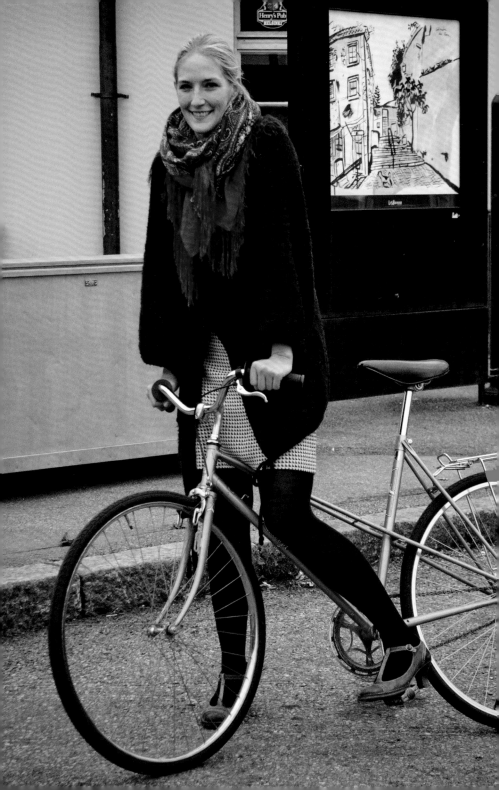

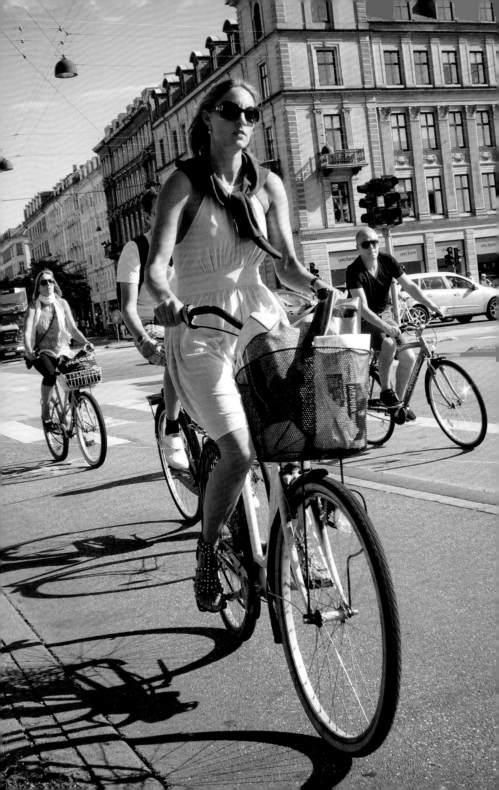

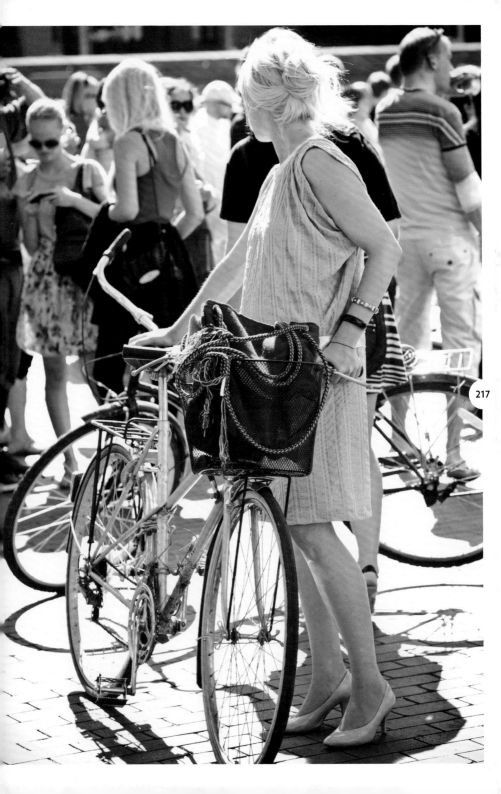

217

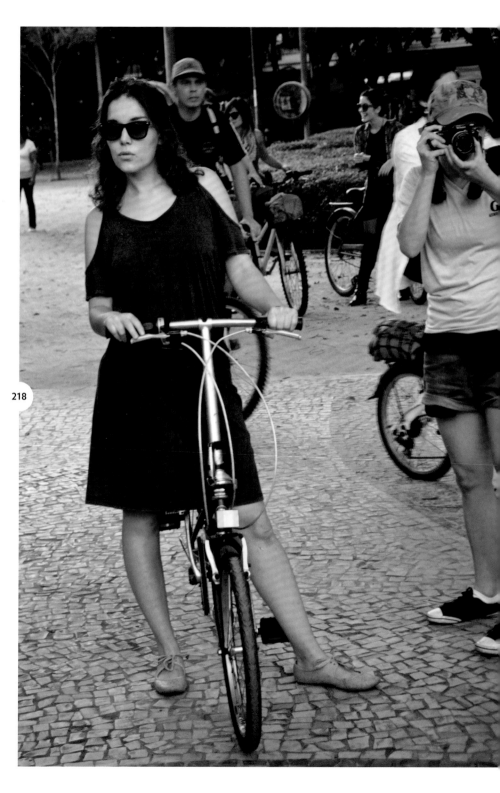

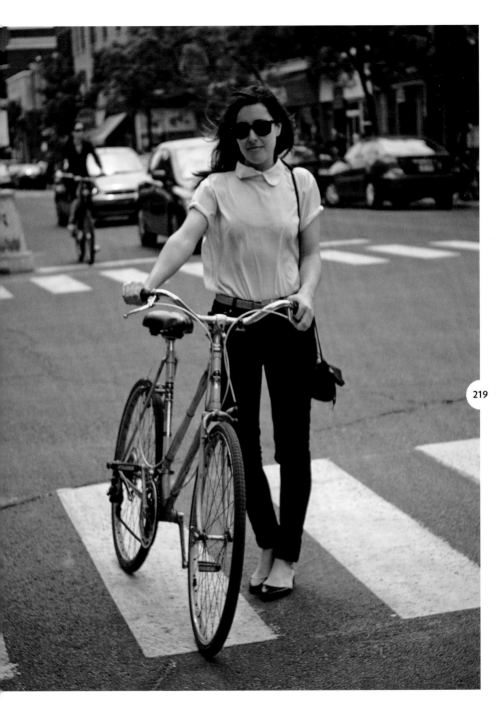

219

MAKE A STAND Standing up for stylish worldwide urban cycling, from Rio de Janeiro (opposite) to Montreal (above), where the public bike-sharing scheme has some 300 stations scattered throughout the city.

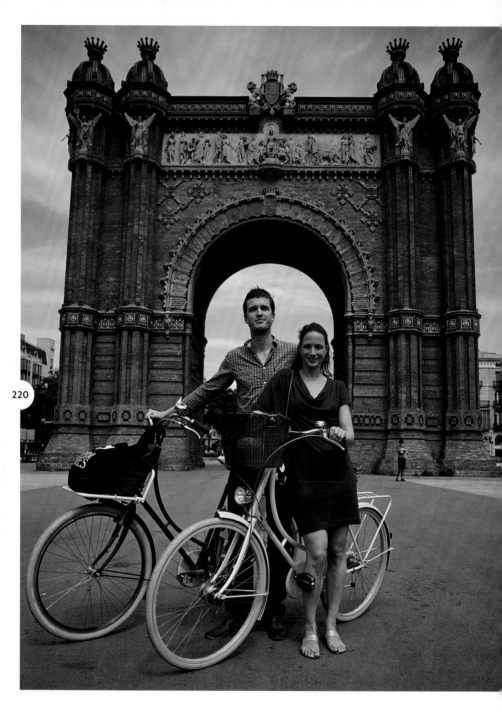

220

RED HOT A spicy red bike turns up the heat in Barcelona (opposite), where this cyclist looks set for dancing. The Moorish arch was built for the Barcelona Expo of 1888, and today provides a photogenic backdrop for style-savvy cyclists.

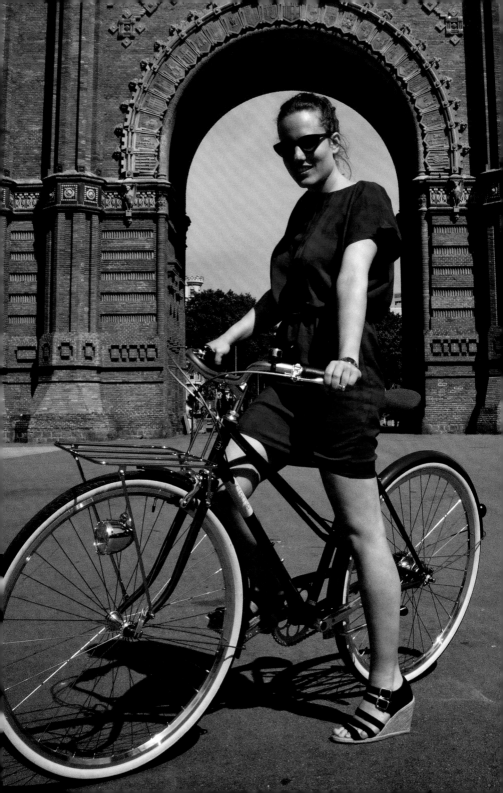

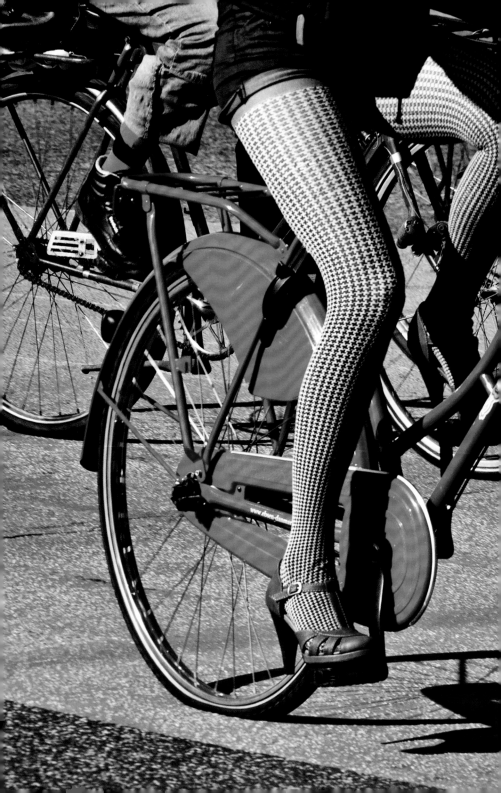

ANGELS IN
THE DETAILS

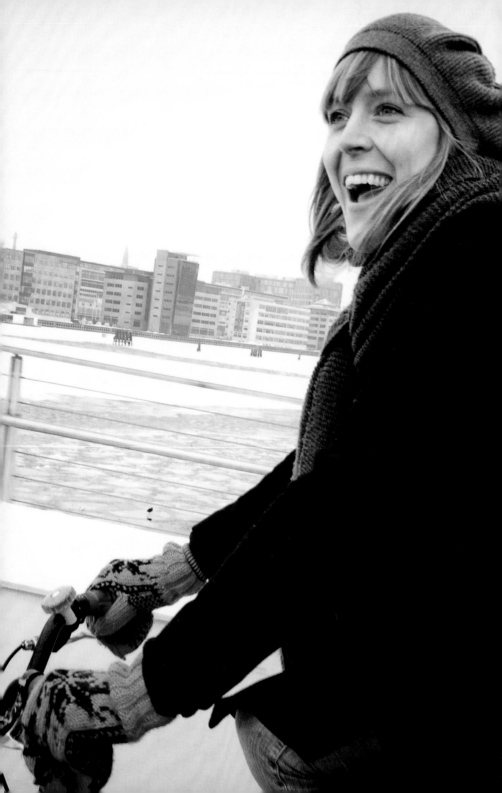

Quite often it's the Big Picture we focus on when regarding the return of the bicycle to the urban landscape. Especially in Emerging Bicycle Cultures, there is enormous focus on the task of increasing bicycle traffic, the role of the bicycle in urban society, and so on. All good.

There is, however, fantastic beauty to be found in the details when people take to 'the wheel', as it used to be called in the early days of Bicycle Culture 1.0. The bicycles themselves provide countless opportunities for personalization. Adding bells, skirt guards, stickers, or any of many other accessories is a must. The head badge of a vintage bicycle can be a work of art. Add to that the charms of the person riding it, and the combinations boggle the mind. Personal style is at the core. Make your bicycle cool, funky or pretty, absolutely, but it's not only about the bicycle – it's about people on their bicycles and has been so since the dawn of bicycle culture at the end of the nineteenth century.

This chapter is about the details, the accessories or style choices that stand out within an ensemble. When we see other people on the streets or in photos, it's the details that we notice: 'Great outfit! Love the shoes!' In these pages, let's zoom in a bit and focus on those sunglasses, that pair of shoes, that cool hat. Fashion is like architecture. It is a structure containing many bricks – each with their own purpose, but all of them contributing to the beauty and impact of the final work.

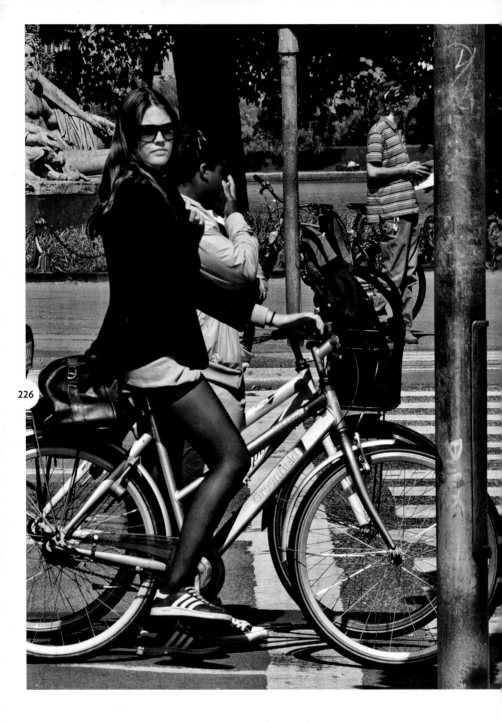

226

TINTED WINDOWS OF THE SOUL Face it, the future is bright.
And don't forget your shades! Any style will do. In Barcelona
(opposite, bottom right), a little pirate chic is thrown into the mix.

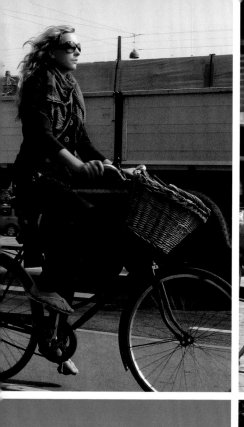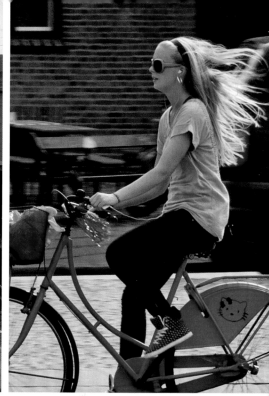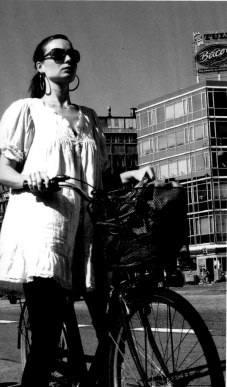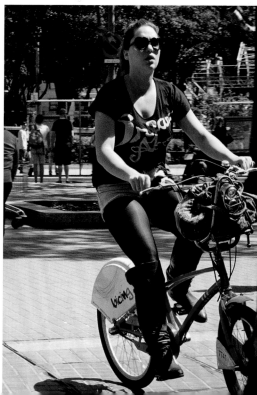

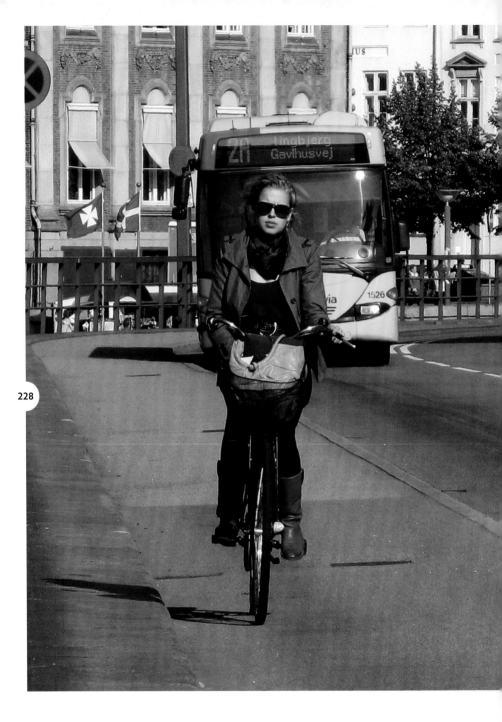

228

TICKET TO RIDE Copenhagen is justly proud of its cycling policies. This streetside counter (opposite) tracks the number of cyclists that have passed, with this stylish commuter coming in at an impressive 5,305 so far that day.

27°C

15:19

r cyklist nummer

5305

i dag

f sammenlagt

747727

yklister i år på
nne strækning

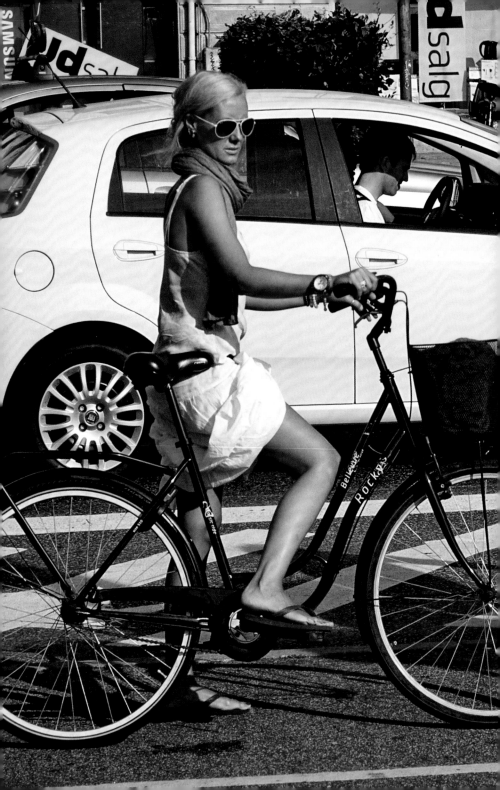

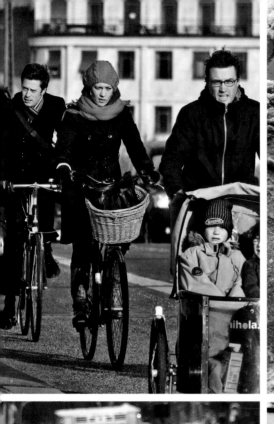
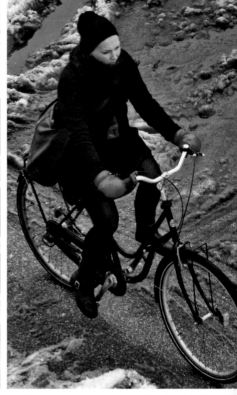
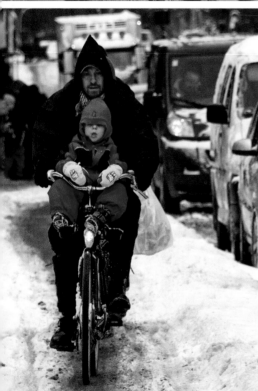
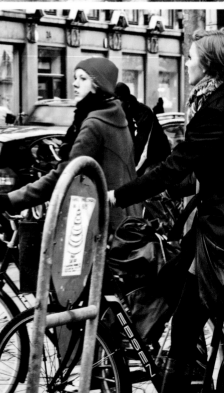

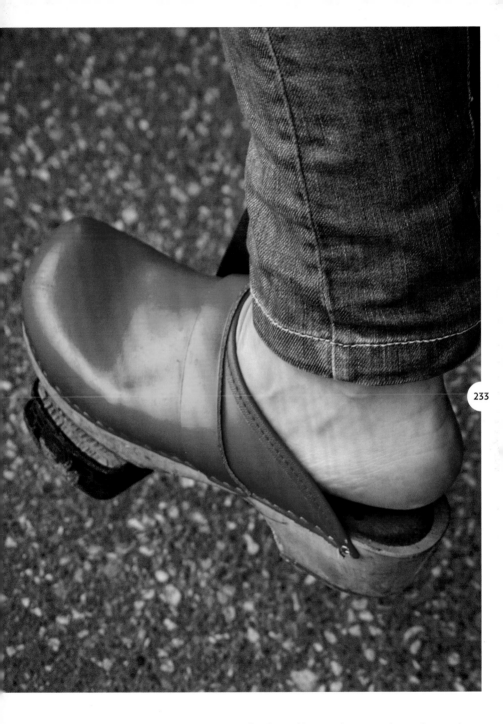

233

RED'S NOT DEAD Bright-red bits and pieces – hats, gloves, clogs, even miniature snowsuits – are like bold punctuation marks on the cityscape, in every season, whatever the weather.

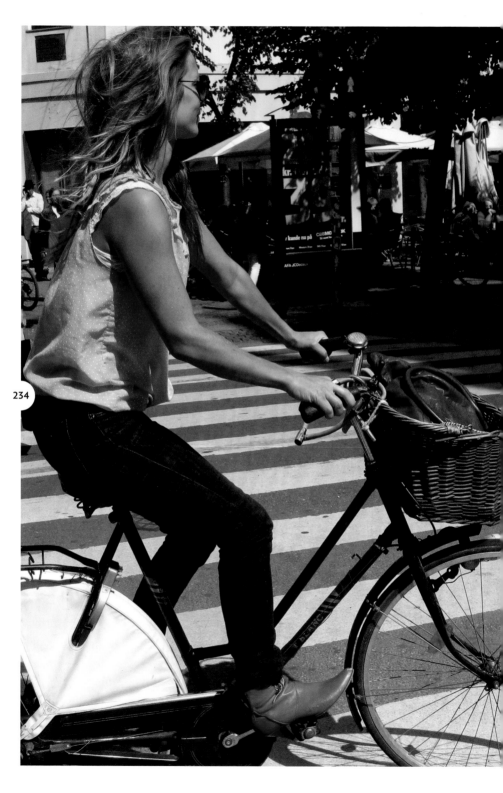

234

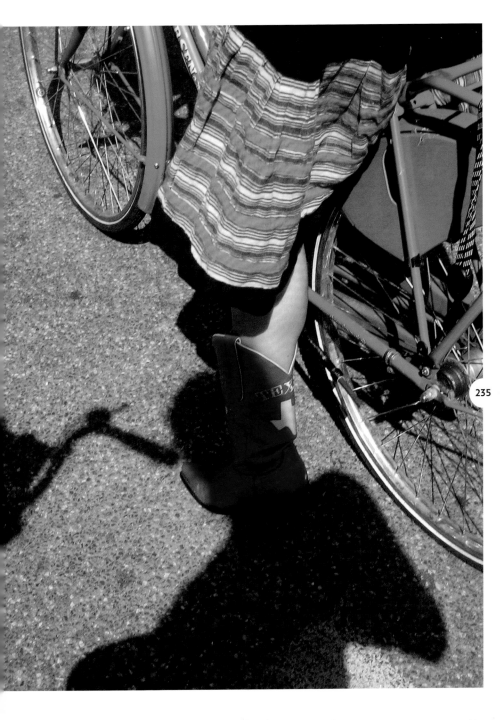

BOOTIFUL It's not every day that a sixteenth-century essayist is quoted in bicycle-related matters, but occasionally it happens. 'One must always have one's boots on, and be ready to go,' said Michel de Montaigne – and it is so.

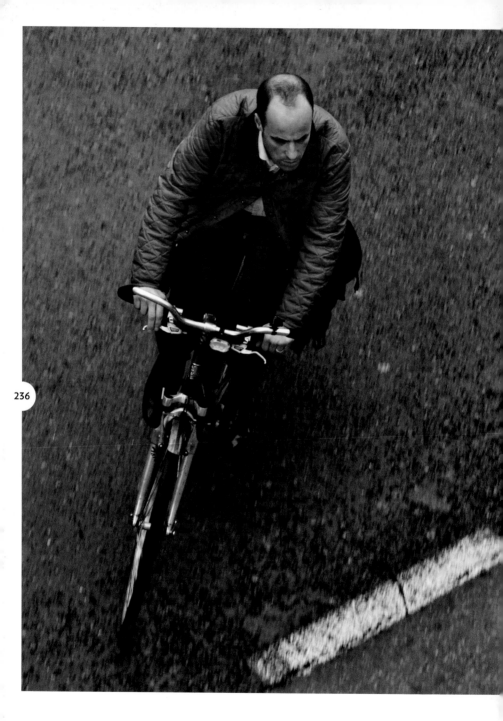

236

PADDED OUT The classic blue padded jackets more normally associated with France are migrating north – to Brussels (above) and Copenhagen (opposite), where the jacket is matched with both shirt and bicycle.

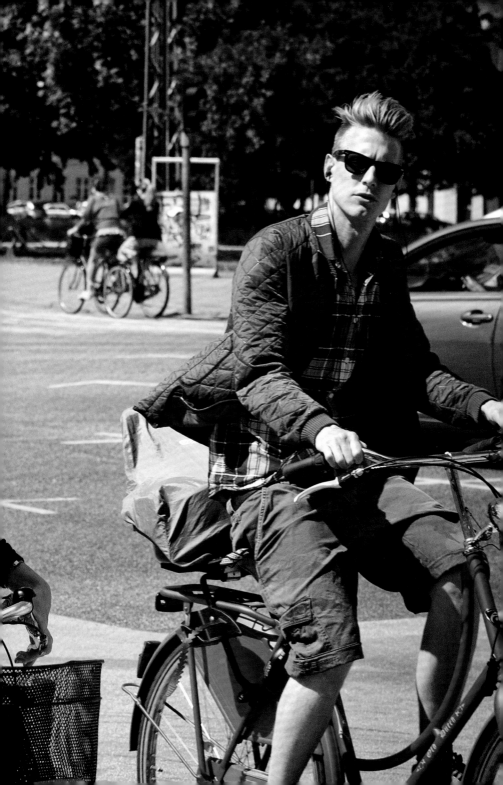

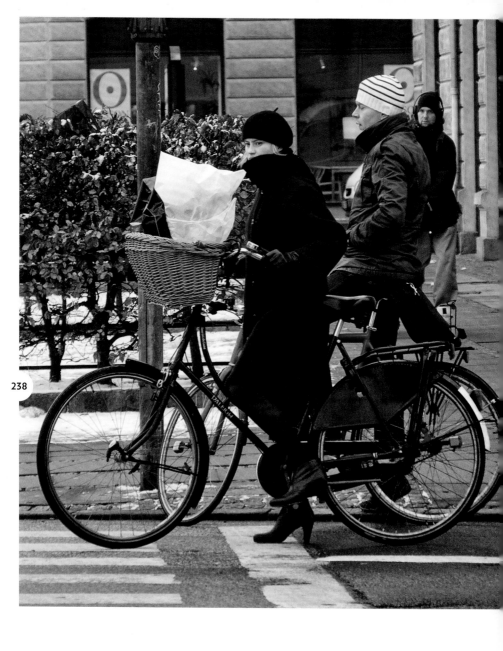

BONNIE BERET Whatever your colour preference – raspberry or otherwise – the beret has got to be one of the most resilient hat styles in history, and looks especially fetching when teamed with ankle boots and a classic ladies' bike.

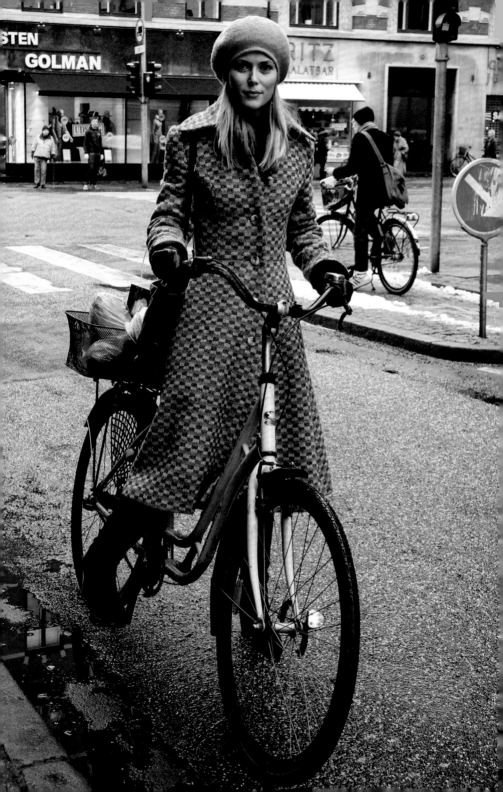

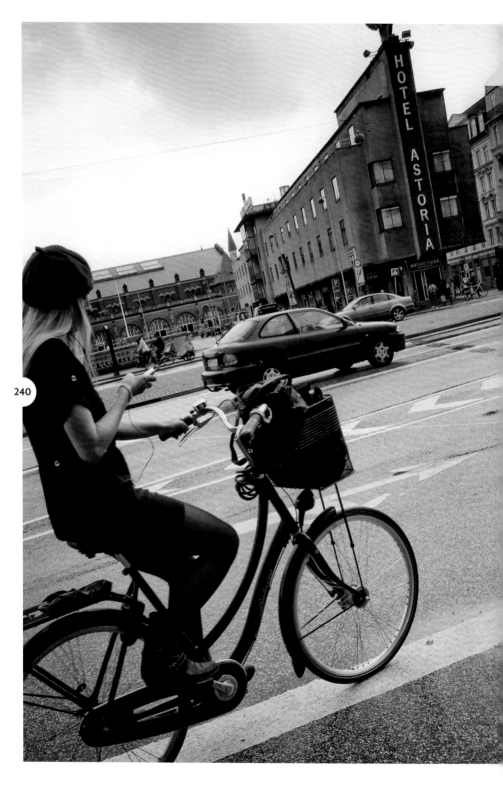

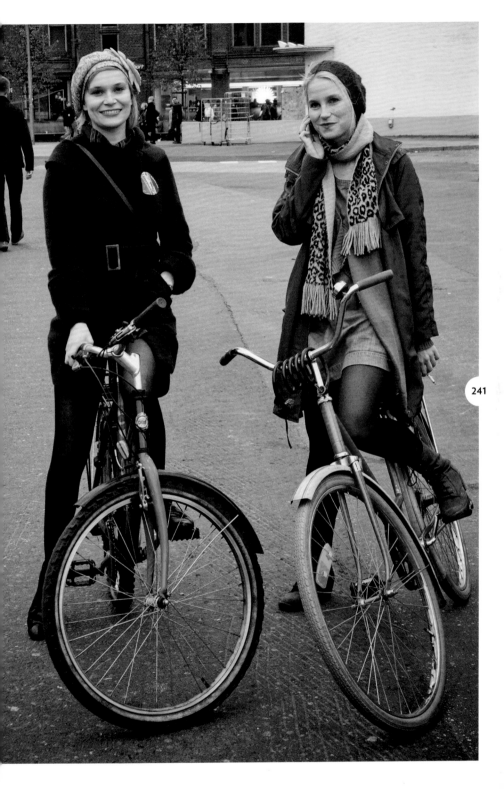

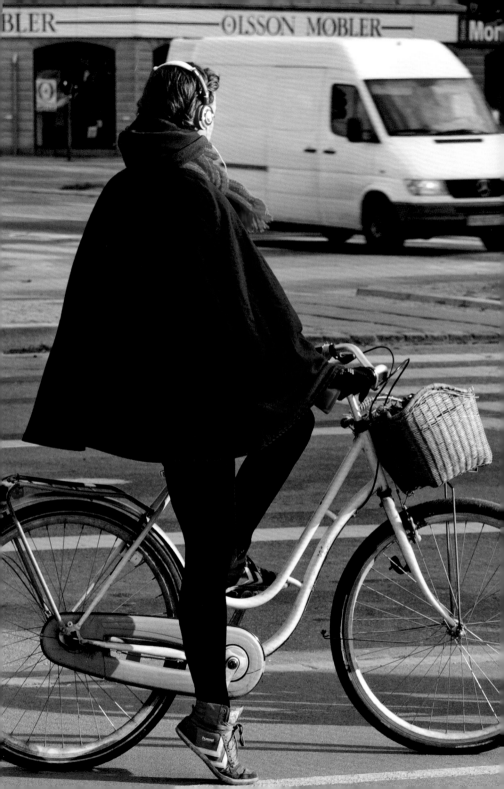

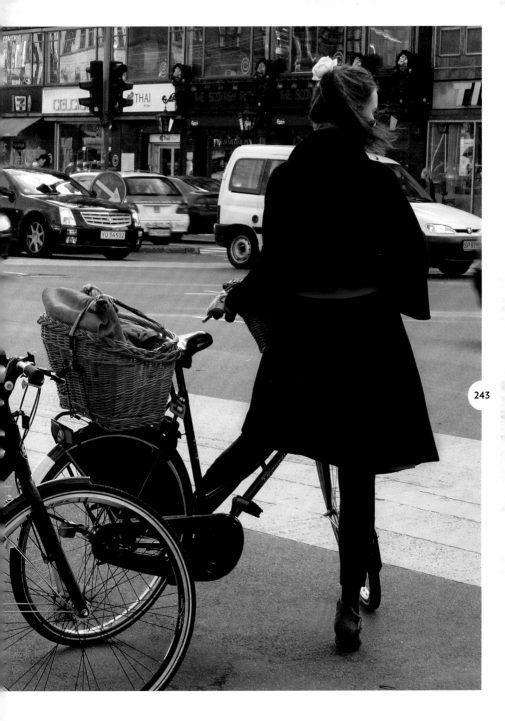

CAPES OF GOOD HOPE If urban cyclists are the superheroes of our transportational future, it is only appropriate that they wear a cape. Wicker baskets, whether you prefer them at the front or back of your bike, are optional.

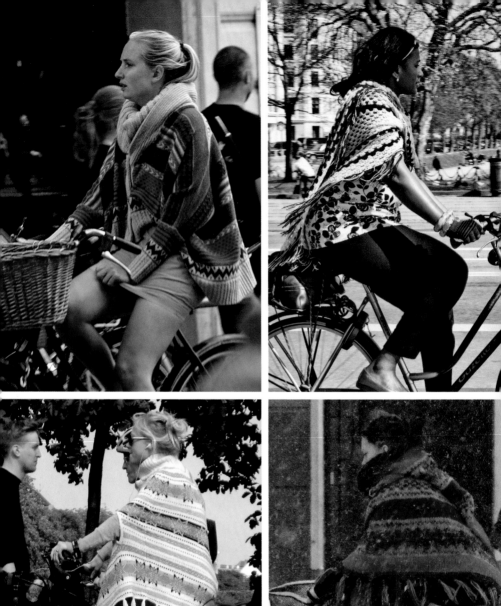
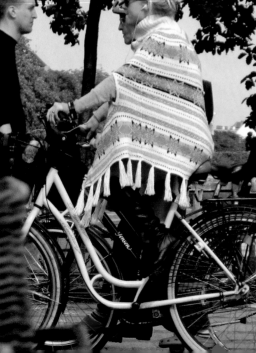
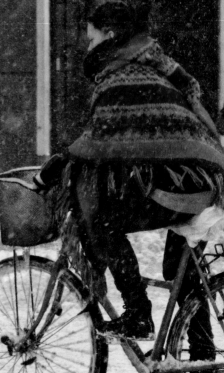

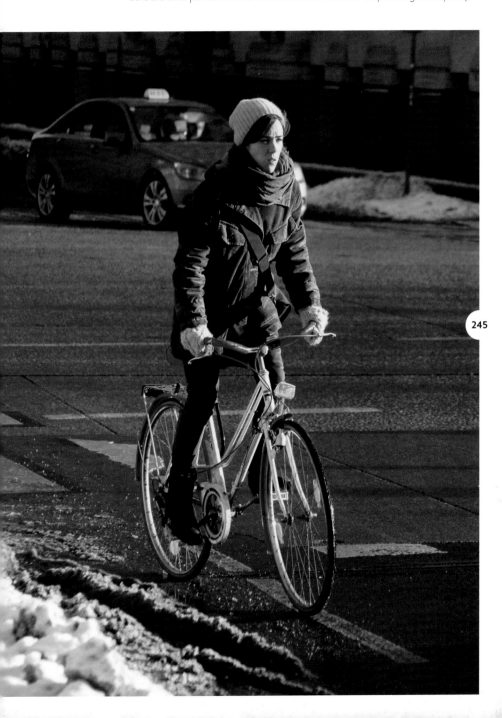

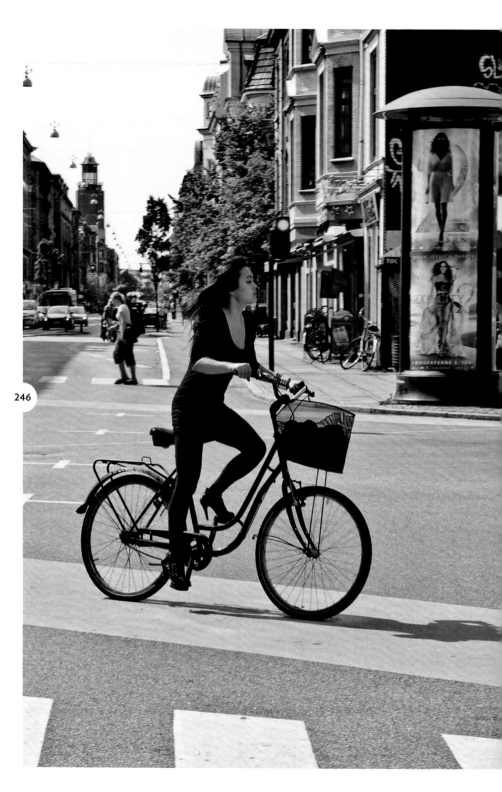

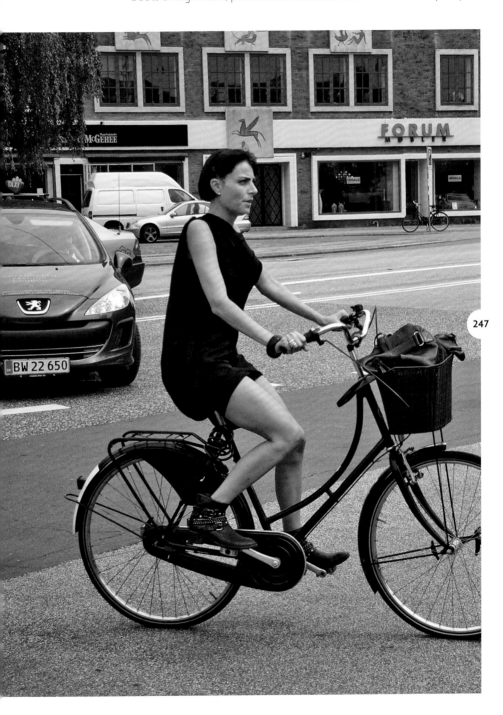

247

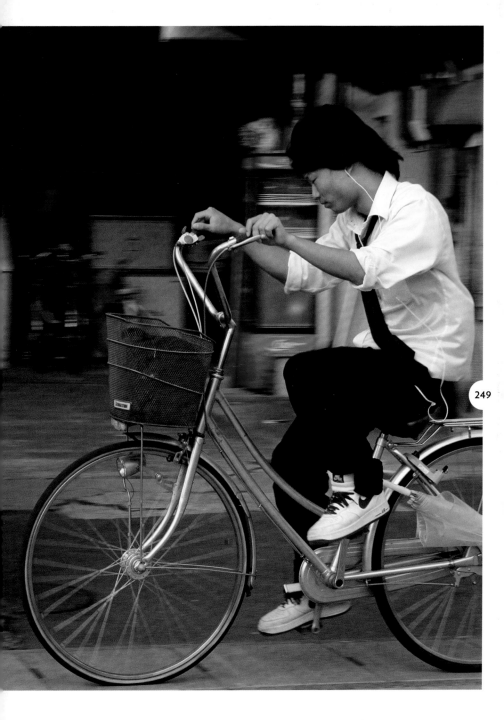

CHOPPER STYLE Lean back, be cool, enjoy the ride. Choppers come in many styles and are cool additions to the bicycle armada, like this silver specimen in Fukushima (above). In Bordeaux (opposite), the future's orange.

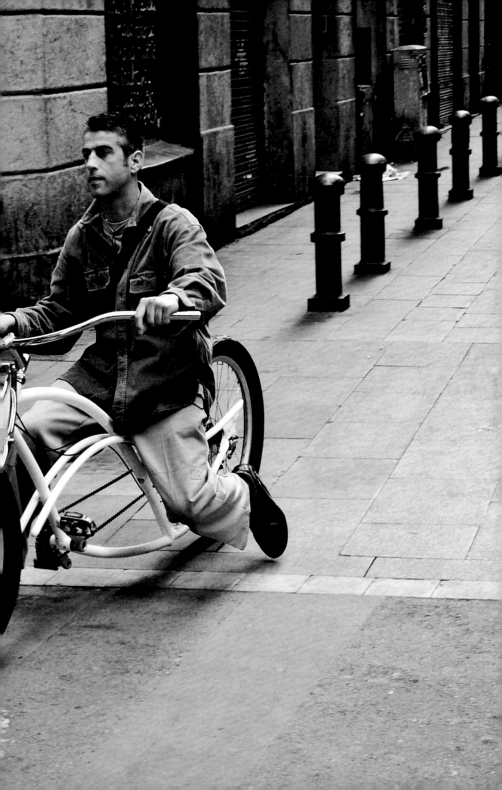

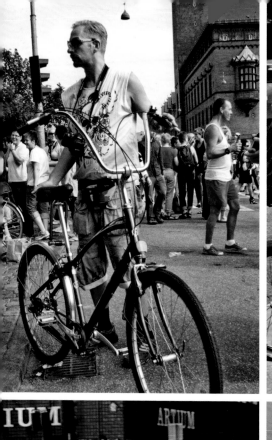
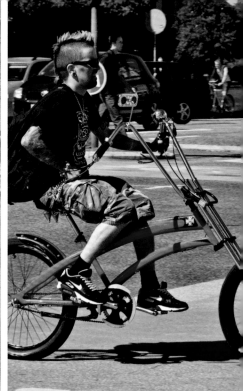
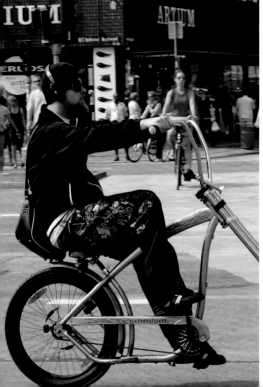
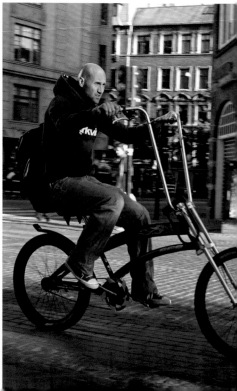

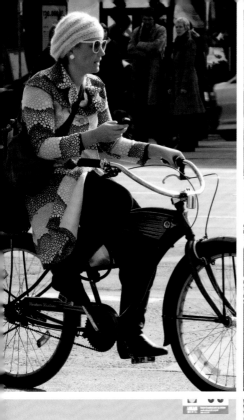
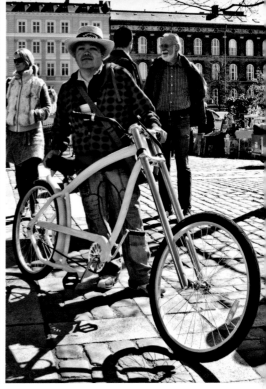
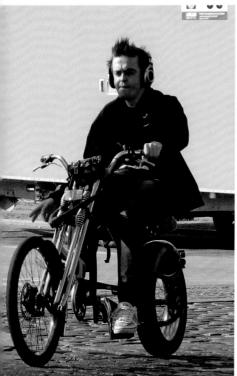
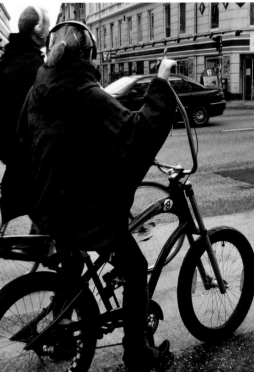

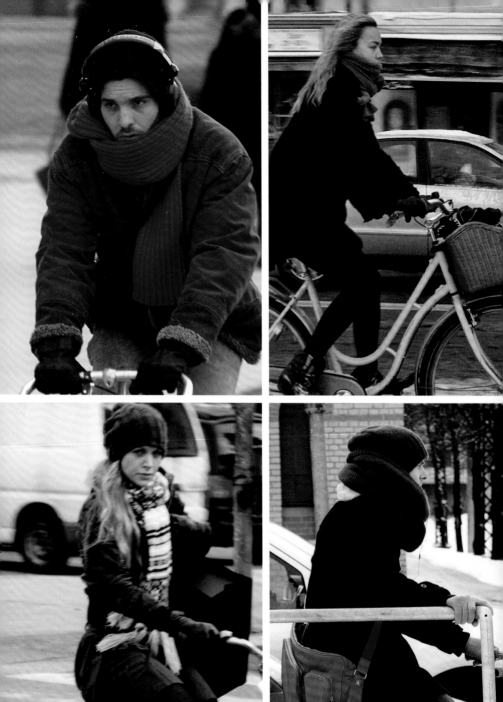

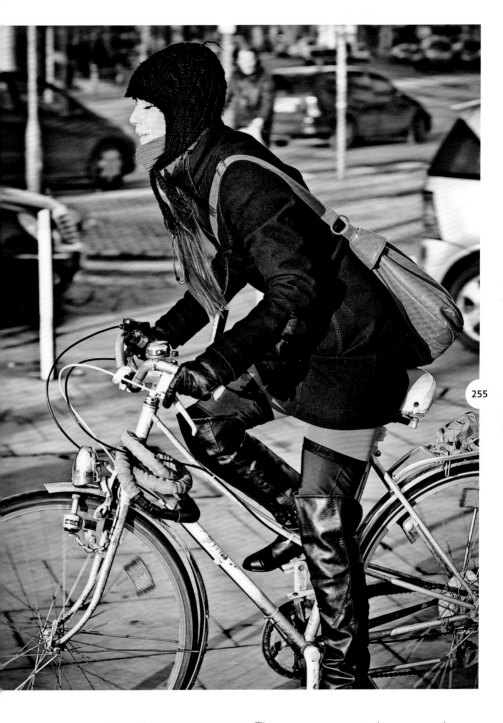

255

A TEA COSY ON YOUR HEAD There are many ways to keep warm when on your bike in adverse weather conditions. In Budapest (above), over-the-knee boots and an under-the-chin woolly hat provide the sensible solution.

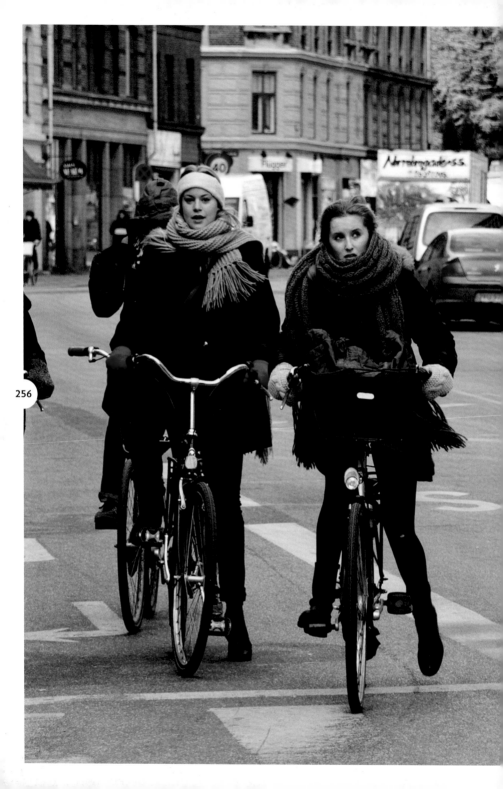

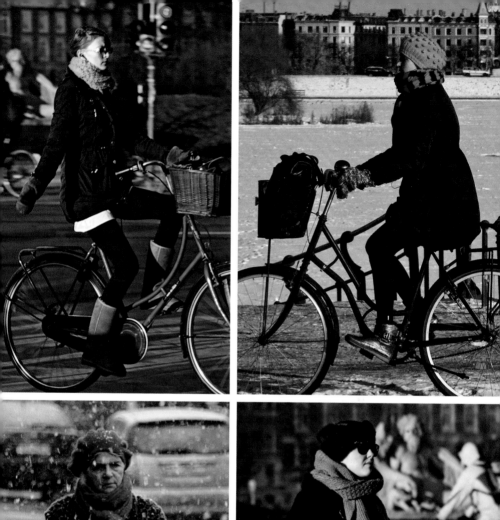

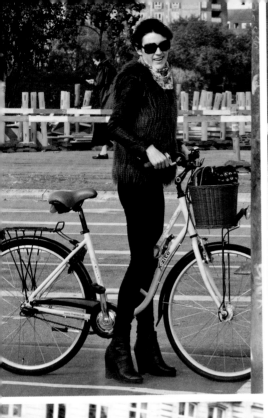
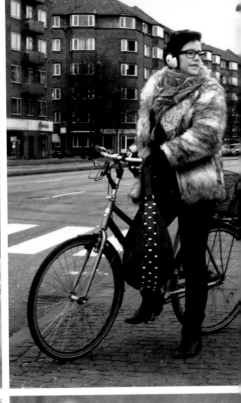
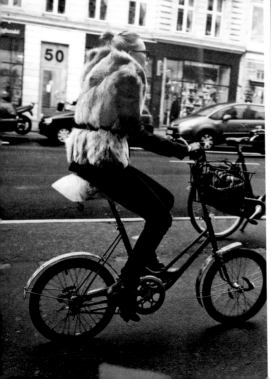

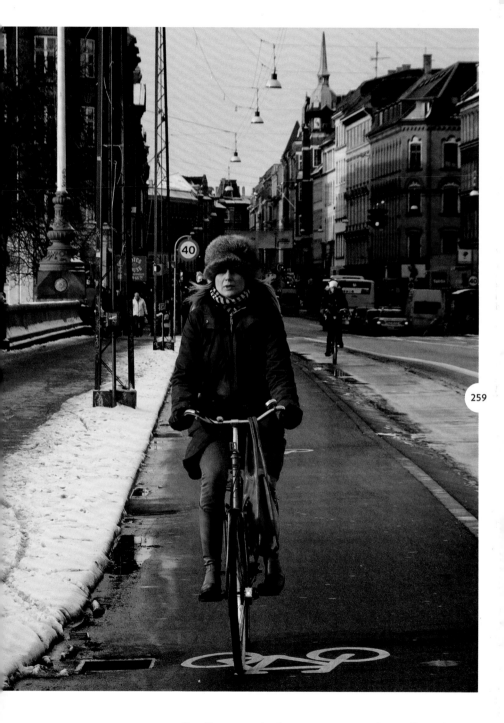

FURRY FABULOUS Bundling up in the freezing winter weather in Copenhagen.
Nørrebrogade, or North Bridge Street (above), is a main artery in the city.
After a trial period, it has now been closed permanently to through traffic.

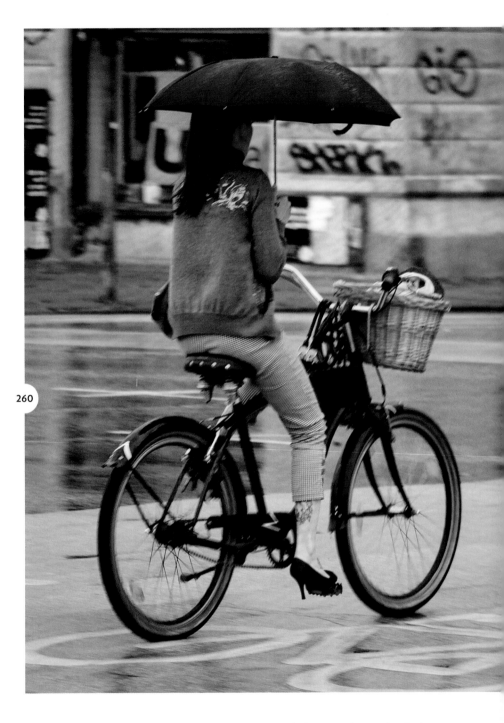

260

RAINY-DAY ELEGANCE As incredible as it may sound, there are those who think it is difficult to cycle in heels. Worn with drain-pipes or pedal pushers, high heels add a certain dash and confidence.

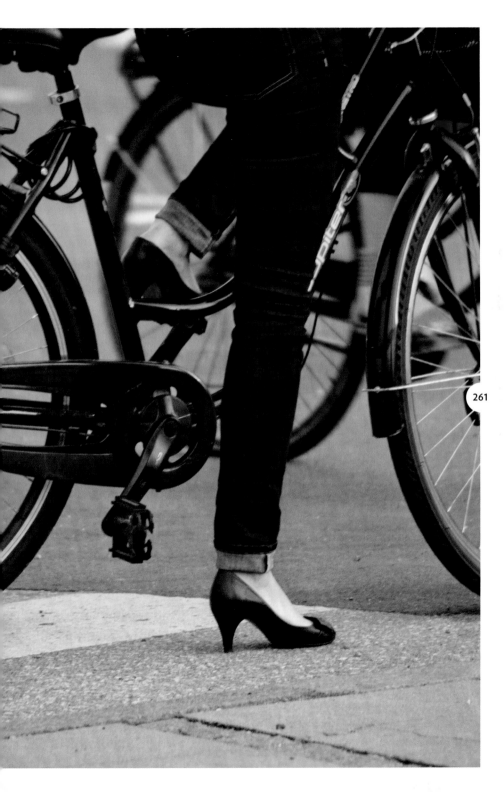

'SWEET SHOES ON PEDALS ...
CYCLE TEASE, CYCLE GIRLS.'

**POUL HENNINGSEN,
'THE BICYCLE SONG', 1935**

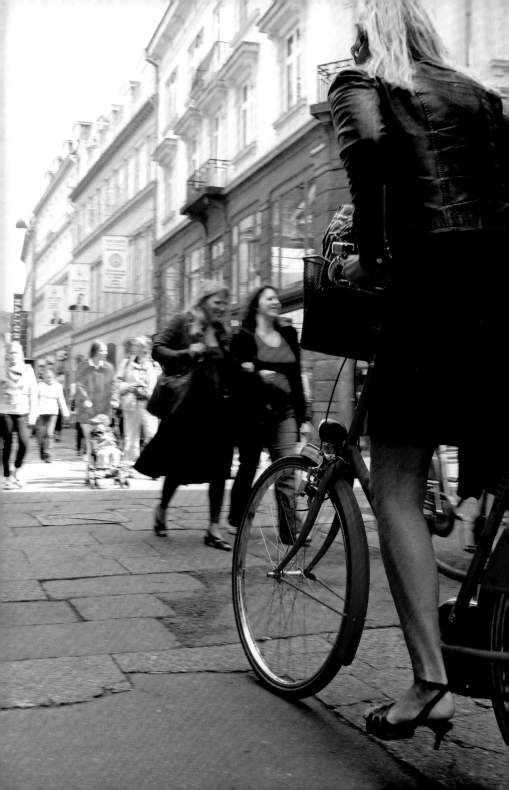

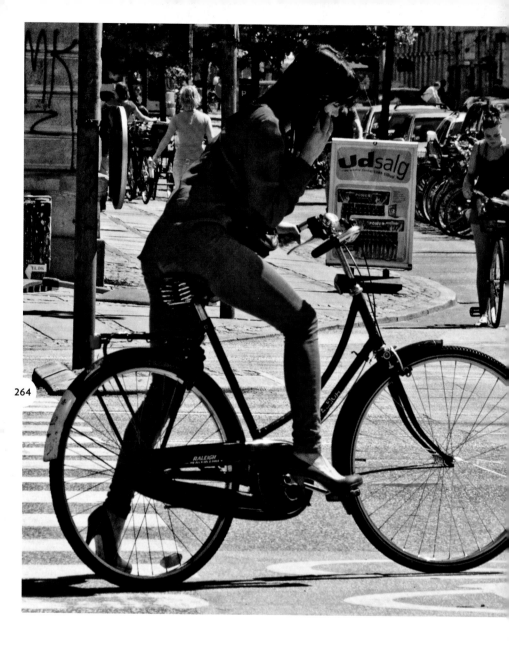

264

TO THE POINT Danish girls never let sensible shoes get in the way of making a fashion statement. True to the Cycle Chic ethos, their clothes are fun, stylish and individual – a neat summing up of the manifesto, in fact, in 10+ centimetres.

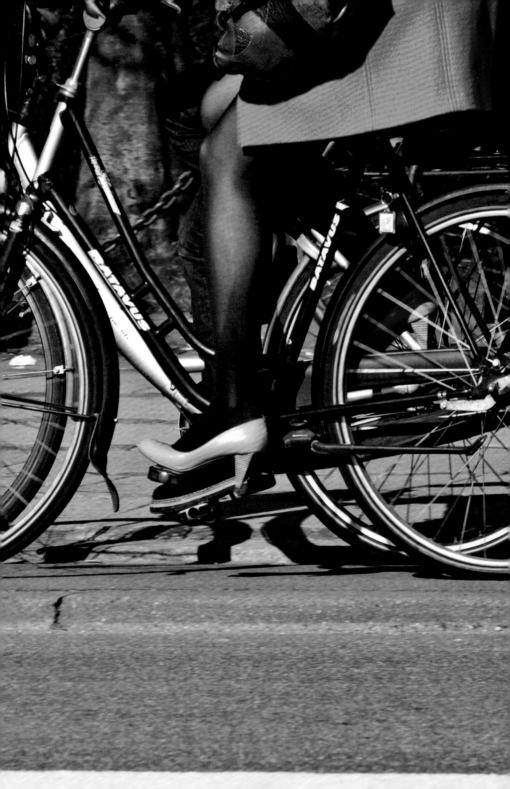

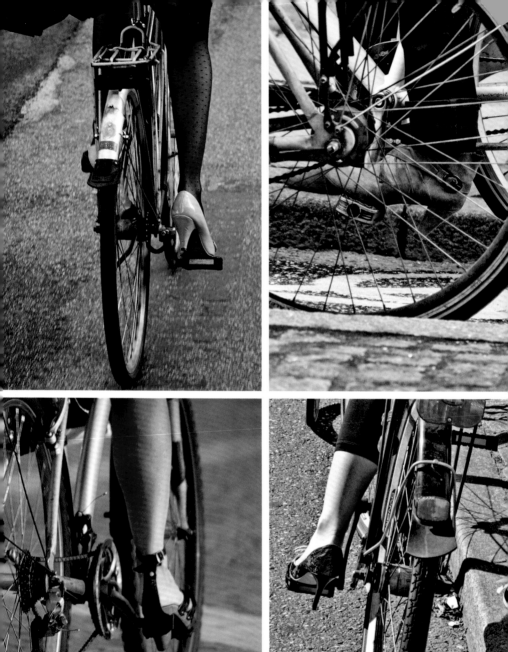

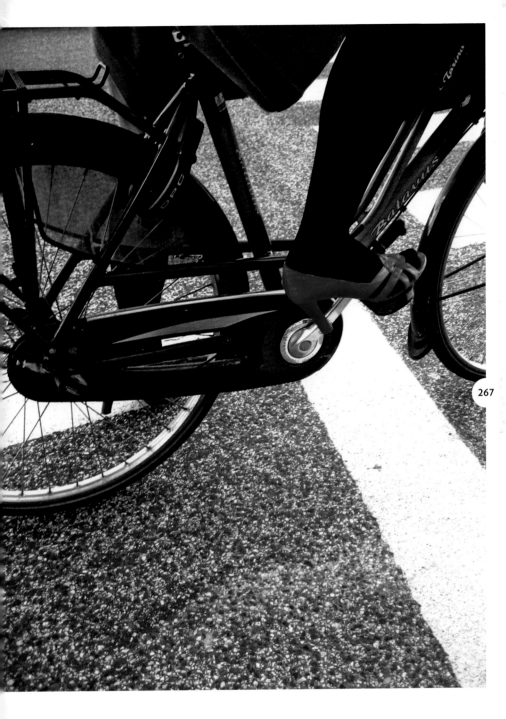

ALL HAIL THE HEEL Millions of female cyclists – throughout the twentieth century, and well into our own – can't possibly be wrong. Everything from the stiletto to the high-heeled boot to the 1980s cone heel is on display.

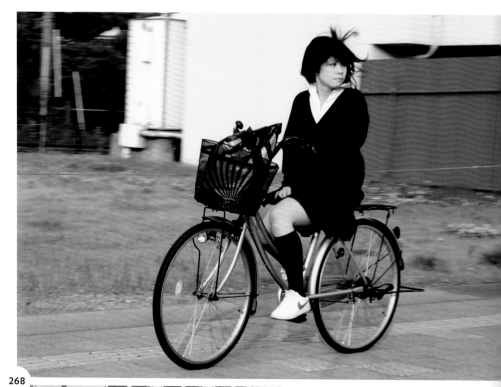

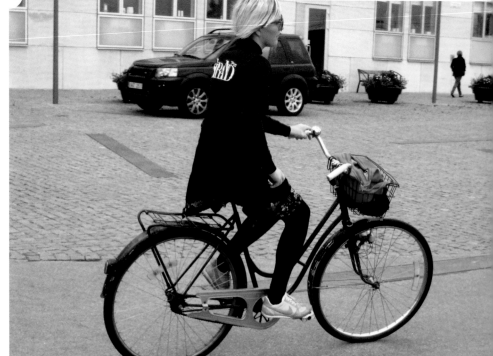

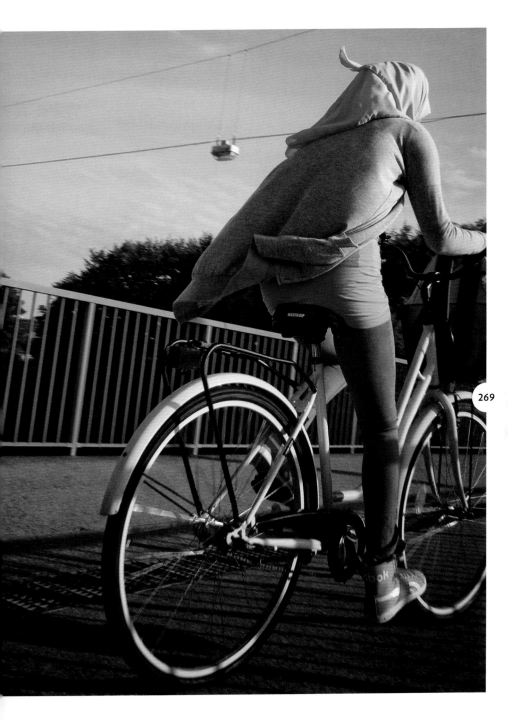

269

IN TRAINING Matching 'swooshes' in Malmø (opposite, bottom) and Fukushima (opposite, top), where bicycle culture is firmly established. At the city's train station, workers are employed to keep the rows of parked bikes neat and orderly.

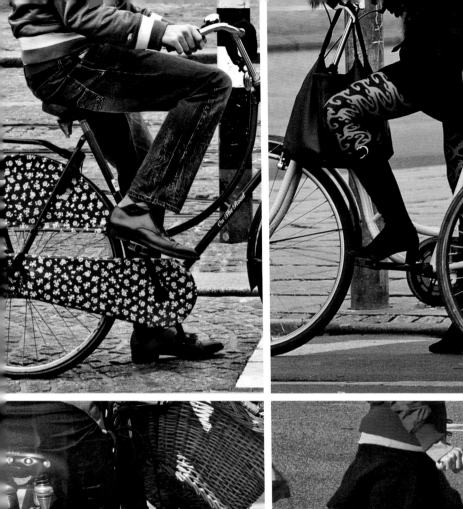

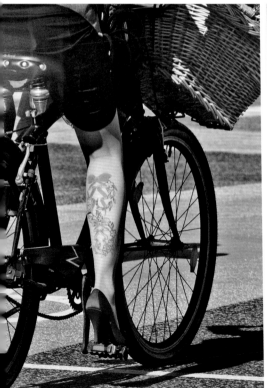

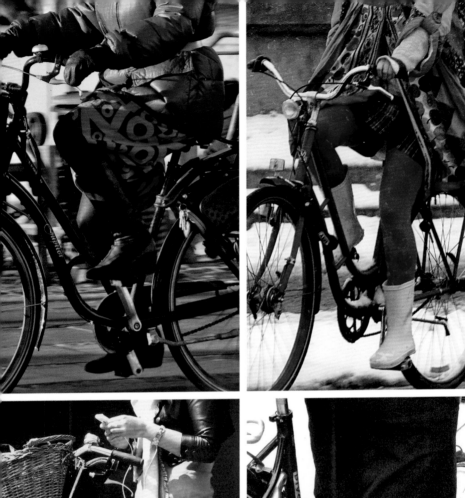

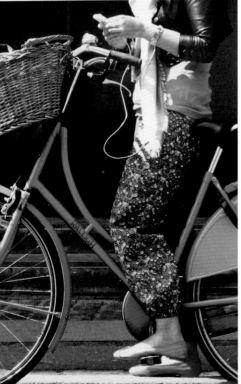

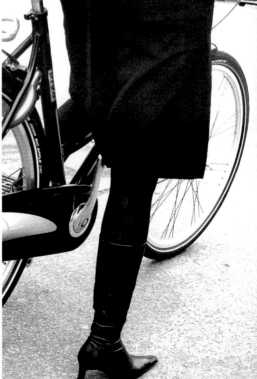

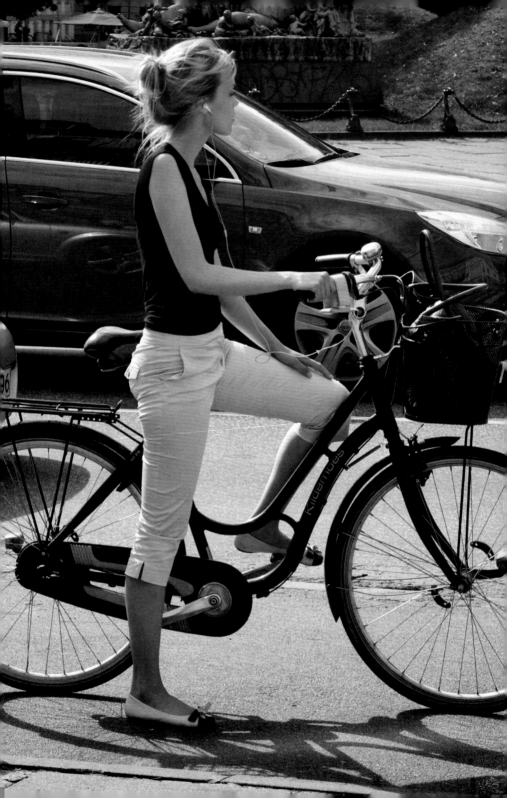

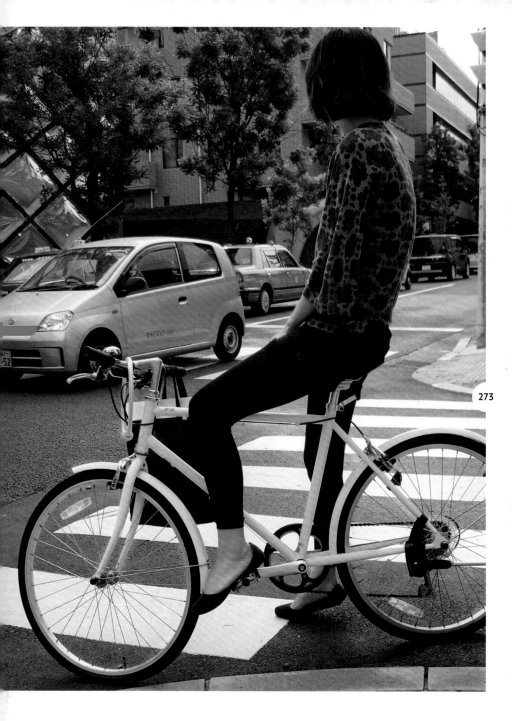

FLATLANDS Keeping their feet firmly on the ground in ballet pumps in Copenhagen (opposite) and Tokyo (above). Japan has led the way both in safety and in providing innovative and inspirational parking solutions.

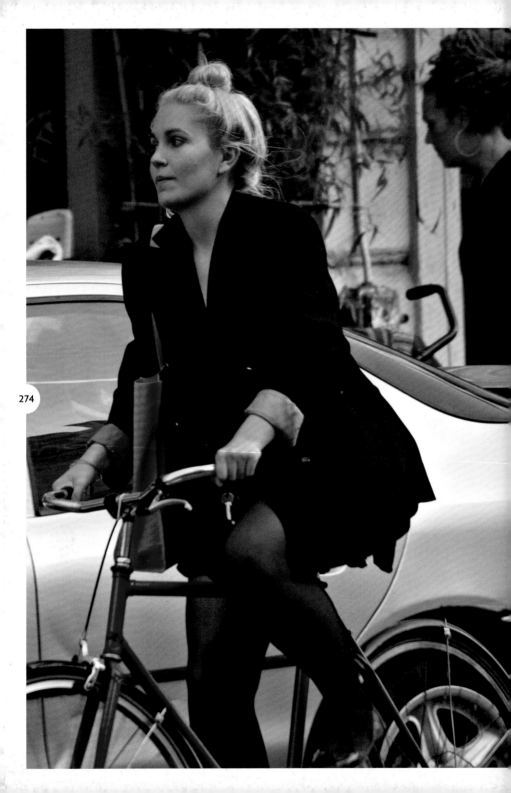

'THE BICYCLE'S TRIUMPHANT MARCH ACROSS THE WORLD CONTINUES EACH AND EVERY DAY THAT PASSES.'

CYCLEN MAGAZINE, 1899

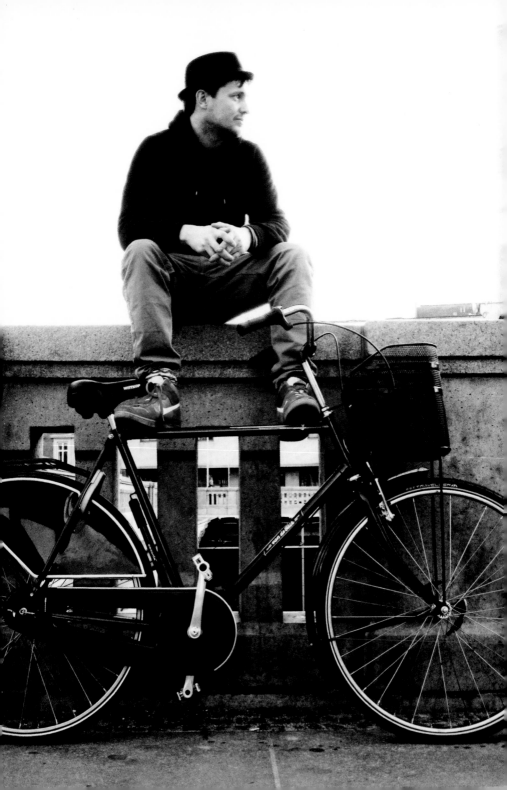

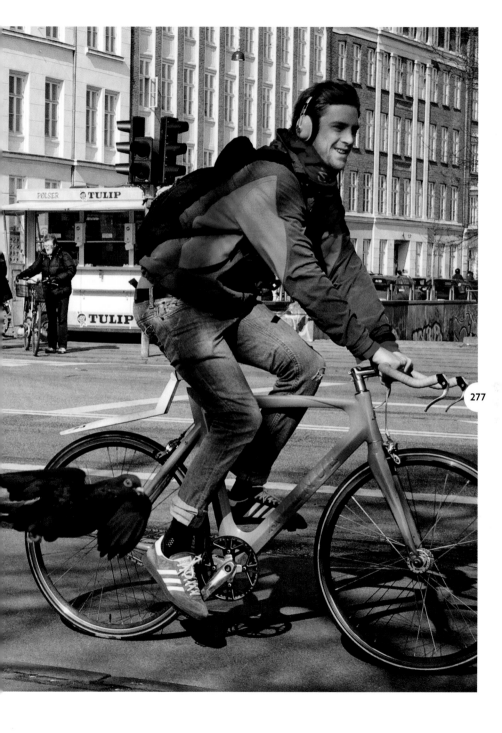

GREEN MACHINES Contrast your green jeans with your shoes, or, if you prefer, do like this Citizen Cyclist (above) and match them to the low-flying pigeons on your route.

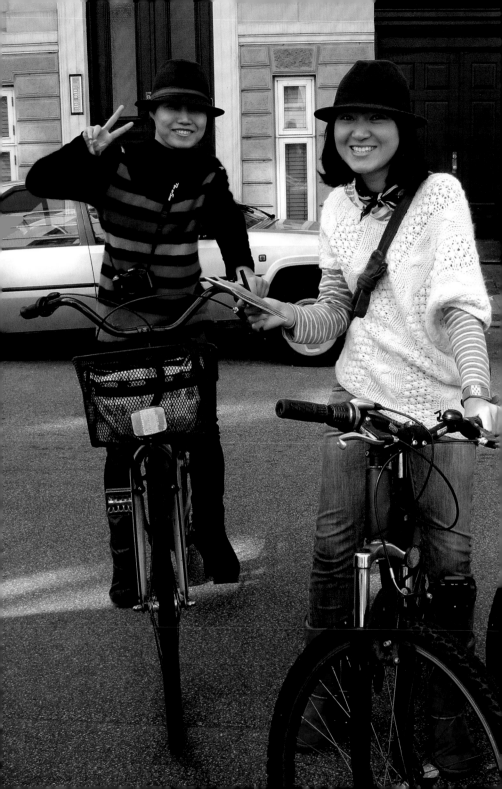

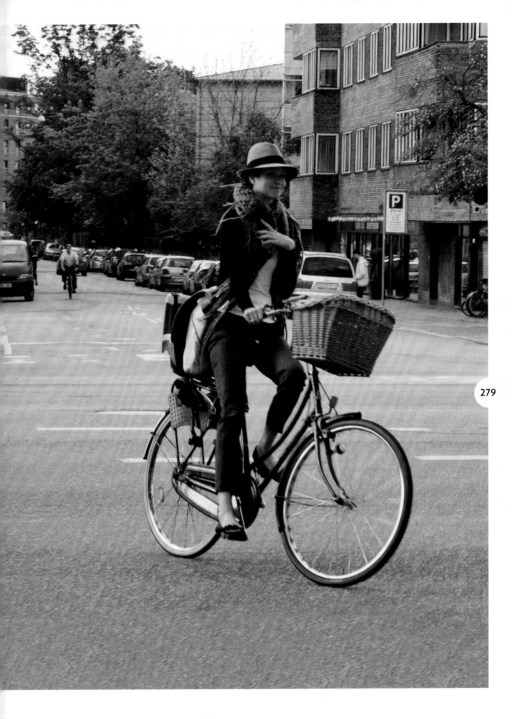

279

TIP OF THE HAT The return of the dapper trilby followed the return of the bicycle to the urban landscape. Coincidence? I think not. And how much better to team it with a fluffy, fringed scarf and pedal pushers.

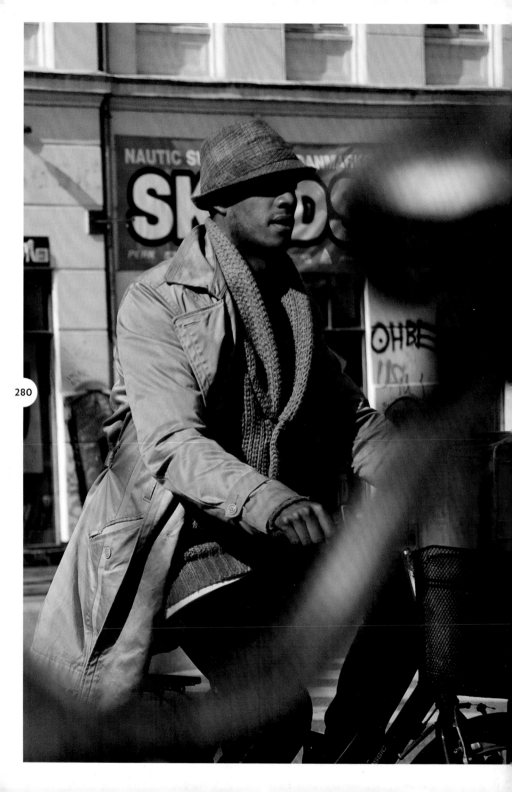

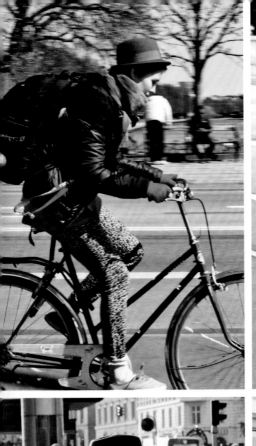
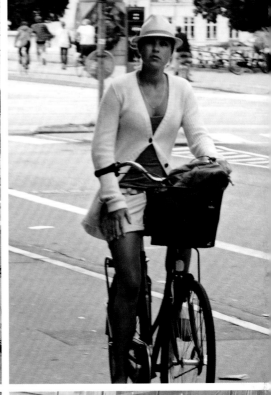
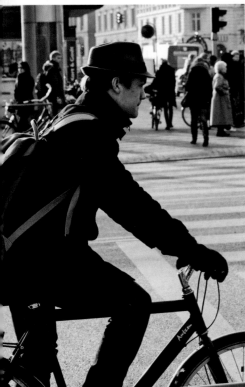
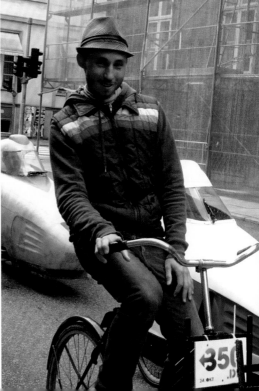

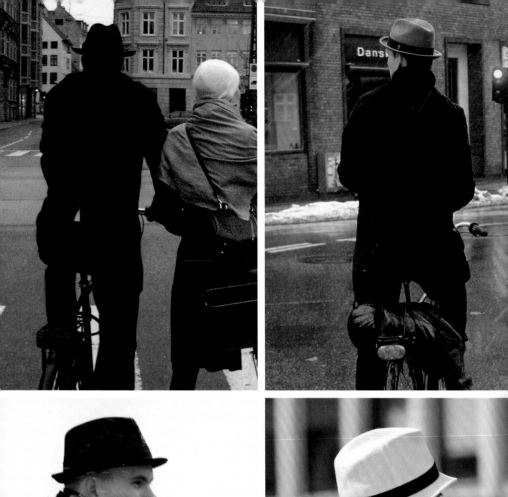

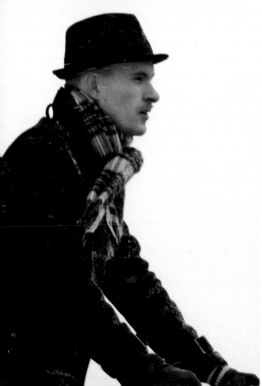

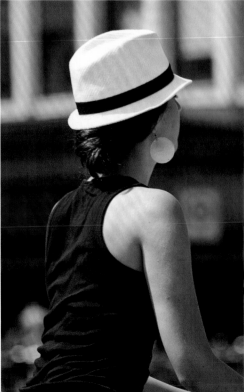

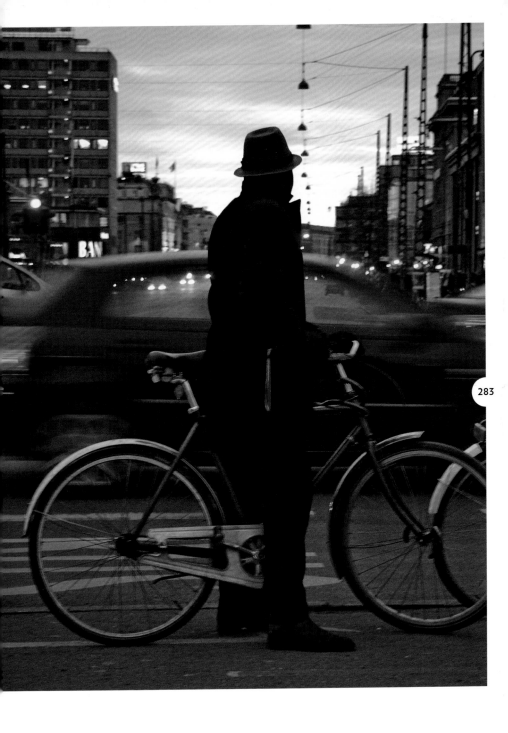

283

MAKING HEADWAY So many hats, so little time. Sometimes it's enough to stop and stare at a gorgeously pink sunset. That's what Cycle Chic is all about.

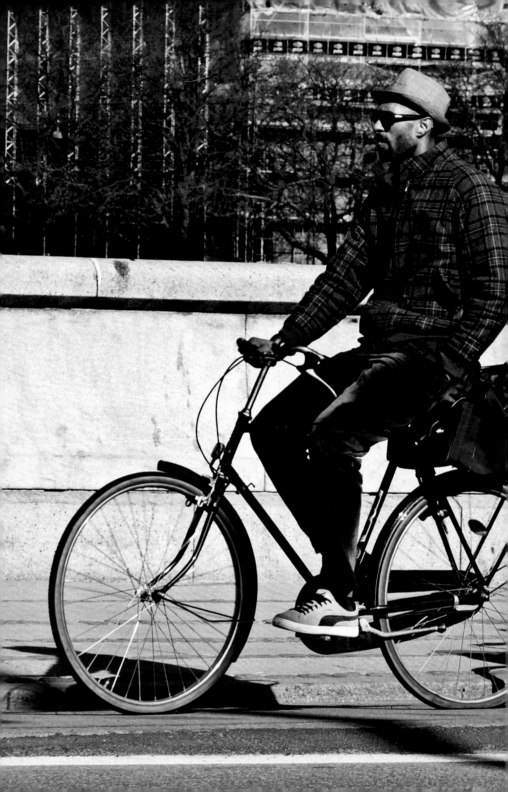

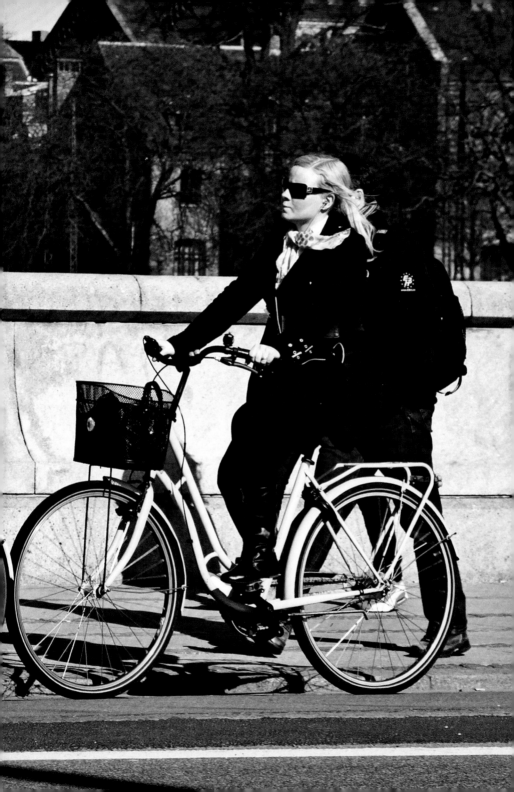

PICTURE CREDITS

All photos by Mikael Colville-Andersen,
except for the following:

25, 154–55, 161 (top), 186 (top left), 206 David Phu,
Vancouver/Berlin Cycle Chic; 44 (top left), 59 (bottom right),
193, 217, 286–87 Liina Lelov, Tallinn Cycle Chic; 45 David Serna
Zuluaga, Bogotá Cycle Chic; 52 Miguel Barroso, Lisbon Cycle
Chic; 98, 188, 254 (top left) Paul Rasper, Vienna Cycle Chic;
161 (bottom) Chris Traynor, Ottawa Cycle Chic; 186 (bottom
right), 192, 208, 209, 255 Gál Zoltán, Hungarian Cycle Chic;
213 Victoria Furuya, Vancouver Cycle Chic; 235 Mary Hudson
Embry, Copenhagen Cycle Chic

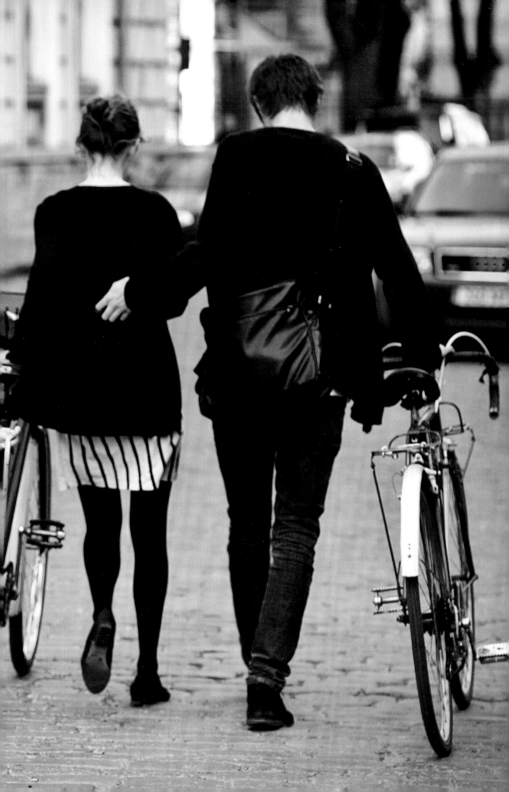

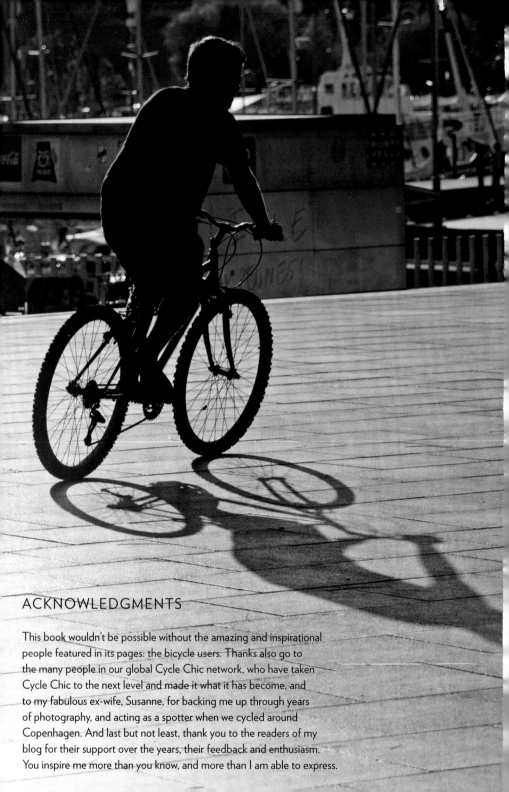

ACKNOWLEDGMENTS

This book wouldn't be possible without the amazing and inspirational
people featured in its pages: the bicycle users. Thanks also go to
the many people in our global Cycle Chic network, who have taken
Cycle Chic to the next level and made it what it has become, and
to my fabulous ex-wife, Susanne, for backing me up through years
of photography, and acting as a spotter when we cycled around
Copenhagen. And last but not least, thank you to the readers of my
blog for their support over the years, their feedback and enthusiasm.
You inspire me more than you know, and more than I am able to express.